CARTOONISTS' &
ILLUSTRATORS'

TRADE
SECRETS

Robin Hall

A & C Black · London

741.5

First published in Great Britain 2002
A & C Black Publishers Ltd
37 Soho Square, London W1D 3QZ
www.acblack.com

ISBN 0 7136 5488 0

Cover illustration by Robin Hall
Frontispiece by Robin Hall
Cover design by Dorothy Moir
Design by Susan McIntyre and Robin Hall

Printed and bound in Scotland by Bell and Bain, Glasgow

A&C Black uses paper produced with elemental chlorine-free pulp, harvested from managed
sustainable forests

CONTENTS

ACKNOWLEDGEMENTS

Many thanks to:

All the terrifically talented and very generous cartoonists and illustrators who contributed their expert advice.

The editors and designers at A&C Black – Linda Lambert, Michelle Tiernan, and Susan McIntyre – for their faith, patience and expertise.

My best friend Niki MacPherson who helped drag me away from my computer now and then. I'd *still* be lost without you.

My constant companions, Spencer, Lady, Merlin, Pablo and Pepe for making life a fun experience.

My agent Michael Hughes (www.irishartgroup.com) for helping to put food on my table.

And of course my Mum – the youngest looking pensioner in the universe – for all her love and support.

PREFACE

My previous book *The Cartoonist's Workbook* actually came about through fear. I had been asked to give a workshop on cartooning and, terrified at the likelihood of stage fright I decided to make some notes to cling on to. Those notes turned out so well I extended them into a book. For some odd reason I then wrote to Charles Schulz and asked him to write a foreword for me. He declined but told me he thought the method was 'one of the best he had ever seen'. (I have lived off this quote for years!). Armed with a recommendation from the world's richest cartoonist I sent the manuscript to a publisher (A & C Black) and they amazingly accepted it. If only it was *always* that easy.

The Cartoonist's Workbook is now published in six countries. I have translations in Spanish, Italian and Korean sitting in my bookshelf. It has received some great reviews but one of the most exciting outcomes of the book were the letters I have received from readers. They never cease to amaze me. I got a letter from a man in Brazil who begged me to send him a free copy because it would have cost him a weeks wages. He sounded desperate ... 'Please Mr Robins, please send book, love book ... no monies, please, please ...' How could I refuse?

Then there was a man in England who, after writing several times, told me that my replies had cheered him up so much they had stopped him from taking his own life due to depression. Wow!

Another guy from America told me he was thoroughly enjoying the book as it helped him pass the time of his two year prison sentence (must have held-up a comic store).

The list is endless, young and old, professional and amateur, they all said the book gave them so much enjoyment.

The reason the book worked so well is simple – it is full of 'secrets', tricks, formulas, methods, that *really* work. I wasn't born a cartoonist (as you will see in the following pages), I just had a desire to *be* a cartoonist and worked out how to do it by studying other cartoonists. Then I wrote all the secrets down and turned them into a book.

I suppose that's what this second book is all about, sharing more of the secrets I have learned about cartooning and illustration over the last 15 years. I spent 15 years working all this stuff out. You lot are the lucky ones. You get to save all that time.

Some of the 'secrets' I and many top pros are about to share may at first seem totally irrelevant to you but trust me – some day when things are going wrong or you are stressed out or can't get your brain into first gear you'll remember this book and hope-fully not be regretting that you gave it in to a second-hand bookshop – BEWARE!!

PART 1

Evolving as a Cartoonist

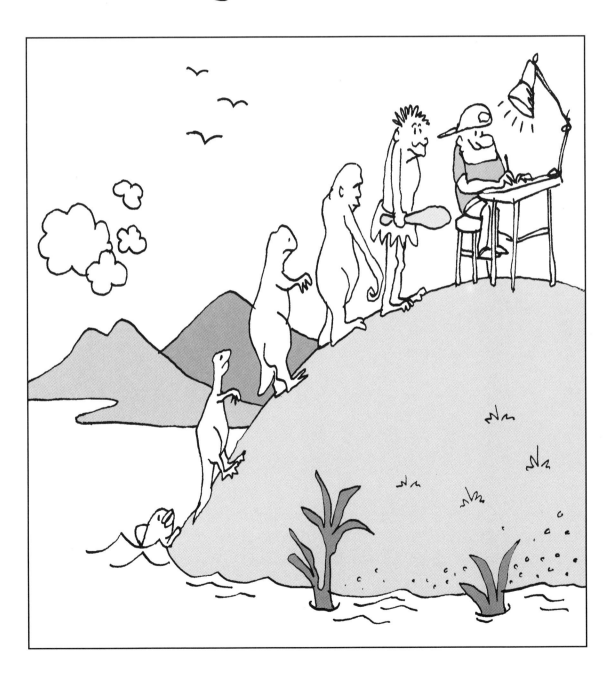

YOU HAVE TO START SOMEWHERE

I wasn't born with any natural abilities for cartooning or illustration. I always had an interest in anything to do with art and comics but my only talents lay in copying – I couldn't actually *create* anything out of my own head. If someone wanted me to draw a dog or a cat I had to get photographs or drawings to copy from.

Unfortunately, because I was *so* good at copying, my family and friends gave me the false impression that I was the greatest artist in the universe (beware of amateur admiration!).

It was only when I went to Art College and saw people creating exciting, original images without using any reference at all, that I realised I wasn't anywhere near as good as I thought.

At the mature age of 24 I finally got around to learning how to draw using my imagination without the use of a safety net. You can see by the following examples how awful my first attempts were. So take heart, if I could become a professional, *anyone* can. Also, be prepared that it takes time. It took five years of constant refinement of my work before it was anywhere near a good enough standard to be submitted to publishers and I am *still* trying to improve on it every day.

WEEK 1 – At the age of 24, my lack of natural ability is painfully obvious to everyone but me*!! Notice … not a decent joke in sight!*

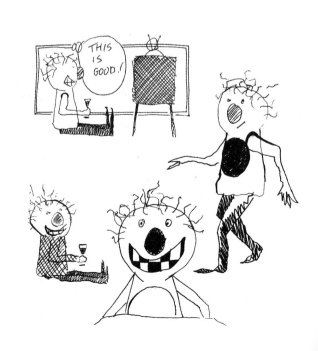

LOOSENING UP

A year and *thousands* of drawings later things had improved but I was still so 'tight' with my style and had such a fear of drawing backgrounds and placing the figures that I made dozens of these templates depicting backgrounds drawn from photos – so that I could trace them out for every strip. (The scardiest cartoonist in the west.)

I would also very carefully draw each character in set poses and then trace them out whenever I needed them – into my traced out backgrounds. This did *not* help my style loosen up.

This is a character called 'Phil Mupp' in various bath poses.

Unfortunately the one thing I couldn't disguise was the lack of humour.

Eventually I realised that these traced-out cartoons were more like lifeless, cardboard cut-outs. The problem was, I was so used to copying, I found it hard to approach cartooning any differently. No one told me that I needed to forget about finished artwork and concentrate on learning how to *draw* and *think* for *myself*.

The reason it took me five years to learn the art of cartooning is that I spent 90% of that time worrying about paper, pens, ink, borders, lettering, sizes, formats, submission packages, cover letters, copyright, titles, characters' names, the cartoon markets – syndicates, newspapers, magazines etc., – and only 10% of my time actually practising drawing and thinking up ideas.

What I didn't realise at the time was that when you eventually come up with good drawings and good ideas, it only takes you about a *day* to work out the rest! When you can draw well you can automatically do good lettering and borders and it doesn't matter in the *slightest* what pen or paper you use. When you submit great cartoons it doesn't matter what your cover letter or submission package is like either. All of that stuff is just a *complete* waste of time yet invariably it's the *only* thing that (other) books on cartooning talk about.

Do yourself a *big* favour and stop trying to finish off mediocre drawings and ideas. Take a year off from finished work altogether. Buy 10 sketch books and draw everything in sight. Don't go anywhere without a drawing pad. Draw on the bus, on the toilet, before you go to sleep, when you wake up, in your classroom, in your office. Draw the TV, the lamp, the sofa, cups, chairs, plants, vases, ornaments, images on the TV, the dog, cat, family and friends. Then draw from memory. Just be loose, *very* loose, even if it looks awful, as I said, you have to start somewhere.

Now and then try to be humorous. Go for variety. See if you can draw the TV set in five different styles. Try different shapes, poses, angles, shading, etc. Sketch things in motion. If you tend to draw characters facing to the left, practise drawing them facing to the right. Go through encyclopaedias and make *very* quick, loose sketches from the images. Copy other cartoonists' work. Practise until you can't tell the difference. Just sketch, sketch, sketch from morning to night.

At the same time study the gag-writing process. Read as many cartoon books as you can. Immerse yourself in the cartoon world. Make it a part of your subconscious. Try to write some spot gags but forget about strips for a while. You can lose yourself too much in the 'process' involved in a cartoon strip. Save yourself time by *investing* time in improving your drawing and your ability to think up ideas. There are a lot of great cartoonists out there looking for work – you need to be *brilliant* to compete with them.

THE IMPORTANCE OF CONSTRUCTIVE CRITICISM

I was very lucky when I was learning my trade. My brother, who also draws cartoons, and knows a good cartoon when he sees one, always gave it to me straight. I would show him my latest creations and he would tactfully tell me they were 'not quite there yet'. It always annoyed me because I was always *sure* my work was brilliant but the tiny seed of doubt that he planted in my mind would niggle me until I made improvements.

Thing was, he was right *every* single time but because I was too close to my own work I couldn't see it as he could see it 'from the outside'. In fact it took about five years before I learned how to see my own work with a keen critical eye.

Aspiring cartoonists from all over the world send me samples of their work and mostly it's 'not quite there yet' and it worries me that it never *will* be unless they find someone who will give them knowledgeable constructive criticism.

Find someone who knows what they're talking about to critique your work. Tell them you want total honesty, if they genuinely like it, fine, but if they don't, you want to be told the truth. Don't argue with them because this will put them off being honest with you in the future. Try not to let it show if you are upset by what they say. It needs to be someone whose advice you respect and who is reasonably broadminded in their tastes.

If you don't know anyone personally, then send your work to professional cartoonists and ask for feedback. First of all – praise *their* work (that softens them up) – then ask 'Could you tell me in what ways I can improve my work' (this will make it easier for them to be honest with you – I'm never really sure that people *want* any constructive criticism). Don't forget to include a stamped addressed envelope for their reply. Better still, give them your email address and you may get an immediate response. If they all say your work is awful then at least you'll know to either find another line of work or get back to the drawing board and make changes. To begin with, my own work was worse than awful so anything is possible.

Gary Hamilton – a good friend of mine – who draws for *The Dandy* is a great example of how beneficial 'constructive criticism' can be.

Even though Gary is one of those lucky sods – a natural cartoonist – there was a time when his work was 'wanting' in a few areas. His layouts were great, the sense of movement and vitality in his drawing was great, his colouring was great, in fact most of his drawing was almost perfect, yet here and there small things were wrong. A mouth would be an odd shape; an arm would be out of proportion; an expression wouldn't fit the scene … for some reason Gary had a blind spot when it came to these tiny but extremely important details. I could spot the mistakes a mile off but *he* couldn't seem to see them at all.

If he had been a lesser talent I might not have offered any constructive criticism at all (it is not always well received) but when someone is *that* close to perfection I find it difficult to keep my mouth shut. To his credit he took on board everything I had to say and didn't take it personally even though he couldn't always see the mistakes himself.

Through accepting criticism and applying it to his work he eventually reached the point where he could see the faults for himself and was amazed that he hadn't been able to see them before. Shortly thereafter he landed the job with *The Dandy* and his work just keeps going from strength to strength.

Having the ability to see your own work as others see it ('warts and all') is, in my mind, what sets amateurs and professionals apart. What I am hoping you can learn from Gary's story is that your work may have major problems that you just can't see *yet*. Lots of people have sent me cartoons which are full of faults and probably they will waste years sending them off only to be rejected. Save yourself some time. Practise more; refine your work more; seek constructive criticism and *seriously* study the work of other cartoonists.

In the opposite pages I have de-constructed some of Gary's work to show you just how analytical you have to be when studying other artists' work. The more closely you can observe in this way the quicker you will be able to apply what you learn to your own work.

LEARNING FROM THE PRO'S

In *Lord of the Jungle* look for the sense of movement that runs through the entire page. The page is almost like an animation. It is the *extreme* contortions of the characters that gives this effect. Even in the first panel, although the character is standing still, he has an animated posture. Look at the detail in all the panels. Gary gives as much attention to a piece of rock as he does to his main characters.

Look at the stylisation
- The outline of trees in panels 1 and 2
- The change from extreme close-up to far-away
- The body language of the monkey
- The exaggeration of the hole when he falls
- The exaggeration of the dust the animals make
- The footprints when he gets trampled
- The trampled body position
- The flow of the artwork throughout

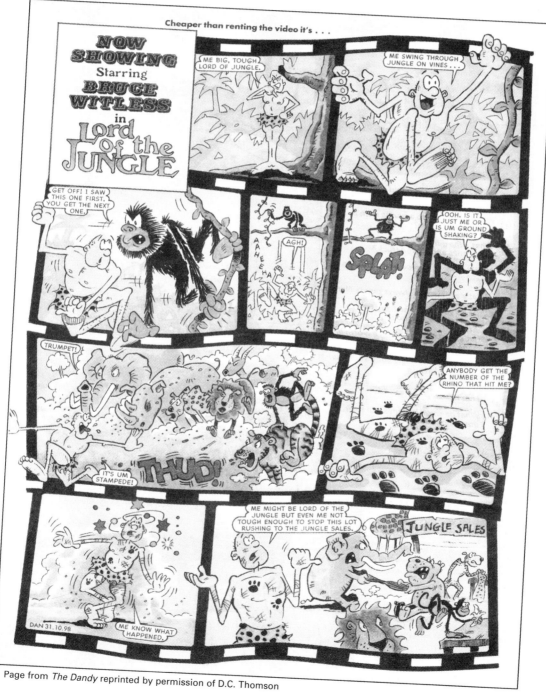

Page from *The Dandy* reprinted by permission of D.C. Thomson

REFINE YOUR WORK –
PRACTICE

It's not what you draw – it's the WAY that you draw it

There are as many cartoon styles as there are cartoonists so what is it that sets amateurs and professionals apart?

An amateur cartoon has a clumsy, untutored feel to it. A professional cartoon on the other hand has a slick, practised feel to it. There is a confidence in the way it has been done.

Look at a cartoonist like Mel Calman. His cartoons are almost scribbles yet quality oozes out of every line. We know that his style is *very* deliberate yet not forced – he just knows how to perfectly capture a scene in just a few loose lines. Years of practise can lead you to that point but I also believe you can help speed the process along.

Calman

Cartoon by Mel Calman, © S. & C. Calman

The golden rules of practise

- Practice until even your doodles look confidently drawn. Draw everything you see.
- Practice what you *can't* do – not what you *can* do.
- Study composition – how to place the various elements on the page in a harmonious way.
- Study other cartoonists and practise their style to learn their secrets.
- Don't overdraw – learn when to stop – study this in other cartoons.
- The viewer mustn't see a lifeless 'drawing' – they must see a 'live' cartoon character.
- Any tiny fault will ruin the illusion. Faces and hands are of utmost importance. I don't mean they have to be realistic, just confidently drawn. A viewer's eyes are immediately drawn to the face and hands. First impressions count.
- Always wait for the right drawing to appear. Keep sketching until a drawing comes out that *feels* right (see page 20).
- Be prepared to drop your style – or even an entire cartoon strip (and its cast of characters) – in favour of a new improved one.
- Don't try to force originality – let your own uniqueness blossom *as* you progress.
- Place your work beside published work and compare.
- Look at your work from all angles – upside down – in the mirror – reversed on a lightbox. This will allow you to see the overall balance of the composition – or obvious mistakes.
- Imagine you are an art critic or another cartoonist looking at your work.
- To begin with – be overly critical. Nearly all professional artists will tell you that they can't believe how amateurish their early work was – yet they thought it was great at the time. Try and use this knowledge to your advantage.
- Do warm-up exercises before you practise your character drawing (50 clockwise circles followed by 50 anti-clockwise circles).
- Practise the art of creative observation in *all* aspects of your life (see page 24).
- Remember, there is *always* room for improvement.

REFINE YOUR WORK –
REPETITION

Building your creativity muscles

I can't emphasise enough the importance of repetition. I always liken it to learning to play the piano. No one would expect to play well without first having to practise scales and exercises over and over. It is no different if you want to become a great cartoonist.

Repetition leads to a point where the right drawing just 'happens' – *every time*. Eventually your characters come 'alive' because you have got to 'know' them by drawing them so often.

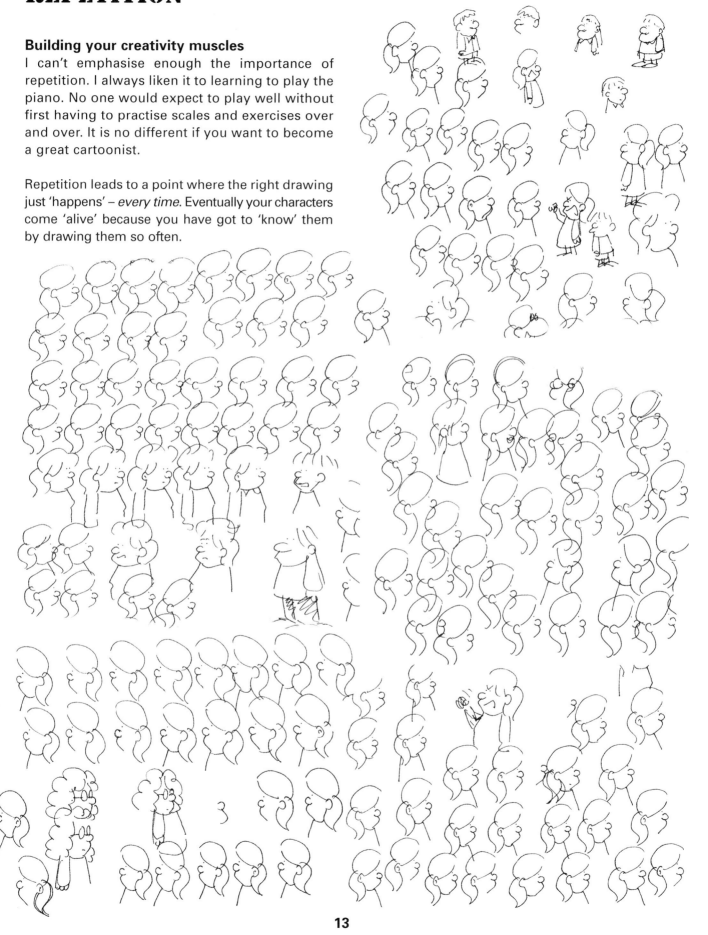

13

PRACTICE, REPETITION & EXPERIMENTATION

Here is an example of how I developed one character, Jean. I wasn't 100% happy with her initial look so I tried a few variations. It is also important to try your characters with other characters to see if they 'fit' with one another. You can see how much she had changed by the final page.

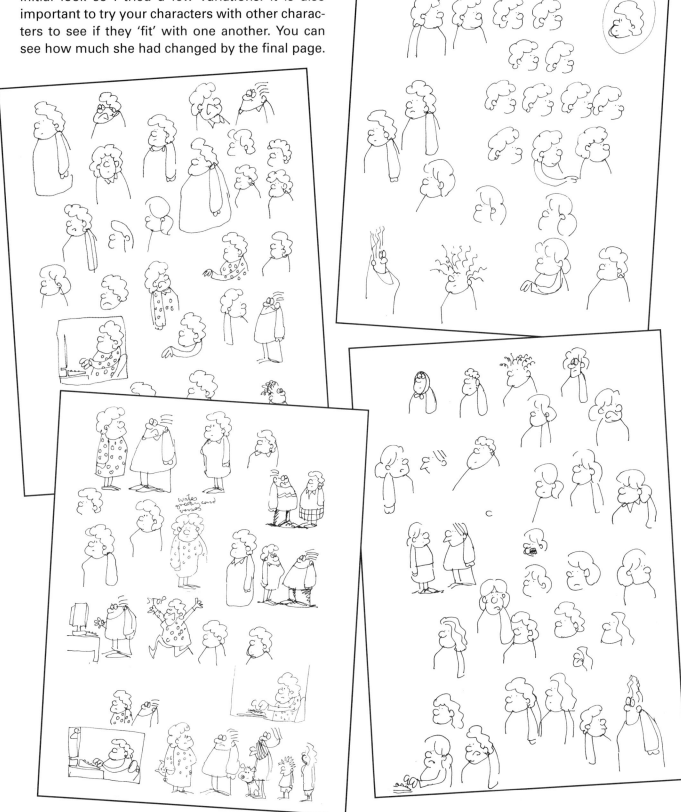

14

UNLOCKING YOUR FULL POTENTIAL

Ideas are everything

I would say that a cartoonist's main task is to think up original, clever and funny ideas. The drawing part, the technique, is secondary. A technically good drawing won't save a bad joke but a good joke can survive a poor drawing.

In order to evolve as a cartoonist we have to improve our ability to think up ideas. Drawing practise alone won't help.

If you developed your ability to think up ideas you could throw out all your books on cartooning techniques. Even a genius of technique like Bill Waterson could not have touched our hearts as he did if his ideas had not been genius also.

Where do ideas come from?

There are no formulas that will guarantee a great idea. This is why 99% of books on cartooning deal mostly with drawing 'techniques'. The question cartoonists get asked mostly is 'How do you think up the ideas?'. Practise and the use of certain methods and 'formulas' can help but at the end of the day an idea has to arise 'within' you - seemingly out of nowhere. If you can increase your ability to make this happen successfully you'll be way ahead of the game.

Study and practise can only take you so far

Obviously, the more we practise thinking up ideas, the better we will become but even more importantly we need to improve our ability to still our minds in order to think creatively.

Becoming better at 'thinking' creatively will improve both your ideas *and* your drawing skills. 'Thinking' comes before 'drawing'.

A clear head

It helps to have a certain amount of 'control' over your mind. A person who is overly worried, depressed, anxious, bored or unable to sit quietly, is unlikely to be in the frame of mind required to think up clever, lighthearted or rip-rouriously funny cartoons. From experience, when something is bothering me I find it very difficult to think up even serious ideas. So, just as an athlete needs to keep their body in perfect order, a cartoonist needs to be able to keep their 'head' together.

'In the zone'

We often hear sports commentators talking about athletes being 'in the zone'. When an athlete is 'in the zone' it means they have hit a peak where they are performing perfectly and effortlessly. They have gone beyond 'trying', almost as if something else has taken over.

Believe it or not, this 'zone' is the ultimate goal for artists aswell – to be in full flow – when great ideas arise spontaneously without effort. We have all had moments when this has happened, when it was as if some strange power took over and everything we did was brilliant. Afterwards, we may have even wondered 'Did I really do that?'.

The problem is, it doesn't happen very often, and we soon drift back into our usual routine of '99% perspiration and 1% Inspiration'.

An athlete or artist who finds themself 'in the zone' usually has no idea at all how it happened or how to get the feeling back. People imagine that these experiences are random occurrences that are simply due to years of practise. What they don't realise is that 'the zone' is a state of mind that one can enter at any time. A state of mind where *anything* you do, from cooking a meal to playing tennis to dealing with a client, happens effortlessly.

It is true that practising your craft with absolute devotion may eventually put you *in* the zone now and then, but you can also practise entering it *directly* at will.

Originality is beyond thought

While it helps to study the work of the master cartoonists, there comes a time when you need to create something no one else has thought of. True originality is more than just a reworking of old ideas. True originality is somehow beyond mind, beyond thought. For instance, if you wanted to whistle a completely unique tune, what would you do? You couldn't just start whistling random notes because it would probably sound meaningless. Nor could you whistle old tunes you have learned because that would hardly be original. You would have to be silent for a few seconds and try to 'listen' within yourself until some sort of theme popped into your mind out of that silence. *Then* you could develop that theme into a tune using your prior knowledge of other tunes.

Obviously it would be of tremendous benefit to *any* artist if they could tap this inner 'resource' any time they wanted. The practise of moment-to-moment awareness can help you do this.

The practice of awareness

If your mind is always 'somewhere else' you will find it hard to focus it on specific tasks. The practise of moment-to-moment awareness increases your ability to be fully present with whatever it is you have to do whether it be driving your car, dealing with other people or thinking up brilliant ideas for cartoons or illustrations.

You may think you *are* aware all day but actually most of the day people live in their thoughts. We eat our breakfast thinking about the problems that may lie ahead. We do our work thinking about whether it will ever be successful or not and this blocks the creative flow. As John Lennon said 'Life is what happens while we are busy doing other things'. Watch people walking down the street. They have their bodies on automatic pilot while their minds are somewhere else; the kids, the wife, the pay rise, an argument with someone, the yearning for more money, a holiday, what they'll have for dinner. It is no wonder people keep bumping into one another.

We are so used to living in our thoughts in this way it seems perfectly natural. But as long as we constantly dwell on the past or future we miss life as it is here and now and as I said, this greatly affects our ability to be creative because pure creativity needs a certain amount of awareness or alertness in which to arise.

There are many ways in which we can become more aware and open to this intuitive creativity – the genius that lies within all of us. There are no rules however, we are all different and you have to search until you find the way that suits you best.

The most I can do here in a few short pages is to recommend some books that have helped *me* along the way. Not only will they help you creatively, they will help you live a more joyful and relaxed life. My suggestion is to buy them all and spend the next ten years reading them. Awareness rarely happens overnight.

Recommended reading

(You can order all of these books at Amazon.co.uk or Amazon.com)

Wherever You Go There You Are
By Jon Kabat Zinn

What Is Meditation
By Osho

Zen O'clock
By Scott Shaw

Zen Made Easy
By Timothy Freke

Awareness
By Anthony De Mello

Everyday Zen
By Charlotte Yoko Beck

The Seven Spiritual Laws Of Success
By Deepak Chopra

The Power Of Now
By Eckhart Tolle

As It Is
By Tony Parsons

Meditation, A Foundation Course
By Barry Long

Also check out the websites on page 140 under 'Creativity and Wellbeing'

And on a more personal note; If any of you ever have any trouble or know anyone *else* who has trouble with Panic and Anxiety Disorder (as I once had) a book called *Self Help For Your Nerves* by Dr Claire Weekes will sort you out in no time.

HOW TO STAY SANE

Many cartoonists and illustrators I have spoken to suffer from some form of stress or anxiety. It seems to go with the job. Why? I'm not sure, but perhaps it's because freelance artists are never completely sure where their next pay cheque is coming from. We are also constantly striving to improve our work which means that our minds are rarely satisfied. Then there are times when writer's block sets in and we wonder if we will ever think up another idea again.

To the average person who has to work nine to five it seems as if our whole life is one big holiday but at least *they* get the rest of the day off. Freelance artists never stop working, even in their sleep. Someone once told me that I sat up in bed one night – still fast asleep – scribbled on the wall with my finger, and went back to sleep. I sleep with a marker in my hand nowadays in case I miss out on a great idea.

It's your *job* to be funny – you can't be funny if you are stressed out – so learning how to manage stress is as important as learning how to draw cartoons.

There are many ways to avoid a build up of stress.

Your office
Make sure it is very functional. There is nothing more stressful than trying to find things in a cluttered room. Get into the habit of tidying up every morning before you start work. Put things in order, make a list of things you have to take care of. If you have important things that need doing that aren't to do with your work – like paying bills – then take care of them first or they will be on your mind.

If you haven't much table space then build shelves – I have 30 shelves in my room and could use a few more! Most of my shelves are for holding paper, refill pads, notebooks, pens, rulers, etc. so I have one wall filled with 8ft x 1ft (280cm x 35cm) shelves that are only five inches apart.

Invest in a good office chair. You will be spending most of your life in this chair so spare no expense. Make sure the cushion is soft at the front of the seat where you lean on it most. Get one with wheels so that you can easily glide from computer to drawing board to lightbox to bookshelf.

Don't draw flat on a table. Use a large drawing board and keep it at a good angle so that you won't get a sore back or shoulders. If you mostly use a computer and a graphics tablet, incorporate the tablet into a drawing board. It is also very important that your monitor has good definition and is large enough so that you can see everything comfortably. People underestimate the amount of stress generated by inappropriate computer equipment. And remember, when using computers, take regular breaks to stretch your limbs and rest your eyes.

Lighting is also very important. I like to have my room as bright as possible with a good anglepoise lamp at every work station.

Reference Material
There is nothing more stressful than a blank mind at the start of a job – or if a deadline is looming. This is where a having ton of reference material is imperative. Very often, before I begin to work on my own ideas for a job, I will hunt through every book I can find that contains anything even remotely relevant and set it on the table beside me. Very often I don't even bother to look at it again but just knowing it is there gives my mind the security it needs to flow freely on its own. I must have five hundred books in the house that I keep in case of emergencies.

But whatever you do, *never, ever* copy someone else's drawing or idea exactly. Apart from being unethical, it's not going to help build your confidence. Study and borrow – never steal. Let me give you an example … (at the risk of being sued).

Look at the cartoon I did on page 7. When I came up with the title 'Evolving as a Cartoonist' I had the obvious idea of using the Darwinian image of man evolving from the sea through the various stages from cave-man to modern man. In the back of my mind I remembered seeing a Gary Larson cartoon using this same imagery (though he's done a cartoon on practically *every* subject). When I flicked through the Gary Larson biography *The Pre-History Of The Far Side* I discovered that not only had he done a similar joke but *his* opening chapter had a similar slant to mine. He called the chapter *Origin of the Species* and the cartoon underneath was – you guessed it – a 'cartoonist emerging from the sea'. I had second thoughts about using the idea after that because I wondered was I just having total recall of Larson's cartoon but when I thought about it, I decided nine out of ten cartoonists would have come up with the same image for 'Evolving as a

Cartoonist' – what other solution would there *be*? Anyway, as you can see, I went ahead with the idea. Not only *that* but I 'borrowed' some of his styling for the drawing itself. This is what I mean by 'borrowing' – it's not done with any sense of 'stealing' someone else's entire idea and claiming it for yourself.

Diet

It's a little known fact that a cartoonist uses up more calories per minute than the average office worker, manual labourer or rocket scientist. This is why so many cartoonists eat incredible amounts of junk food. Also, because their minds are filled with important issues such as finding the right title for their latest comic strip, learning how to grill fish and cook broccoli is not high on their list of priorities. But seriously, poor eating habits can lead to tiredness, fatigue, headaches, digestive trouble, colds, flu and a string of other problems that could seriously disrupt your creative output. So, just as a car needs the right fuel, *you* need nourishing food. My suggestion is to buy lots of healthy food that is easy to prepare. Have plenty of fruit and nuts close at hand for when you have a snack attack. Don't go to extremes, I used to worry myself sick trying to eat the right foods. Just try to eat as much non-processed food as you can but if you pig out now and then – don't panic.

Exercise

As for exercise – if you don't get enough, your creativity will suffer. Spending *all* day at a drawing board will catch up on you eventually. You need the equivalent of an hour's walk every day for the benefit of body *and* mind. I used to suffer from back ache, neck ache, shoulder ache, stomach ache and every other kind of ache until I got two dogs which need to be walked four times a day. I haven't had an ache since! Our bodies *need* exercise. If your body is feeling poorly, your mind will not function as efficiently and your work will suffer.

Work needs rest and play

I find that I work more effectively if I can take my mind completely off the work at regular intervals. We all know how beneficial a holiday can be for recharging our batteries so I try to have a mini-break every hour or so. I go for a walk, play with my cats or dogs, have a snack, phone a friend, sit and meditate, play the guitar or even just tidy up the mess I have usually gathered around me. I make it a deliberate policy to forget about the work for a while and when I return to it with a fresh mind I nearly always see it in a different way.

Like all things in life it's all about finding the right balance. Creativity needs space and emptiness in which to arise. You can't think up a new tune if you keep singing an old one.

You cannot be serious

I used to think that becoming a successful cartoonist was the 'be all and end all' in life. I always had a sense of urgency, that it had to happen *soon*, that time was running out. I worried and worried and every time I had a new idea my mind would go into a kind of trance hoping that maybe this would be the 'breakthrough' I'd been waiting for that would bring me fame and fortune and imagined happiness. Then after a few rejection letters, doubt would set in and I'd wonder if I'd *ever* 'make it' as a cartoonist and should I become a plumber or a dentist.

It took me many years to realise that these highs and lows always passed, I always moved on and forgot about them, the sun kept shining and the world kept turning. I used to think that I would only be really happy if I became a cartoonist. That was just a symptom of me incorrectly thinking that happiness came from things outside myself – a job, a house, fame, other people. When you live with that belief, happiness is always 'round the next corner' – always out of reach. My *first* priority in life now is to learn how to enjoy the moment I find myself in. If you aren't happy drawing cartoons then either figure out how to *be* happy at your work or do something else.

IF AT FIRST YOU DON'T SUCCEED...

Some days things just don't go according to plan

I was commissioned to do some illustrations for the fine art print market. Fine art prints apparently sell better in pairs so after I had painted *Moonwalk* (pictured right) I had to work out a match for it. I had an idea to do a couple 'dancing in the moonlight' and imagined it would be fairly straight-forward. It turned out to be one of the most difficult illustrations I have ever worked on. If you look carefully at the roughs you will see that my creativity had gone on holiday.

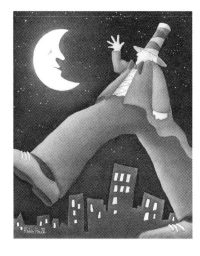

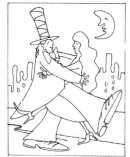

I ended up having to trace parts of *Moonwalk* to get the same loose style. Then I added the female figure but the trouble I had getting her head right was unbelievable. Look at the awful attempts on the facing page. In despair, I had to trace the shape of the *man's* face in *Moonwalk* and turn it into a female face on the lightbox. This is a good example of *waiting* until the right drawing appears. I spent at least a day on just the sketch for this illustration. It was extremely stressful but worth it in the long run. If you *know* a drawing isn't as you imagined it in your head then keep sketching till you feel that it's right. Don't settle for less.

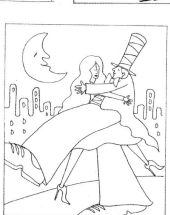

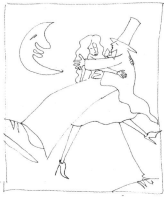

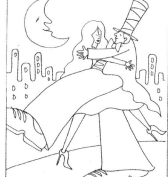

The first 'tracing'

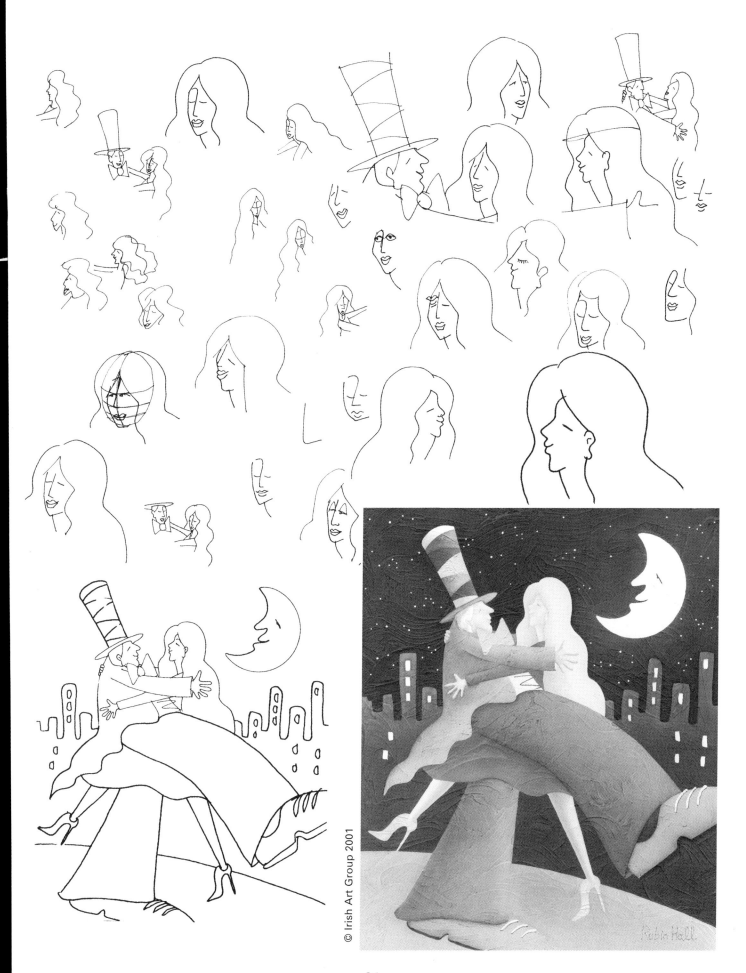

21

'WRITER'S BLOCK IS FOR AMATEURS'

Charles M. Schulz

For the past hour I've been sitting staring at the title of this page trying to figure out how to begin writing about it. I had to laugh when it dawned on me that I was having writer's block about writer's block. Everyone experiences days when they can't get their brain into first gear. Even days when they wonder if they will ever think up another idea again. I have two ways that I deal with this problem.

1. Go with the flow

If you have no deadlines to meet and you don't feel motivated *at all* to work then don't fight the feeling. Put your feet up and read a good book, watch TV or go to the park. Periods of inactivity are an integral part of the creative process. Night needs day, up needs down, activity needs rest. The trick is to go with the flow without feeling guilty. We often imagine that these necessary rest periods are an indication that we've lost the plot altogether and we'll never get it back. If you find that you feel guilty doing nothing then go halfway and find things to do that are related to your work but relaxing at the same time. Tidy your office, get your work in order, weed out mediocre ideas, make a list of things that need doing, sort out a few bills, make more 'future time' by doing things now that you know will need doing, spend some time with your spouse, get some exercise, visit your poor neglected friends, your Mother, your bank manager ... do something purposeful. I can have periods like this that last for *months* so don't despair – it happens sometimes. All I can tell you is this – every time it happens – when the creative urge returns – as it always does – I notice improvements. I see mistakes I couldn't see before. I can draw a little bit better and I always wonder why I got so worried in the first place.

2. Work through it

If you have a deadline to meet and writer's block strikes, that's a different story altogether. Very often it is brought on by fear and pressure clouding your thinking. This is the time to bring out the reserve plans.

Plan A. Gather reference material. Look for images from books, magazines and encyclopaedias that relate to your needs or look at how other artists have tackled the subject. Keep it all close at hand in case of emergency.

Plan B. Make a list. In my first book *The Cartoonist's Workbook* I described various methods for coming up with ideas. I guarantee that they can't fail. In a nutshell, my way of starting the creative flow is to first of all write down *anything* and *everything* that comes into your mind about the subject in question. Don't try to be creative to begin with, just start by writing single words. Let's say you had to come up with a joke about golf and your mind has gone blank in the jokes department. Forget about being funny and simply make a list of things relating to golf – clubs, golf balls, trolley, the green, driving off, the club house, shouting 'four', slice shot, smashed windows, the bunker, 'plus-fours', cheating, golfing 'widows', playing in all sorts of weather, etc.

Okay – that's list number one. Now, make another list that expands on the first one.

So, for instance, think more about the 'bunkers' – are there kids making sand castles in it? Is it quicksand? Is there a skeleton of a dead golfer in it? etc. By the time you've done this with every

word – *something* humorous is bound to come into your mind.

Plan C. Start doodling. Don't go for finished drawings – just doodle *anything* on your list. Very often you will 'see' a joke by looking at a drawing, or a character will 'speak' to you from the page.

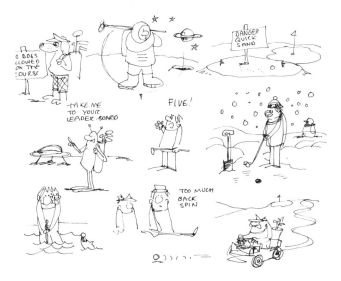

Plan D. Try a new approach to the problem. Flick through a few cartoon books and see if maybe another cartoon format might work better. You may have been thinking that an illustrative gag was the solution but maybe a Gary Larson type panel may work better or a cartoon strip. Someone once gave me a photograph of a group of about 30 schoolchildren and asked could I caricature them all for a thank you card for their teacher who was leaving. To save them money and myself about three weeks work I decided to simply add funny things things to the photo instead – hats, hair, beards, moustaches, glasses etc. The result was just as funny and everyone *loved* it. It also helps to

go through books just to give your mind something new to latch on to.

Plan E. Have a break. Tidy up. Go for a walk. Forget about the problem for a while. I'm sure you've had that experience where you are trying to remember a name and you *know* it's at the back of your mind but it just *won't* come out so eventually you have to give up and then later on when you aren't thinking about it it pops into your head. Our subconscious can work on problems more easily sometimes if 'we' get out of the way for a while.

Plan F. Meditate. To be honest, meditation is what helps me break writer's block more than anything else. I would put it at the start but until you practise it for a while you won't believe how effective it can be.

Plan G. If all else fails ask for more time. Sometimes you may be able to extend your deadline to give you some breathing space (as I did with this book several times). It also helps if you know other cartoonists to whom you can pass work on. Above all, remember that it's not the end of the Universe if you can't get the job done.

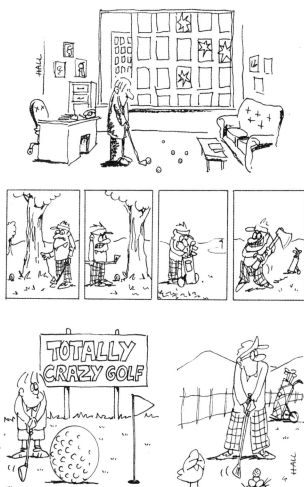

YOU CANNOT DRAW WHAT YOU HAVE NOT SEEN

Ronnie Baird *has worked in a broad range of visual communication areas including illustration, advertising, marketing and video production. He has won a number of national and international awards for video, children's illustration and animation character design. He is presently an active researcher at the University of Ulster, within the field of visual communication as applied to New Media conduits, particularly CD-ROM and DVD.*

'I jest you not'

In today's world of 'High Art' the cartoonist is the Jester, the Fool, the Clown, there for the amusement of others. Called in when we are bored to perform his party tricks. He amuses the masses, and being a fool can say what he likes.

History tells a different story, the 'Fool' or 'Jester' was in fact a very serious political animal capable of bringing down kings. He may have played the fool but that was just his cover for he had important things to tell which needed the protection of his apparent madness. For who, after all, could accuse a fool of telling the truth?

Is it a tiger? No, it's a blanket

The 'Jester' has metamorphosed to become the Cartoonist or Humorous Illustrator we know today, that person capable of serious social comment who can say what they like within the protection of their apparent foolishness. Just as before, society needs the fool to reveal the secrets of the court to ensure that the truth will out and justice can be done. Whether that truth be based on international politics or the complex life of a child, as in *Peanuts* or *Calvin*

& Hobbs, the brilliant observation, narrative and illustrative skills of the cartoonist reaches true 'High Art'.

See, see, see!

The common thread running through all of this is 'observation', one of the major factors that separates great cartoonists from the mediocre. The cartoonist, like a jester, must move through his world looking, seeing and noting all. There is a world of difference in looking and seeing, we all look but only selectively 'see', and just as with the jester, we will only be given a short time to get our message across. The drawing has to contain instantly recognisable elements to catch the reader and then pass on the message efficiently and without confusion.

'You cannot draw what you have not seen'

The cartoonist needs to see clearly what it is that makes a subject unique. There is always something that the trained eye can select as outstanding and characteristic within any given situation. There is an old saying that should be the motto of all cartoonists, 'you cannot draw what you have not seen'. How many of you have actually been 'seeing'? You may do a lot of 'looking' but are you actually 'seeing'?

How many lines?!!

There are only two kinds of lines, straight and curved, its how you join them together that is the hard bit and what makes it even harder for the cartoonist is the fact that the actual number of lines used is often restricted within the frame. Here again is a reason for the cartoonist to be capable of seeing clearly so that he can select the minimum number of elements to tell the story humorously and clearly.

Is that a voice I hear?

Looking and seeing is hard work that requires time and dedication until it becomes second nature. You eventually get that you only need a few seconds to identify what makes a situation or character unique. Remember it might be the voice, not something that you can actually draw but an element that speaks to you in such a way as to help you get the form of the character. I used to design characters for animation and could only draw them when I had a voice to associate with them. For me the voice is a major part of the characterisation. The voice can change your attitude to a person and in turn can change the actual physical characteristics of the face. Imagine Mr Magoo with a smooth thick chocolate voice or Homer Simpson with a hard sharp penetrating voice. How would that change your impression of the character?

It's in the detail

Look for detail in small things. Each of you reading this probably has something you particularly like to draw, in my case it's shoes. You can say so much about a character by the shoes they wear, and not just your female characters. People use details all of the time to make major statements about themselves.

Anyone for coffee?

So where do you go to do all of this looking and seeing? Start with your local shops and cafes. Really start to see what it is that is all around you. Look closely at the people and how they dress, what are the common characteristics? Why do the people that drink coffee here look different from the people that drink coffee there? Why do certain types of car drivers always apply the same stickers to their cars or why do certain types of kids' walk in a certain way? What is there about the way that people decorate their homes or sit or stand or hold things that make it a very personal thing.

Remember you are looking for the small things, the things that others look at but don't 'see'. You want to identify the things that make an environment or character especially unique to your eyes so that your observing and seeing can be seen as different, more interesting, amusing and intelligent than someone else's.

People love a good story

You draw because you have a story to tell, people look at your work because you have a story to tell. They want to see that story as clearly as possible and, when it's a cartoon, as fast as possible. You want to aid them all you can, give them the fast track to your narrative, get the picture to tell a thousand words. You point and shove them along the way using elements taken from their everyday lives, elements some of them may not even realise were there but when isolated by you jolt their memories and set them thinking along a certain wavelength of your choosing.

Be nosy

To draw people well you need to have a real interest in them and you need to be like the jester, invisible in their company, so they behave naturally, letting their guard down enough for you to see the real person behind the facade. All great political and social cartoonists are good researchers, observers of the common man in his natural environment. You need to spend a lot of time in the company of others, in some cases in places you would not normally want to go to, but you have to go to look and see. Spend time in shops looking at what people buy, look at the detail on garments and objects, looking for the elements that attract people to purchase. Spread out and observe regionally, nationally and internationally, looking at the work of others, de-constructing the images and storylines and in so doing learning what it was about the chosen elements that made them so important.

Think like an Art Director

Look at the fine detail in well art-directed advertisements, commercials and films. In the first two the Art Directors have the same problems as you, a story to tell in a very short time. In all three they have to establish mood, atmosphere and character types using visual elements. Try using a DVD player to de-construct movie scenes to see just how much work goes into detail, or a video player to study commercials. From a motion narrative point of view its good to look at early animations to see the elements used to imply character and movement, moving on then to the sophisticated computer-animated images of the present.

In brief

Looking, seeing, understanding and doing are key words for the committed cartoonist. You cannot draw what you have not seen, is a simple fact. No matter how mad the image is, it is compiled with elements the artist has previously seen. How he or she chooses to put them together is their unique trademark. You need to develop and fine tune your analytical and de-construction skills so as to be able to convey a storyline rapidly, effectively and economically and you do this by practise, observation and de-construction of the work of others.

The drawing is the easy part, no, I joke, but you need something to draw which has been well-considered and observed and an idea that will speak clearly to the target audience you have in mind. To be convincing you need to live and breathe your characters, know them as part of your family or as your best friends. In some cases you are a 'god', creating and giving life to a world of your choosing, a world that will reach out and affect others – its an awesome responsibility.

Oh, and don't forget, a lot more people need glasses than realise it – check you're not one of them.

PART 2

The Business of Cartooning

GOING FREELANCE

'ONCE upon a time there was a budding cartoonist who lived with his parents. They paid the mortgage, gave him an allowance, bought his food, clothes, deodorant, toothpaste, toilet roll and washed his underwear. One day a beautiful syndicate editor who had received his work did tell the handsome young cartoonist that her syndicate wanted to show his cartoons throughout the land and sent him lots and lots of money whereby he bought a huge castle and lived happily ever after'.

Then he woke up and had his breakfast.

Unfortunately, this is one fairytale that far too many aspiring cartoonists believe in. Trust me, the reality is somewhat different. Whether you like it or not – the time will come when you will *have* to learn the business side of being a freelance artist. You will have to deal with clients, price your work, write out invoices, keep books for income tax, pay bills, rent, a mortgage, an overdraft, your credit card bill, etc. There is no way to avoid all this, believe me, I've tried.

There are two ways to approach the business side of things; one is to muddle your way through as each problem presents itself. The other, easier way is to study up on it before it happens.

The realities of going Freelance
Many aspiring cartoonists and illustrators imagine that going freelance is similar to working for someone as an employee. The fact is that when you go freelance you become self-employed and you have to work out your *own* finances, tax, books, invoices, receipts, etc. It is imperative that you learn a bit more about these things before you start.

Prior planning
Before you even *think* about going self-employed as a cartoonist you will hopefully have spent several years perfecting your skills. But it is also helpful to think about certain practical things you can do in *readiness* for self-employment. For instance, it would be much wiser to build a website *before* you decide to submit work to people so that you can direct potential clients to your 'online portfolio'. Set up a studio, attend a business course, draw up a business plan, enquire about funding, grants, business loans etc. Design promotional material, research your potential markets, write to editors and enquire about submission guidelines. Get a 'feel' for the world you are about to enter. Get involved in clubs or societies.

Part time self-employment
Look before you leap into the world of self-employment. If you are in employment (or receiving unemployment benefit), going it alone can be quite a culture shock. You could ease yourself into it by trying self-employment on a part time basis. If you are in employment and paying tax, contact your local tax office and tell them you are going to do some self-employed work as well. They will send you a form to be filled in at the end of the year. (Odds are your first year's net profit won't be big enough for you to worry about tax but it keeps you legal.) Same goes if you are receiving unemployment benefit – tell them that you are doing some part time work and they will make you fill out the appropriate forms – I know it's a pain but trying to dodge people is more stressful in the long run. The poorest people I know are always trying to dodge paying tax or something or other.

Build a client base
Okay, you have a product to sell, now you have to find some customers. Let the world know you are on your way. Submit plenty of work – get some feedback. (Check Sid Richards' advice on page 38).

Gain some experience
Take *any* job that comes your way – no matter how small or how poorly it may pay. Work for nothing if you have to. Think about your first few years as training. If it takes you a month to do a job and you get paid peanuts, see it as part of that training.

Don't be too afraid of getting into debt!
Strange advice I know but the first time I asked for a bank loan I was refused because I had never been in debt. Sounds bizarre but actually it makes sense. If you have never had to pay back a loan or credit it is hard for banks or credit companies to know if you are good at paying off your debts. The more you have *been* in debt (and paid it off) the easier it will be for you to receive loans or credit. Don't go mad – get some computer equipment on credit or apply for a credit card or an overdraft.

The reason this is important for cartoonists is that there will be times when you might need a loan or to use your credit card to get you through

some lean times. Certain projects (that will pay off in the future) may take so long to complete that you are not able to actively seek paid work for several months. When I first started out I suffered unnecessarily by thinking that getting into any sort of debt was a bad thing. But then I realised that cartooning is a business that can take time to pay off. Also, if you can't buy the proper computer equipment or studio supplies your work may *never* reach a standard where it will pay off. Every other business has to put in money to begin with and continually invest in the business – cartooning is no different.

Beware the credit card trap

At first, credit cards seem like a great idea. You buy things with the card and if you pay back the money within a month you don't get charged any interest. Sounds great – how on earth do the credit card companies make money? – you ask yourself. And for a few months you even manage to pay it off on time. But then you get used to using your card, you buy a few more expensive items – it's *so* easy. You tell yourself that you'll pay it off over two or three months, it will only be a tiny amount of interest.

The *big* problem is, you only have to pay back 3% of what you borrowed each month, so that's exactly what you end up doing because you don't *have* to pay any more than that. Meanwhile, interest builds up and six months later you notice that your balance isn't getting any smaller even though you keep sending them money. Then, you notice that another card company is offering a low interest rate on balance transfers to *them* so you get *another* card. Now you have *twice* the temptation. And so it goes on. Be very very careful.

Full time self-employment

If you reach a point where enough money is coming in for you to scrape a living, then you may want to take the plunge and go out on your own full time. First things first, the day you become 'self-employed' (or the day you decide to do freelance work *as well* as work in Burger King) inform your local tax office. They will then send you a tax form to be filled in at the end of the tax year. Don't leave it or it will play on your mind and the longer you leave it the more you will worry. It's just a phone call to begin with, you won't be interrogated under a spotlight!

Funding

There are various schemes nowadays to help small businesses get off the ground. Contact your local employment agency and they will direct you to the relevant sources. Or you may try approaching your bank for a business loan. Due to the nature of the work, 'cartooning' is not taken as seriously as many other business ideas so you have to show that you are *serious* about being humorous. Whether you seek financial help or not it is a good idea to draw up a business plan.

A business plan

No artist would design a comic or a page layout without working out some kind of structure or plan beforehand yet when it comes to starting in business many just dive straight in at the deep end without any game-plan at all. It isn't any wonder that so many get into trouble. If you work things out at the start you will save a lot of headaches.

Your business plan could include the following:
1. Marketing. Identify your markets (or possible markets). Have you any contacts already? How are you going to market yourself? The internet? Advertising? Word of mouth? Submissions?
2. Anticipated expenditure. Work out either weekly, monthly or yearly what you are liable to spend not only on the business but daily living costs – food, rent, heating, clothes, travel, etc.
3. Required profit. Once your bills are covered, how much profit do you realistically need to be making?
4. Business forecast. How do you expect the business to develop over two or three years?
5. Depreciation value of equipment. Don't forget that a car or any equipment you buy will depreciate in value and may need to be renewed after a year or two. You need to plan for this.
6. Strengths and weaknesses. Do a points analysis. Be brutally honest about areas you are good at and areas that you need to seriously study up on and develop.

Your bank manager will take you more seriously if you can show him not only a business plan but some work that you have actually sold or had in print. This is why it makes sense to go freelance part time to begin with so that you can build up a client base and a good portfolio of published work while having the security of a 'day job', unemployment benefit or rich parents.

MINDING YOUR OWN BUSINESS

Think in a business-like way

The thing I have noticed most over the years is how, when my attitude towards the business side of cartooning changed, my financial circumstances changed also. When I started out – because I had never had much of an income up to that point – I settled for very little, in fact I was *happy* with the little I got and I didn't really feel that I should have been earning more. Probably this attitude stopped me from pushing myself to greater heights. As I grew in confidence, both artistically and in business matters, I realised that I not only *needed* a higher income but my skills were worthy of a higher income and because it now feels natural to be making five times as much as I did at the start, I *do* make five times as much.

The thing is, I didn't take the business side of things seriously to begin with and I think that held me back for many years (I held on to my struggling student mentality for far too long).

Don't think that being a good cartoonist will automatically make your business a success. You also need to develop good business sense.

Keep a record of ALL your business transactions

Try to get used to keeping a record of everything you do that applies to your business. If you spend an hour on the phone to a client, make a note of it so that you can either add the time to the final costing or know in the future to avoid costly phone calls. When you submit work, make a note of who you sent it to, exactly what you sent (make a copy of your cover letter) and what date you sent it. If you spend five minutes every day doing this it will save you hours of extra work in the future.

Paying your bills

The best piece of advice I can give you about paying bills is to pay any regular ones like the phone, electric, heating, etc. by direct debit. This means that the money is taken out of your bank account at regular intervals and the job of paying them is taken out of your not-very-reliable hands. It also saves time and worry.

I would also suggest that you learn how to live within your means. Tighten up on wasteful spending but also learn when to spend money to save money. For instance I underspent on my first computer thinking it would 'do the job'. Two months later I had to sell it at half the price to help me buy the computer I *really* needed. I have reams of cheap printing paper going to waste because it is such poor quality compared to the dearer stuff. I have dozens of expensive magazines that are full of ads when I would have been better buying a few expensive books (that I felt were too expensive) that at least contain information I can *use*!

Sit down some day and look at how much money you waste on a daily basis. Do you *need* every radiator or lightbulb in the house on? Do you *need* to spend so much time on the phone? You could probably live for a week on the amount you spend in one night at the pub. I'm not saying you should turn into your mother but at least try not to be wasteful when you can't afford to be. Things can get out of hand before you even realise it.

If you *do* get into difficulties, don't be afraid to talk to someone at your bank or in a credit agency. You can get long-term loans that can help you get through difficult periods.

In the UK, if you aren't making enough money to live on you can get unemployment benefit or help with your rent. You may as well make use of it.

You can also find help on the internet. Type 'Debt' or 'Financial advice' into a search engine for a list of websites. Or go to www.debt.co.uk or www.debt.com

I'm afraid you're badly overdrawn Mr Hall

INCOME TAX

Yes ... even cartoonists and illustrators have to pay tax. It may not be fair, but how else are we going to keep the country armed to the teeth with billion-dollar warplanes?

This is the way it works

1. Freelance work is classed as 'self-employment' and any money you receive you will have to pay tax on.
2. Everyone is allowed to earn a certain amount that is tax free. Anything you earn over that amount is taxable income.
3. You will only be taxed on your 'net profits'. This is the amount left over when you subtract your business-related expenditure (equipment, rent, phone, etc.) from your total year's income.

 For instance, if your total income for a year was £12,000 but you had spent £5,000 on business-related items then your 'net profit' would be £12,000 minus £5,000 which would be £7,000. The government would then subtract your tax free allowable income from this net profit and calculate how much tax you owe.

 In the UK at the present time (2002) you are taxed at the rate of 10% on your first £1,880 taxable income and 23% on taxable income over £1,880 up to £27,520. Beyond that – who cares? – Hire an accountant – you can afford one.
4. Business-related expenditure can include –
 - Equipment, materials, computer equipment, pens, paper, postage, books, magazines, comics, etc.
 - Phone
 - Premises costs – electricity, rent, rates, office furniture, repairs, etc.
 - Car, petrol (gasoline), maintenance, etc.

 If you work from home you have to calculate what percentage of the rent, phone, electricity, family car, etc., you use for business. For instance if your house has eight rooms and you use one room for business then you divide the total costs for the house (except food and bathroom supplies) by eight.

If you are only making a modest income and not spending much either you will probably not have to pay tax until your turnover increases. However if you are making a small income but spending most of it on the likes of expensive computer equipment, it is not necessarily a good idea to put *all* of that cost down as outgoings for one year. If you spread the cost over a few years (because it is equipment that will be in use for many years) you may be able to use the expenditure to help pay less tax in a year where your earnings have increased. It is a good idea to see an accountant or read a book on how to save on your tax bill.

In the UK you will have to pay National Insurance Contributions, though you may be exempt if your earnings are low. *The Writers' & Artists' Yearbook* covers all this, but always ask your local tax man.

Bookkeeping

The easiest way to keep track of your income and outgoings is to write it all down in a book on a daily or weekly basis. You can buy special books designed for this purpose from any stationery store.

It is a kind of diary where, on the left hand side of the page you write down any income you have received and, on the right hand side, you write down any expenditure you have made. At the end of the day, week or month you add the figures up. This makes it easy at the end of the year to calculate everything and for the taxman to check your accounts (should they ever want to). Remember you also need proof of all that you write down.

If you don't do this, at least keep some record of all your transactions. Keep a big container in your office and put business-related receipts, invoices, bank statements, etc., into it. Make sure you ask for (and keep) a receipt every time you buy anything related to your work. Then at the end of the year you can tally it all up.

Tax forms

At first glance a tax form is a frightening thing. At second glance it is even *worse*. Fortunately, when you read the booklet that comes with it you'll realise that if your net profits are under a certain amount, you will only have to fill in a few boxes – your income, outgoings, net profit, the month and year you started your business and the date from which you are calculating your tax. An accountant acquaintance of mine told me to just start my business from the start of the tax year to keep things simple. Don't worry too much about not getting the form filled in correctly – if you get something wrong they will get back to you. Just make sure your figures are accurate and make sure you get the form in on time or you will be fined. If you ever start to make some serious money, hire an accountant.

HOW MUCH ARE YOU WORTH?

I wish I could tell you that there is an easy way to put a price on your work but there isn't. There are so many variables.

NEVER price 'on the spot'

Tell the client that you 'will work out a price and get back to them' (don't let them bully you). Very often you forget all the hidden costs. Apart from your usual overheads (and the fact that a percentage of what you earn will go to the tax man) some jobs require research or meetings that can take up a considerable amount of your time. Some clients expect you to travel across town to meet with them but will not expect to see that time on their bill.

And although you are pricing for 'skilled' work each job has a different level of difficulty. Charge more for a humorous cartoon (that either has a caption or is simply 'visually funny') than for a straightforward illustrative drawing.

Tell the client that there is a price difference between a 'drawing' and a 'humorous illustration' or cartoon so that they will keep in mind that making a drawing 'funny' is an added skill.

You have to be a mind reader

You also have to intuitively decide how much the client can afford or is willing to pay. If it is an ad agency or a big business then you can safely ask the maximum amount.

What *is* the maximum? At the time of writing, the minimum wage here in the UK is around £5 (i.e. Burger King wages). When I price a job at the maximum amount I charge £40 to £50 per hour. This may seem extreme until you consider that – due to years of experience – I can often finish a job in a few hours. You have to keep this in mind starting off. If you are inexperienced and it takes you a whole day to do what I can do in a few hours you can't expect to charge the same rate per hour. As well as that clients will only accept that rate if they know for sure that you will do a great job. Now and then I do jobs for £10 per hour (never less) if it is easy work and I don't have anything else on.

If you get the feeling that the client just wants a 'wee cartoon' to brighten up their brochure or menu or whatever then they may faint if you say £50 per hour. Even people in business think that cartoons are a hobby and that we should be giving them away free. People like this need to be led by the nose to a reasonable price. Start by telling them you are 'quite busy but you should be able to squeeze them in'. Then explain about the difference in price between drawings and humorous illustrations and cartoons. Explain that colour is an added consideration and ask them do they need the artwork put onto CD. Add in any technical jargon you can think of. If the client has contacted you by phone *don't* give them a price there and then – tell them you will work out a price and get back to them. If they have come to see you personally wait till the very last moment before you give a price.

Nine times out of ten I price too low, the client says 'hey no problem' and I go to the bathroom and kick myself for not asking for more. Always ask for slightly more than you would be happy with. If they look shocked you can backtrack by saying 'well what price did you have in mind'. When they tell you the preposterous price they *did* have in their mind you try to suppress your laughter and meet them half way if you think it's worth it. A phrase that often works is 'I would normally charge about £XX for this type of job but I could probably do it for around... ' or 'I'm sure you already know that an *ad agency* would charge you around £50 an hour for a job like this – I could do it for...'. It's the usual thing about making people think they're getting a bargain. Drives me mad but you just have to learn to get used to it.

I have said elsewhere in this book that you should never turn down work when you need to gain experience and exposure but this doesn't mean that you should work for less than a client can afford. If someone (who you know can afford to pay well) asks you to work for peanuts – show them the door (unless the work will lead to bigger things).

Check out Planetcartoonist.com

At Planetcartoonist.com there are lots of resources for freelance cartoonists and illustrators and very informative articles from Bob Staake.

He recommends studying the Graphic Artists Guild Pricing & Ethical Guidelines Book to learn about rates for a variety of freelance jobs and discusses the importance of setting up a computer 'database' that enables you to track clients and catalogue all your business transactions.

INVOICES

An invoice is the bill you hand the client when the job has been done. You also need a copy for your own records. It can also act as a receipt. If you have been paid you simply write 'Paid in full' on the invoice. If you are paid *after* you have given someone an invoice they may ask for a receipt but because most people pay by cheque nowadays the record that the bank have of the cheque being cashed acts like a receipt.

There are certain things you need to include on your invoices

1. Your details, name or name of business (most clients prefer a 'business' name on an invoice but if you haven't got one, just put 'Joe Smith Cartoons' or 'Joe Smith Humorous Illustrations'), address, phone/fax, email, etc.
2. The Clients details. Name and address at least.
3. The word 'INVOICE' – you can easily forget this.
4. A number on the invoice so that it can be tracked down in your files *or* the clients files. Just remember to give every invoice a *different* number.
5. A description of the work carried out.
6. The amount to be paid (or if it has already been paid)
7. The time allowed for payment (i.e. 30 days)
8. Your signature.

You can buy invoice books in any stationery store but as an artist it is in your best interests to design your own. Something that ties in with the rest of your stationery, your letterheads, business cards etc.

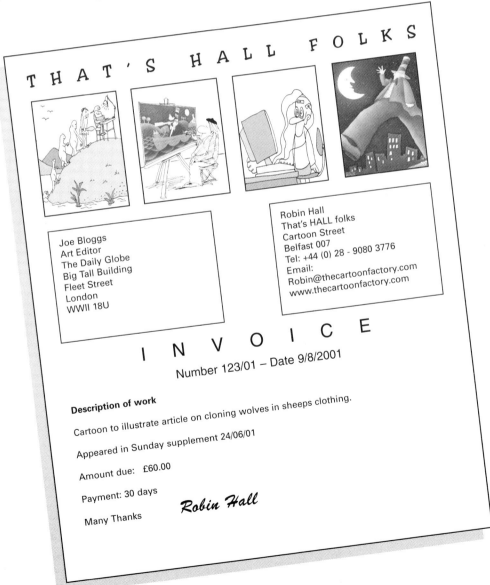

DEALING WITH CLIENTS

Cartoonists and Illustrators very often get approached to do jobs that involve a certain amount of graphic design – page layout, text, type-setting, etc. Here's some expert advice from a good friend of mine.

Paul Donaghy *has been running a successful design studio in Ireland for the past 15 years. He learned his craft the old-fashioned way (using pen and paper) but has been involved with computer-aided design almost since this method became user-friendly.*

The aim of a graphic designer is to communicate a message to his audience successfully through the organisation of words and images. The graphic designer Paul Rand defined the designer as being 'like a juggler, demonstrating his skills by manipulating various ingredients in a given space'. This is an apt description although it does not give adequate credit to the aesthetic judgements involved. The principle, however, remains basically the same whether applied to the design of a letterhead or the creation of computer-generated television titles. A well-designed poster or book may appear to be the result of an almost casual effort on the part of the designer but this is rarely the case. More often it is the result of a lengthly process, including experimenting with many options until a satisfactory one is found.

Good design has to take into consideration the practical constraints imposed by a client's brief – the budget, schedule and audience. The designer acts as a go-between, carrying a message from client to customer. To do this well, a designer must be familiar with all forms of graphic reproduction, have a working knowledge of relevant computer technology and be able to work with printers, photographers, illustrators and other technicians.

The briefing

A designer talking to a client is almost like a psychiatrist talking to a patient. You have to unearth their innermost desires because at the end of the day it is *they* who will be deciding the fate of your designs. If they say they'll 'leave it all up to you' don't listen to them – keep digging away at their subconscious. The trick is to find a happy medium between what *you* believe is best and

what *they* believe is best. Don't dismiss any ideas your clients may propose. They know their business better than you do. Designers can often be too 'arty' for their own good and while their work may look aesthetically pleasing it may not actually do the job it is meant to *do* which is to sell/enhance the product/service of their client. Once again, design based on common sense marketing principles is better than design based on trendy 'flavour-of-the-month' styling principles – the latter tending to go out of date faster than Ben Johnson being chased by a herd of rhinos.

Some clients have a fair idea of what they want so it's just a matter of working out the details but remember that most of your clients aren't designers (that's why they have come to you). They know they want a brochure or an advertisement or whatever but they may not be able to give you any ideas about how it should look. Marshall McLuhan was right when he said 'the message is the medium' but it is up to you –the designer – to work out which medium is best suited to get the message across – be it brochure, advertisement, poster campaign, mail shot or whatever. Don't be fooled into thinking that they'll accept *anything* you give them however. Everyone has likes and dislikes. It's your job to get inside their minds and find out what their particular likes and dislikes are so that you don't waste time. In the past I've found that as well as telling a lot about someone from the shoes they wear you can also tell a lot from the kind of car they drive, the colours they wear and, maybe even more telling, the kind of music they're into. If they say they listen to Dire Straits you know that soon they're likely to stop listening to music altogether and therefore probably have a bland, conventional taste in other things including design. *You* may be into Radiohead … *they* may be into Michael Bolton. *You* may be into minimalist design … *they* may hate it. *You* may like Monty Python, *they* may prefer Abbot and Costello. You say tomato, I say tomatoe. I say potato, you say potatoe. Tomato, tomatoe, potato, potatoe – lets call the whole thing off!

Find out at the *start*. Ask as many questions as you can. Show them other examples of your work or designs in magazines or books and note what they prefer. If layouts are required, sketch a few out on the spot. Ask them 'Is *this* the sort of thing you're after?'. *Don't* let them go until you are *sure* you have a good idea of what they want. There is nothing worse than having to phone up a client to ask a question you should have asked at the briefing.

Here's a useful checklist
- What is the budget/deadline?
- Who/what is the target audience?
- What is the product/service?
- What should be the medium/message?
- Do they have an existing logo/brochure, etc., this can often be used as a starting point or as an example of what NOT to do.
- Make notes with visualised doodles throughout the meeting(s) (you may think you have a better memory than you actually have).
- Is it 'hard sell' (like a second-hand-car dealer) or is it a more subtle 'soft sell'.
- Have they any ideas 'in mind' about how *they* see it?
- What direction for the layout? minimalist? dynamic? contemporary? subdued? in your face?
- What type of material/paper is it to be printed on? Provide samples.
- The lettering or text – any preference in style, colour, size, emphasis, positioning. Will the copy be provided or does it need to be written?
- Colour? How many? Spot colours or full colour? What colours do *they* have in mind? Are there any colours they really *don't* like?
- Make sure you get contact details phone, fax, email, etc.
- Do some on-the-spot roughs, if necessary.
- If you send them work digitally – what type of computer do they work on? Do they have the software needed to view your work? Adobe Acrobat is useful nowadays for viewing/proofing work because it is cross-platform (Mac to PC) therefore anyone can view your work regardless of if they have your design software or not.

Roughs

When you have thoroughly interrogated your client and are *sure* you think you know what they want, sit down immediately afterwards and draw up some roughs while it is all fresh in your memory. The adrenaline that has helped you deal with the client can often help ideas to flow as well.

Nowadays, the layout pad has largely been replaced by the mouse pad but I still find a pen and paper is the best way to work through the first few raw ideas. Shortly after this a computer can offer you a dozen or so variations at the click of a mouse which you often wouldn't achieve on paper.

A working routine

Personally I like to approach design jobs by building upon a solid foundation. Try to develop a working

Roughs for a logo for an interior design firm in Belfast, influenced by the work of Scottish architect/designer Charles Rennie Mackintosh

routine – I usually start (in the case of a logo) with a geometric system such as a circle(s), square(s) or polygon(s) or (in the case of a publication) a modular grid system based on quarters or thirds (like a newspaper page) where the various elements of the design are laid down in order of importance. *Then* I try a few variations. Keep in mind that odd numbers work better in design terms than even ones. Look at classical Greek and Roman architecture for example, always 5 or 7 columns not 4 or 6. The reason being odd numbers leave you a centre. A lot of it is down to years of practise but I still make use of reference. 'Borrow' from books, art history, design classics, magazines, the internet, etc. Clients *want* you to mirror current trends, not be so ahead of them that no one takes notice. I'm not saying that you should be 'trendy' all the time. Just take note of trends and fit them into *your* preferred design style. Remember if you're going to plagiarise be brazen – there's nothing worse than a half-hearted rip-off. Do the original work the justice of following it to the letter, otherwise, you can end up with a B-movie zero design monstrosity. Obviously, take care to be 'influenced' by something which is in the public domain. Most clients have some sort of existing trademark or logo that you can use as a starting point. You can take elements of that for your overall design. Keep experimenting with your initial ideas until you intuitively feel that one or two of them are heading in the right direction. Then concentrate your efforts on those ideas and try some semi-finished roughs.

Second meeting (or send roughs via email)

This is a crucial moment between yourself and the client. Don't present too many unconnected ideas. You will give the impression that you are unsure yourself and *they* will feel like a kid in a candy store with too much to choose from. Once upon a time, in a far off land, there lived a big, big advertising agency. One day, they presented their client with just one idea as if it were the finished article. Not surprisingly, they did not live happily ever after. This approach, I feel, is not only arrogant but risky and it underestimates the important interaction between designer and client in the overall process of design. Your finished roughs may not be what they had in mind at all. If that *is* the case, don't panic, the discussion will probably make what they *do* want a lot clearer.

Third and (hopefully) final meeting

When your finished roughs get the 'go-ahead' its time to do up the final artwork which is then taken

Cover for a property brochure Armagh, N. Ireland
This is a direct example of working with a 'grid' system

Poster for Women's Studies, Queen's University, Belfast,
influenced by the work of French artist Henri Matisse

36

to the printers for a 'proof' (a print-out that will be very close to the finished job). This used to involve doing a costly 'colour matchprint' but nowadays a digital proof is almost as good and much cheaper since plates/film don't have to be run off. Show your client this proof and when they have either okayed it or made corrections get them to sign it off so that you can't be held accountable for any errors after it has gone to press. If further corrections are made at this stage the printer may then do another proof, get you to okay *that* and then get you to get the *client* to check and sign off again, so that *they* (the printers) can't be held responsible. Basically, everyone is scared to death – it's great fun. After this stage, the job usually goes to press but there have been known to be third, fourth and 'to infinity and beyond' proofs!

If small changes are needed you can save time by arranging for the client to come in to your studio and see the changes carried out on screen. In this way you can quickly run through a variety of colours, fonts, etc., and get a better idea of the clients 'obvious' likes or dislikes. This also gives them a greater sense of involvement in the overall process. By now you should have agreed exactly what the client will be getting in terms of colour, materials, finish, size, quantity, etc.

Off to the printers
There are three things to remember – printers make mistakes, printers make mistakes and printers make mistakes. Oh … and did I mention … printers make mistakes. But seriously, it's one thing making a mistake in a one-off mock-up – it's another when a mistake is repeated *thousands* of times at considerable cost! The usual advice is to check everything three times. My advice is to check everything *thirty* three times and then get someone else to check it as well. All designers seem to be dyslexic (did I spell that correctly?) and everything they do should be checked by someone who isn't. If you use any spot colours make sure you choose them from a recognised colour matching system (e.g. Pantone©) and make it absolutely clear to the client which colour(s) they will see when the job is actually printed, and to the printer the exact matching colour you require. Don't trust your computer screen or inkjet/laser proofs (unless they are post-script CMYK quality) when it comes to choosing and indicating colour(s).

Try to get to know the pre-press staff at your printers. Visit them, and if you've time, personally oversee the pre-press aspects of your job on-site. Find out as much about the whole printing process as you can. Ask about paper weights/textures, varnishes, finishes, etc. Most importantly, ask about all technical aspects: the best way to set the job up; preferred software programme; which platform; preferred data transfer format to send the job in and so on. Make sure they can contact you at *any* time of the day in case of unforeseen emergencies – and believe me, with human error and technological glitches – they do happen all the time. Keep checking back with them to make sure all is well and that everyone is happy. Mistakes are inevitable, just try to keep them to a minimum. When you are working out your budget aim to use as good a printer as you can afford. Bad printers can cost you more time and money in the long run. Good printers have quality standards which means if you can *prove* they have made a mistake they will normally print the job again at no extra cost. Because of this, they are a *lot* more careful and produce better work.

If you require short run work it is worth keeping in mind that you can now get full colour digital prints (no expensive plates/films/extra labour costs) at a fraction of the price of litho.

Finally, above all else, try to make sure your dealings with clients are *very* amicable. Most of my work comes through word-of-mouth via happy customers.

Poster for U.S. Presidential Visit to Armagh, N. Ireland 1998

37

Sid Richards *turned full-time freelancer in 1984, specialising in cartoons and humorous illustrations, mainly for ad agencies and publishing houses, including book jackets, illustrations, greeting cards, training manual and corporate brochures. His work is apolitical but often topical and has been published in various newspapers and magazines. His strip, Gulliver, for West Country Weekly Newspapers has run for many years.*

Always deliver on time, editors don't always care (or look at!) what you come up with, all they want is to get the completed publication out on time.

When you are ready to sell your talents get some business stationery printed and start calling yourself a cartoonist. Don't be precious with them, give them out to all and sundry, you will be surprised at where work will appear from. To get work in any field you need to shout about yourself. Tell everyone you meet about your talent and aspirations. Distribute your business cards far and wide and very soon the work will start coming in. Success breeds success. The more clients you get the more referrals you get. Develop a lasting business relationship with your customers by delivering on time and at the right price.

Success in cartooning isn't measured by how many gags you've had published in *Private Eye* or *Punch*, Initially, if you have never had work published before, do not limit yourself to approaching the most obvious publications. Look at the smaller, local publications. These are an easier market to crack than mass-circulation newspapers and magazines. At this point you should be looking towards having your work published somewhere! The market is wider if you are prepared to tackle any assignment and the more potential clients you can find the sooner your work will be published. Remember published work is positive proof of your expertise to future, more lucrative customers.

A great deal of work can be found outside the realms of print media. In fact you will probably find this type of work easier to obtain. Commercial clients include: advertising agencies, PR companies, printers, design studios, retailers, educational institutions, manufacturers, government departments – in fact any organisations that may have their own marketing departments.

Advertising and design fees are considerably higher than those for editorial work. There is also much more scope for negotiation. It is important to bear in mind however that you will be confined to a very strict brief and the industry 'creatives' can be fairly harsh task masters. Deadlines in advertising are usually very tight and you will have to be prepared to burn the midnight oil on occasions to meet them.

When negotiating fees, apart from assessing the complexity of the project, take into account, who has the rights to your work and whether the campaign is regional or national. Most advertising agencies are notoriously slow payers. Expect to wait at least 60 days for settlement.

Some agencies have an art buyer within the organisation who is responsible for looking at portfolios. They know what projects are being carried out within the agency and will refer you to the appropriate creative team or art director. When working with creatives it is important to listen carefully when taking the brief and make sure you can interpret the concepts correctly.

Lots of small businesses, educational establishments, shops, associations, charities etc. do not retain the services of an advertising agency. There are endless possibilities for cartoon work with these corporate clients.

With the growth of desktop publishing, more and more companies are producing their own literature 'in-house'. This work is often carried out by an employee who knows little or nothing about visually improving their promotional literature. With the advent of digital photography and easy to use page layout software, the missing piece is often the cartoon.

Outside the realm of the corporate world there is plenty of business to be found on your local high street. Could you, for example, create an illustrated menu for a local restaurant? Could you improve the leaflet of a hair and beauty salon with a figurative illustration? Take a look at your local retailers and consider ways that your skills might assist them.

You can aim your business at the domestic market. There is scope in offering your services in providing personalised greetings cards, possibly with caricatures or personal messages.

There are limitless opportunities for illustration work if you can strike up a relationship with your local printer. Illustrated wedding invitations, postcards, personalised stationery, company calendars. Talk to your local printer and show them the kind of work you can do. You will have to work out some kind of flat rate for the type of services that you intend to offer. In this way the printer's customers are aware of what they will pay beforehand. The total cost will be your charges plus what the printer would normally charge. You could consider providing this kind of service off your own bat. This would entail advertising your services in some way.

A postcard in a newsagents window can be effective, especially with items like wedding stationery. Once you have created your artwork you should talk to several printers and get the most competitive quote. You will be amazed at the variety of prices you will be quoted. Put a handling fee of say 20–30% on this price and build in your costs. You should have a nice little earner.

'Stand back I'm a lawyer … loosen his wallet'

PART 3

Lost In Cyberspace

CARTOONING IN THE DIGITAL AGE

Cartoons have been around a lot longer than computers so *do* we really need them (computers I mean)?

The answer is *not really*, but even if you never decide to go the digital route I guarantee that nowadays your cartoons will end up in a computer *somewhere* along the line.

I used to completely hand-draw my cartoon strips, characters, lettering, colouring, borders … and then put them in a secure expensive envelope, drive through heavy traffic to the post office, wait in the queue, spend a fortune on stamps, drive home through more heavy traffic and then sit for two days biting my fingernails, praying to God that the package would actually arrive at its destination.

When the newspaper received them they were then scanned into a computer where my scruffy hand drawn borders were replaced by computer generated ones that reproduced better in print. Very often the scan caused a dramatic colour shift and my thin hand drawn lettering became illegible.

Then I thought – 'Well, if ya can't beat them, join them' – and decided to overcome my antiquated ways and enter cyberspace. I can't say it was easy to learn but it certainly wasn't as hard as I imagined it would be. Within months I had learned enough to be able to create and send my work digitally.

Nowadays it takes me about 20 minutes to complete a strip – from start to finish including *delivery* (see pages 48 to 51). The downside is that I never get to see what the outside world looks like anymore because I don't need to go to the post office but I *do* have a picture of it somewhere on my computer.

Another major advantage of using computers is when you are sending multiple submissions of strips, card designs or illustration samples. Imagine sending a folder of 10 pages of hand coloured artwork to 20 or 30 editors, or paying for expensive colour copies. If you can print your work from your own computer you can get high quality at low cost but best of all – (if you are submitting via email) – there is virtually no cost whatsoever for an unlimited amount of submissions.

So, as far as time and money are concerned a computer is essential. I would even argue that 'creatively' they give you more freedom. Over-use of computers can cause predictable and boring designs but if used wisely they are an essential piece of equipment for any serious graphic artist.

Let's look at what a computer has to offer:
- Hand drawn artwork can be scanned in and manipulated in various ways.
- You can add lettering – any size, shape, style or colour.
- Line drawings can be coloured, or 'shading' tones can be added.
- You can add effects, details, change colours, fix mistakes, etc.
- The image can be distorted, stretched, squashed, reversed, turned into a negative.
- Two images can be blended together.
- Multiple printouts can be made – any size on any type of paper – even on canvas.
- Artwork can be placed into brochures, magazine or book layouts, posters, postcards, letterheads, business cards, etc.
- A lot of artwork can be stored on small inexpensive CDs which can then be posted to editors, printers, publishers and opened on their computers.
- Artwork can be sent via the internet or placed on a website as part of a 'digital' portfolio which any one in the world can view online.

Certain styles of artwork can be created *entirely* in the computer either by using what are known as 'vector' drawing packages or by using an electronic drawing tablet and pen.

Entire documents (such as this book) can be created, printer ready, at home without the need of an expensive designer. (Apologies to all you expensive designers out there who need work.)

The list is endless.

COMPUTERS ... DON'T LET THEM SCARE YOU

My first experience with a computer was at Art College at a time when making it draw even a simple shape entailed typing in lengthy, complex instructions. That put me off for years. I would even say it made me 'anti-computers', but they have come an amazingly long way since then and now I wouldn't be without one. I'm writing this on my computer now.

In case you are new to computers and as terrified of them as I once was let me explain them the way a smart friend of mine first explained them to me. If you are already a computer whizz this description may come in useful when you are trying to explain it all to your Mother :–)

A computer is simply an office block in miniature. The hard-drive (or 'hardware') is the building itself.

The software or 'programs' (information on CDs) are like offices, equipment and workers that we can put into the building.

In these 'offices' we can perform various tasks such as typing, magazine layouts, manipulating photographs, complex animation, drawing, colouring, etc.

We view everything on a monitor (TV screen) and each 'office' is represented on the screen by an 'icon' – a tiny drawing which often has a name under it.

A device called a mouse lets us move a little arrow ('cursor') around the screen so that we can move from icon to icon – 'office' to 'office'. If we place the arrow over an icon and click the mouse button this activates that particular programme – in other words we enter *that* office.

When it opens we see more icons and words that are relevant to whatever task it is that we want to perform. We again use the mouse to move the arrow around the various icons and words and follow the instructions until the task is accomplished.

We *can* create images entirely inside the computer but if we want to bring images *in* to the 'building' such as photographs or drawings, so that we can change them in some way in one of the 'offices', we use a device called a scanner. This turns the image into digital information (*in* the computer) which we can then view on the screen. If we want to take images *out* of the 'building' we need a printer which transforms the digital information into images on paper. The image is made up of millions of dots.

Anything we create in the computer can be either stored in files or on CDs for use at a later date or sent to another computer via electronic mail that uses telephone lines (email).

The good news is we don't have to learn everything to do with computers – just enough to let us perform tasks that are relevant to our needs.

ESSENTIAL HARDWARE

Mac or PC ?

Without getting into a war about which computer is better can I just say that in the design world *most* people use Apple Macs so you will save yourself a lot of bother with printing firms, publishers and editors if you join the club. Only the computer hard drive needs to be Apple Mac. The rest of the hardware can be any brand at all as long as it is *compatible* with Apple Mac.

Let's look at the equipment you'll need. When it comes to choosing 'brands' just check the reviews in computer magazines.

Monitor

Get as large a monitor as you can afford. At least 17 inch – 21 inch or more is preferable. What you don't realise to begin with is that a third of the screen is taken up with various little 'windows' that contain information and tools that you need for particular jobs. Even a 21 inch screen seems tiny after a while.

The computer hard drive (the 'office block' and 'engine-room')

By the time this book is printed (or even by the time I make a cup of tea) any computer I could mention will be out of date. Nowadays even a basic hard drive will produce the same end product as the more expensive ones but the latter will do the work a lot faster and allow you to store more information. Your end product is much more dependent on the quality of your scanner and printer. Nearly *all* first-time computer buyers (especially designers) want a faster machine about a week after they've bought the slow one that they thought would 'do just fine'.

RAM (Random Access Memory)

Don't worry about 'what' RAM is or does. The important thing is – you need *lots* of it if you use graphics packages. Most computers come with about 64 MB of RAM – this is nowhere near enough. You may as well buy more to begin with so that the shop can install it and you may get it a bit cheaper. Get 128 MB of RAM – *at least*.

Scanner

This is *the* most important piece of equipment for a cartoonist or illustrator who wants to go digital. Trust me on this. Get the *best* scanner you can afford. Get a professional or semi-professional scanner if possible. What you get *out* of a computer can *only* be as good as the information you put *in*. If you had a really poor scanner it wouldn't matter if the rest of your computer set up was top notch.

A scanner is similar to a camera. Imagine taking a photograph with a cheap throw-away camera. Even if you put the film through a top processor and printed it out on the finest film you still wouldn't be able to improve the quality of the photo if the camera you took it on was rubbish in the *first* place.

I use a Jade II – Linotype-Hell semi professional scanner which gives fantastic results at the price. Make sure you buy a scanner with a removable top.

Printer

Most people use a home printer for personal use only, in which case quality is not *too* much of an issue. However, if you intend using it to put submissions together then quality is important. It also helps if what *you* see on your home printer is close to what a client will see when his job is printed out for real. I use an Epson printer and can't fault the quality at all.

Even the inexpensive Epsons give great results. Don't forget to use 'photo quality inkjet paper'.

Electronic drawing tablet and pen

Don't think twice about getting one of these if you are serious about your work. Not only does it allow you to draw cartoons and illustrations *directly* into your computer but it also makes other common (usually mouse-controlled) operations that require a certain degree of control a lot easier. For a while it's a bit like drawing while looking at your page in a mirror but you soon get used to it. I would recommend an A5 tablet but if you can't afford that size A6 works perfectly well. Because you look at the *monitor* when you draw on a tablet it wouldn't matter if the tablet was the size of a postage stamp.

Storage device

You will need to both store your work and be able to remove it from the computer so that you can give it to editors or printers for reproduction. Your computer itself will store a lot but I prefer to save it all on to separate CDs in case my computer ever blows up (Mr Paranoid). At present the most cost-effective device is a CD writer. You will *definitely* need one.

ESSENTIAL SOFTWARE

SOFTWARE is the term given to the information you put *in* to your computer that allows you to perform various design related tasks.

Like different languages, each software package needs to be learned separately from scratch which can be time consuming, so make sure you learn packages that you intend to stick with.

If you are a computer novice then *don't* buy the huge one zillion page instruction books. Get the smallest book you can find (I use the yellow fronted 'In Easy Steps' books) and work through the essentials. You can learn how to hack into The Pentagon at a later date.

If you create work using 'second-rate' software packages, (that very often come with a computer) editors and printers may not be able to open it. For this reason it is wiser to start with and stick to the 'industry standard' packages such as Photoshop, Quark, Pagemaker, Freehand, and Illustrator.

The two packages I mostly use are Photoshop and Quark Express.

Adobe Photoshop – for Artwork manipulation
Don't even think twice about this one just *get* it. Forget about the inferior photomanipulation package that came free with your computer. Photoshop was apparently developed by George Lucas to help with the special effects in Star Wars. It enables you to manipulate scanned-in artwork in a thousand and one ways.
Check out Adobe.com for more information.

Photoshop images are mostly in a format known as BITMAP. Bitmap images are made up of millions of tiny (square) dots called 'pixels' like a television picture. One problem with this is that if you have composed your picture at a low 'resolution' (a low amount of these dots per inch – dpi) the dots become noticeable if the image is enlarged. So resolution is a very important consideration. (See page 46.)

There are other drawing packages such as ILLUSTRATOR and FREEHAND that create what are known as VECTOR images. This means that artwork is created using mathematical instructions. Should you want to enlarge an image even a thousand times the software will 'reconfigure' the instructions to accommodate the new size, which keeps the image perfectly sharp. If you check out BobStakke.com you will see some great VECTOR images.

Quark Express – For page layout and desktop publishing.
This is *very* expensive but is incredibly simple to use and more importantly everyone else in the design world uses it too. I did the entire layout of this book with Quark even though I only know the basics. Great if you can afford it.

Adobe Pagemaker does a similar job to Quark for around half the price.

If you used any of these packages along with a good scanner you would have the tools needed to produce 'professional' quality art and design. The initial cost is worth it in the long run.

Eudora
This email package will enable you to place cartoons directly onto an email message so that it opens as an immediately visible part of the message without the recipient having to open an attachment. This means you can send a sample of your work as an email with a link to your website.

Graphic Converter (Apple Macs only)
This is a great piece of software that can be purchased for very little on the internet. It is extremely useful for viewing and modifying lots of images at one time. Check out the free trial version at www.lemkesoft.de - you won't regret it.

'Paintshop Pro' does a similar job for PC's.

Metacreations 'Painter'
(not 'essential' but *very* useful)
'The ultimate painting tool for graphic designers and fine artists alike. Painter's exclusive tool set offers an extensive array of brushes, textures, canvas choices, and art materials to faithfully capture the subtleties of an artist's style for high-quality output for print and the Web'. This has to be seen to be believed. All the top comic artists use Painter at some stage in their work.

COMPUTER TIPS FOR CARTOONISTS & ILLUSTRATORS

Image resolution

Images produced in packages like Photoshop are created from millions of dots (called Pixels). The 'resolution' of an image is the number of 'dots per inch' (dpi) it is composed of. The higher the resolution, the sharper the image.

More importantly, printed images are also created using dots and it is the *printer's* resolution that you should try to match. When in doubt, phone the printer and ask for advice.

Try to produce your image at either the *same* size and resolution that it is to be printed at or *higher*. Never produce images at lower resolutions than they are to be printed at.

Most publications print pages at around 300 DPI so make your resolution matches that figure. Obviously, the size of your artwork has to be taken in to account. If your artwork is the same size as it is to be printed then set the resolution to 300 DPI. If your artwork is twice the size as it will be printed at then you can set a resolution of around 150 DPI. If your artwork is half the size that it will be printed at then you will need a resolution of 600 DPI. It's a matter of proportions. Remember, you are safer creating your work at a higher rather than lower resolution than you think you will require.

To check the resolution against the size of an image open it in Photoshop and go to IMAGE - IMAGE SIZE. Uncheck the 'Resample image' box and change the width or height of your image to the size it will be printed at. The resolution will change accordingly.

Should you then want to *reduce* the resolution, 'check' the 'resample image' box and change the resolution to whatever you require. Then re-save the image.

Although it is safer to have your image at a higher rather than lower resolution than it will be printed at, it is not always practical to work with images that are too high a resolution. They take up more space and are slower to work with. For this reason it is a good idea to learn how to bring your images as close as possible to the required resolution.

It is important to work in the right 'mode'

You will come across various formats to produce your work in, ie Bitmap, Grayscale, RGB, Lab, CMYK, etc. If you create work for websites use RGB. Most home computers use RGB as a default setting.

If however your work is destined for any professional publication make sure you change the mode to CMYK. (don't worry about why) This means that if you create a 'new page' in Photoshop you need to set the 'MODE' to CMYK.

Scanning

You can scan artwork in these various 'modes' as well such as RGB, CMYK, Line-art and Grayscale. RGB and CMYK are for scanning colour images. If you need to work in CMYK then scan in CMYK. If your scanner only allows for RGB then scan in RGB and change the mode to CMYK when you open the image in Photoshop.

If you scan an image in 'Grayscale' (even a colour image) it will scan as black, white and gray tones (like a black and white photo). Be warned – if you scan a black and white image in 'grayscale' you may not get 'pure' black and white. If the page your image is drawn on is 'off-white' you may get a slight gray tone.

It is best to scan black and white line drawings as 'line-art' (or 'black and white'). This will mean they will end up as *pure* black and white. But take note that 'line-art' scans are in a mode known as 'Bitmap'. When you open a bitmap image change it to 'grayscale' before you work with it. (don't ask why!) and to confuse you even more, if you want to colour a bitmap image you need to change it to 'grayscale' and *then* CMYK.

To do this in Photoshop you need to do two things.
1. Go to IMAGE – MODE – GRAYSCALE
2. Go to IMAGE – MODE – CMYK

Scan black and white artwork at a high resolution (*much* higher than you will need for output). This allows the scanner to obtain the maximum amount of information from the artwork itself. Later on you can reduce the resolution to suit your needs. Remember again that the size of your artwork needs to be taken in to account.

For example, I draw cartoons for greeting cards at roughly the same size that they will be printed at. I then scan the drawings as 'line-art' at around 1000 dpi (even though most greetings cards are only printed out at around 300 dpi). I then reduce the resolution to the required 'dpi' (check the exact number with the printer) using IMAGE – IMAGE SIZE in Photoshop

Scanning colour artwork is different because if the resolution is too high it can take a long long time to scan. It's a matter of trial and error to find out how long you can be bothered waiting.

Saving your work

When you have finished your artwork and click on 'save as' you will be confronted with a multitude of formats. Which one do you choose?

A safe bet is to save all your work as TIFFs. This is the most widely supported cross-platform format and will save your work at the maximum quality. However, if you are working in a package like Photoshop you may create work that uses various 'floating' layers (such as type) and if you want to save the image with the layers 'active' you will have to save it as a 'Photoshop' format. A publisher may want you to send the artwork with the layers so that they can alter them if needs be. What I do is save two versions of the image. One with layers in Photoshop format and the other – with the layers 'merged' – in a TIFF format.

Saving for the web

Most web graphics are saved as either JPEGs or GIFs. These formats compress images, reducing file sizes which makes for faster downloading. Both have advantages and disadvantages. You would be wise to study up on these formats if you plan to illustrate for the web.

In very simple terms, GIFs can maintain higher quality (than JPEGs) at a very low file size for images with sharp boundaries and flat colour.

JPEGs give better quality than GIFs for tonal images such as scanned pictures or photographs.

To save as a GIF in Photoshop you must first set the mode to 'indexed colour'. CMYK or RGB modes will not allow you to save as a GIF.

When you save as a JPEG you can select how much data is lost during compression. Saving an image at 'maximum image quality' loses the least data but results in the highest file size. Saving at 'lowest image quality' does the opposite; a lot of data is lost, for a small file size.

Keep in mind that the initial size of the image is important as well. If your image is far too large to begin with it won't make that much difference if you save as a GIF or a JPEG. On the other hand if you create the image at too small a size it will lose a lot of quality when compressed. This is something that only experimentation and experience will teach you.

Saving for emails

The problem with emailing artwork is that high resolution images take a long time to send and a long time to open at the other end. You don't want magazine editors to be cursing you for sending a whopping great image that takes ten minutes of their 'precious' time to open but nor do you want to send an image that is so small it is unprintable.

There are three main formats to save work that is to be sent via email. These are JPEG, GIF and TIFF. You can send low resolution images using JPEG or GIF format or high resolution images using TIFF format.

Again it is a matter of trial and error and the best way to learn the process is to experiment with the various formats and the size of the image and then send the work to your *own* email address to gauge the speed of downloading and the quality of the resulting image.

If I am sending a colour cartoon or comic strip, what generally works for me is if the image is resized (go to IMAGE – IMAGE SIZE in Photoshop) to around 12cms square by 100 dpi and then saved as a JPEG at high quality.

Sometimes you may be asked to send a higher quality image which will mean you may have to use a larger JPEG or GIF or save the artwork as a TIFF.

If you use software called 'Stuffit Expander' (Mac) or 'Winzip' (PC) you will be able to compress a TIFF file without losing any quality. But the recipient of the image must *also* have the same software to be able to 'unstuff' or 'unzip' the image when they receive it. You can download Stuffit or Winzip from the internet – just type either name into a search engine.

COMPUTERS
FINISHING A STRIP IN PHOTOSHOP

Finishing a cartoon strip on a computer involves scanning in a hand-drawn strip so that you can add computer-generated borders, lettering and colour. It is easier if your draw your artwork at a size suitable for an A4 scanner. I am assuming that you have a working knowledge of both Photoshop and your scanner software.

'Working-up' a sketch

I needed a football-related gag for my weekly children's cartoon strip – 'Spaced Out'. From my many pages of doodles I came up with an idea about an alien goalkeeper with six arms – drawing 1. I then realised that the strip needed some action to lead up to the 'punchline' so I sketched drawing 2. Finally I decided to show one of the characters trying to score a goal – drawing 3.

The Layout Rough

Even though the borders and the lettering are to be done by the computer it is still necessary to draw the strip out on paper so that you know where everything is to be placed. But before you draw a 'finished rough' you may have to draw a few very loose 'layout roughs' so that you you can establish the important elements such as panel size and placement and size of speech balloons.

In the following rough you will see that the first two panels are my sketches numbers 2 and 3 reversed (using a lightbox). I didn't waste time drawing in the alien or the goal because I knew it would fit in (by again using the lightbox) and I was happy with my initial sketch of the alien (drawing 1).

The Finished Rough

It is now time to draw up a more finished version of the strip which will then be scanned into the computer. Remember, the hand-drawn borders around each panel are going to be replaced by computer-generated borders so don't worry how they look, just make sure they are as straight as possible. Also, since the lettering is also to be computer generated, you can leave it out of the finished rough.

The most important part of the finished rough is the *drawing* within the borders. The drawing will *not* be changed so it has to be as good as you can get it.

At this point it is also important, if you are colouring the strip using the 'paint bucket' (see later), that you 'join-up' all your lines. The 'paint bucket' will fill in any area that you select such as a hand or face or a flower or the sky but each area has to be clearly defined and enclosed by an unbroken border.

Scan in the artwork (see also page 46)

When you scan your artwork into the computer try to place it on the scanner bed as 'squarely' as possible because it is a nuisance straightening it up later on.

Set your scanner settings to LINEART – or whatever setting gives you a pure black and white image.

Set the 'dpi' (dots per inch) to at least 600, crop in on your artwork leaving a bit round the outside and scan. Then SAVE the image to an appropriate folder.

Open the artwork in Photoshop

1. The image will open as a BITMAP (don't ask!) and needs to be changed to CMYK. To do this you need to do two things.
 Go to IMAGE – MODE – GRAYSCALE and press 'okay'. Then go to IMAGE – MODE – CMYK.
2. Depending on how you placed your artwork on the scanner, you may have to rotate the image.
 Go to IMAGE – ROTATE CANVAS – choose what you need. If you also have to straighten the image just slightly then choose 'ARBITRARY' and rotate by a few degrees at a time. You will get used to this.
3. The image was scanned at a high resolution to preserve quality but it now can be brought down in size so that it is easier to work with. Bring it down to about 300 dpi.
 Go to IMAGE – IMAGE SIZE. Change the resolution to 300 but leave the width and height the same by checking the 'resample image' box. SAVE this so far.

Replacing the borders

1. Place your cursor in the rulers at the top and to the left of your image window. Click and drag out guidelines and place them on the *inside* of all your hand-drawn borders (as close as you can get).

2. Then select the squares created *by* those guidelines. (Select the first one then hold down the SHIFT key and select the other two.)

3. This means you have selected the area inside the selections but what you want to select is the area outside the selections so that you can remove the hand-drawn borders.
To do this go to SELECT- INVERSE.
You are going to fill this area with white. Make sure you have white selected as a colour.
Then go to EDIT – FILL. You will see the borders vanish.

4. You will now need to revert to your initial selections. – Go to SELECT – INVERSE.
You can then create a perfect black border around your panels.
First select black as a colour, then go to EDIT – STROKE.
Choose what width you want your line to be (experiment). Choose 'centre' and click OKAY.
Get rid of the selection by going to SELECT – DESELECT.
Get rid of the guidelines by going to VIEW – HIDE GUIDES.
You now have perfect borders which will reproduce well in print.

Add the lettering

Select the type tool and click in the speech balloon where you wish the lettering to appear.

Type in the words and choose colour, size, font, leading, etc. – click OKAY.

You will see that this is now on a 'layer' (separate from the drawing so that it can be altered). You can move it around with the 'move' tool. (If you need to angle the type go to EDIT – FREE TRANSFORM.)

Continue to add type to each speech balloon in this way.

When you are happy with all the lettering go to LAYER – FLATTEN IMAGE. Then save again.

Add colour

There are two ways to add colour.

1. Fill in areas with flat colour using the 'paint bucket' tool.

 To partially fill an area use the 'pencil' tool *and* the paint bucket. For instance, if you want to fill a circle with red yet leave a white highlight at one edge, use the pencil tool to draw a *red* line where the colour meets the highlight and then fill the remaining area with red using the paint bucket.

2. Use the 'pencil' tool like a watercolour brush.

 Normally when you use the pencil tool it draws a solid colour which unfortunately obliterates any black lines it touches. If however you set the opacity of the pencil to 20% (double click the pencil tool to get options) you can use it as if it is a watercolour brush (the colour is transparent which keeps your black lines visible). You really need a graphics tablet to do this properly.

Save the artwork

When the work is complete go to FILE – SAVE AS ... name it and save as a TIFF file. If you are going to send it via email go to FILE – SAVE A COPY and save it as a JPEG or GIF (see page 00).

CREATING THE PERFECT WEBSITE

Before you begin – get a domain name
Before you even *think* about the actual design of your website can I suggest that you go *now* and register a domain name. A domain name is the name of your site, like 'bobstaake.com' or 'icomics.com'. The reason to do it right away is that all the more desirable names are being snapped up at an incredible rate. Even your own name (followed by '.com') may be gone. When I tried to get robinhall.com it was already in use by a fine artist in the USA (check out her site – her work is brilliant). It will take you a long time to find an available name that you actually like.

Choose the name carefully.
Think about the audience you want to reach. If your site is simply an online portfolio, your own name (hopefully followed by '.com') may be sufficient. You may, however, want a name that sounds more like a business or just a fun place to visit like cartoonsville.com or funnyhaha.com (both these names are taken by the way).

How to register a name
To register a domain name go to one of the registration sites like 123-reg.com and follow the three simple steps to buy your name. Be ready with a long list of alternative names in case the one you want is in use by someone else. Trust me, the obvious ones are long gone. For instance, I tried…

 cartoons.com
 cartoonworld.com
 comicscentral.com
 icartoons.com
 worldofcartoons.com
 cartoonsforsale.com
 cartoonzone.com
 cartoonplanet.com
 etc. etc. etc.

You may be lucky and hit on something that no one else has thought of. I was fortunate enough to get thecartoonfactory.com which suits the type of site I have in mind. One way to get a name close to the one you want is to change certain letters. For instance you might have cartoonzzz.com or comix central.com. The other alternative is to use .org or .net after your name instead of .com. In the UK you often see .co.uk instead of .com but I didn't want any potential US clients put off by thinking it might be a hassle dealing with someone in the UK. Besides which, .com is simply preferable – *if* you can find one.

When you do finally find a suitable name and it is one that you imagine other people may want also, buy it immediately with your credit card. If you leave it even until the next day it may be gone. It isn't that expensive to register it for a few years and keep in mind that the .com names are dearer than .org or .net, etc.

A 'Corporate Identity'
The first thing I did after registering my domain name was to create a 'corporate identity'. Think of companies like McDonalds, Shell Oil, Pepsi, etc. They have very recognisable corporate identities through the use of symbols, logos, colours, letterstyles etc. The aim is to create a unique, memorable identity that reflects who you are and the work that you do. The temptation in this area is to be too 'literal'. With my own name 'thecartoonfactory.com' I could easily have gone overboard with factory buildings, smoking chimneys, shop floors, production lines, etc., but to me that is just *too* obvious to have any real 'style'. A lot of amateurish cartoon sites use hand-drawn 'cartoony' style lettering which just doesn't give the impression of a 'serious' business – which cartooning is. People equate big business with the ultra slick computer-generated images they see in magazines and on television, and your corporate identity needs to mirror that.

The golden rule in creating a corporate identity is 'Less is More'. Try to be succinct. What is the simplest image you can create that speaks volumes about your company? Think carefully about who it is you want to impress. If you have a site aimed at kids then 'cartoony' is fine. If you are trying to sell business cartoons to business sites then you will be targeting people who are used to being impressed by fancy restaurants and BMWs. Go to the websites of the major US syndicates and you'll see what I mean.

Also, be careful about using a gag cartoon as part of your logo unless it is absolutely *hilarious*. I have seen dozens of cartoonists ads where the gag wasn't even *funny*. This *really* defeats the purpose. Jokes wear thin when viewed too often. If you use a cartoon, just use an example of your drawing style – forget gags.

When you have created some kind of letterstyle, symbol or logo you can then use elements from that for the rest of your site.

My own 'logo' uses four coloured squares behind 'cartoony' yet precise lettering. I intend using the squares, speech balloons and the colours elsewhere on the site as part of the overall design. I deliberately opted not to use cartoons in the logo because the site will be *full* of cartoons so there is no need for overkill. When I use the logo on letterheads or business cards I include a cartoon as a separate element.

Web Design

There is no point in my discussing the technical aspects of designing a website. For one thing I know very little about it and for another, any technical information I could give you would probably be out of date by the time this book hits the shops.

One thing that will never change however is the neccessity for good planning and common sense design.

If you seriously want to make a decent income from your website then I suggest you get it professionally designed even if it means taking out a loan to pay for it. If you have no experience at web design, don't be fooled into thinking you can do it yourself – you *can*, but the results will look amateurish no matter how good an artist you may be. A lot of what makes a site look professional and work effectively is down to technical know-how. There is no point saving money through designing your own website if it just makes you look like an amateur.

Remember, this is your portfolio – if you go the amateur route your business will stay at an amateur level.

If you are determined to 'do it yourself' at least spend a long time learning both the technical *and* the marketing aspects of web design. Check out other sites. This is the easiest and most effective way to design your site.

Buy a directory of sites from your local newsagent and spend a few days (or weeks) surfing for well-planned, well-designed sites. Don't stick to cartoon sites – a lot of of them are very amateurish from a design perspective (though check out 'Gibbleguts. com' which is expertly designed). Bookmark your favourites and take note of all the things you like or dislike with regard to the design or the content.

Draw up a plan

Whether you design your own site or have it done professionally you will need to have some idea of what you want on paper before you start.

First of all think about the possible pages you could have – separately. Draw up roughs of these pages and then try to imagine how your 'home page' (your opening page) could look in relation to the other pages. How do you 'link' to the pages? With text only or by the use of an icon, or both? Could you use elements of each page on your home page? Do you want the important parts of your home page to be visible on every other page so that you can easily navigate around the site without having to repeatedly link back to the home page?

Choose a site that you really like and print out each of its pages. This will give you a clearer idea of how to design your *own* site. If you can do most of the planning and design and have a clear picture of what you want, the designer will have less work to do and, hopefully, will charge you less.

Important considerations

What is the purpose of your site? Is it simply an online portfolio? Is it a cartoon 'store'? Will people be able to purchase cartoons for their own sites?

Who is your target audience? Are you aiming it solely at clients whom *you* will direct to the site or will you be making use of search engines to *find* potential clients? Do you want your site to be a fun place for people who like cartooning? Do you want to build up a large 'following' perhaps to sell merchandise or to earn money through advertising?

The home page

When you have a clearer idea of the purpose of your site the next most important consideration is the design of your 'home page'. If a visitor doesn't find what they are looking for on your home page they will most likely leave and never return.

People generally visit a website to *get* something. They may want to learn something or buy something or they may simply want to be entertained – but whatever it is, they want it instantly. Few people have the patience to wait for a huge graphic to download that says. 'Hi, welcome to my web site'. When I see that, I leave immediately because I know that the rest of the site will be equally laborious.

On your home page, especially, sacrifice large slow-loading graphics for fast-loading purposeful information interspersed with small graphics and put the most useful information in the top half of the page.

Try to instantly appeal to your visitors' self interests. Involve them in some way. If you were visiting friends and all they did was talk about themselves and show you their holiday snaps you would soon be making excuses to leave and be very reluctant to return. All good relationships require 'give and take'. Websites are no different.

What would make people want to return to your site or recommend it to others? Free greeting cards – a daily strip or gag – a game of some sort – animations – a message board? How could the site be interactive with visitors? How can you encourage the visitor to leave their email address for future targetting?

What sites do *you* visit regularly? Why?

The thing that annoys people most about websites (apart from horrible design) is the length of time they have to spend downloading. Make sure you get good advice about how to make your site download in the fastest possible time.

If you have a lot of time-consuming images to display, show them as small thumbnails and give the visitor the choice of whether or not they wish to see a larger view. Personally I prefer to see thumbnails of cartoons rather than a long list of titles or numbers to choose from. Once I see the image in miniature, – my curiosity compels me to see the larger image.

Consider also whether you want images to appear gradually (from top to bottom as they download) or 'suddenly' (after they have downloaded). I personally hate how cartoon strips usually appear on a website. They never quite look 'at home'. Try to come up with a way to display your cartoon strips that makes them seem as if they were designed for the web rather than a newspaper. Could each panel appear one after the other – like a slide show – or could your cartoons appear in a separate window so that your entire page doesn't have to 'refresh' each time you want to look at a new image? Could parts of the strip be animated? Does the background colour make a difference?

Be aware of colour

Colour is an important communicative device that too many websites fail to utilise. Look through magazines and borrow ideas from contemporary page layouts. Rather than focusing on the fancy 'buttons' or Flash animations on a webpage look at those that just use areas of colour to draw your attention or divide the page up. Look at how background colour affects the ease with which you read the text (i.e. very often you see white text on a black background which gives the feeling that the text is 'floating' in mid air).

If you are just starting out and don't have much to put on a website then you could design it purely as a portfolio. But keep in mind the type of people that you will be directing to view your portfolio. Art editors are not surfing late at night in their pyjamas with plenty of time to spare. They may have two minutes to spare in the middle of a busy day. Can they find what they want in two minutes if they visit your site? Put yourself in their shoes.

Visit my own site

Check out www.thecartoonfactory.com where I will hopefully be adding some more advice on web design as I gain more experience in this area.

CAN CARTOON SITES MAKE MONEY ?

John Cook *is an Australian cartoonist whose work has appeared in a number of Australian newspapers. In 1995, he created the Sev Wide Web website with an emphasis on science fiction cartoon parodies. A thriving online community has grown around the website, attracting half a million visitors a month. Currently, John is working on an animated movie based on his cartoon spoof 'Sev Trek '.*

Can cartoon sites make money?

Well, it's taken me five years to figure it out. I tried merchandising but only made a moderate income from it (although my online store was fairly amateurish – I'm in the process of programming a more professional shopping cart system).

But I made a lot more income from banner advertising – for the last two years, that's where the money has been although I'm finding the income seems to be drying up a little lately – dunno if it's a developing trend or just a lean time.

As for how to get an advertiser, well, I was lucky – I was contacted by an advertising network, www.ugo.com who offered a two-year contract in exchange for exclusive advertising rights on my site. I went with it and had a fruitful relationship that allowed me to cartoon full time from home. But it isn't a bottomless pit – as I said, it's getting leaner now and I'm looking for other ways to earn income, such as making my online store more productive.

Unless you have the time (and marketing skills and resources) to pursue advertisers yourself, the easiest way to get ad revenue is to use an advertising network who do all the marketing and give you a cut of the profits (typically 50%).

The thing is, you need about 100,000 visitors per month to your website before banner advertising pays (in fact, that's often a minimum requirement before they take you on). So it takes a lot of hit building before you can get to the point of making online money. In other words, it's not a free ride – it takes just as much work as selling cartoons the traditional way.

The way I'd suggest approaching it is build your website hits, then visit a bunch of websites that have advertisers. See who the advertising network is, then go to their website and see what their requirements are for websites to advertise on and if you fulfil the requirements, email them to see if they're interested in taking you on.

PART 4

How To Make It Big In The Art World

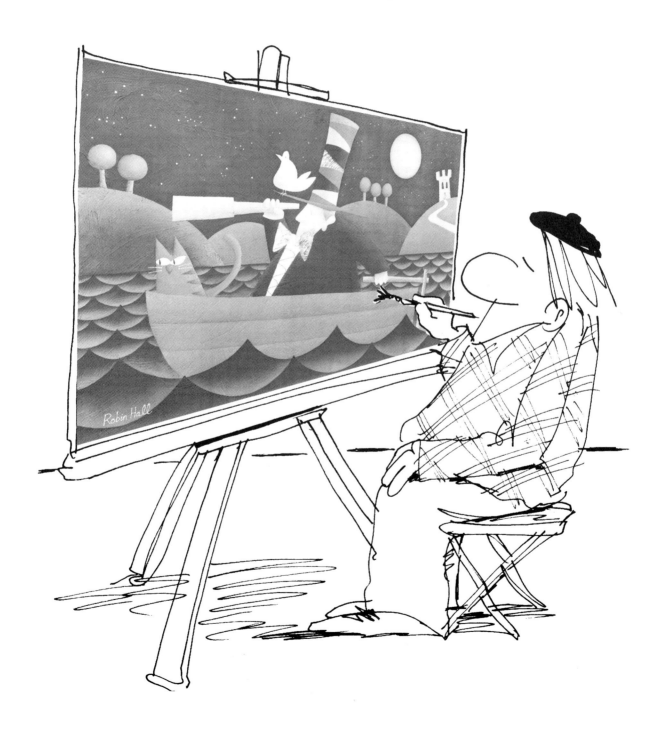

BE AWARE OF MODERN TRENDS

If you look through any fine-art print catalogue these days you will see a growing trend for lighthearted, quirky, very stylised images. This trend is being reflected in most of the 'high street' art galleries up and down the country. People are much more open to buying less traditional and more illustrative style paintings than ever before. Many a gallery owner has told me that they are actually having difficulty selling the more traditional images.

Some contemporary art published by Washington Green Fine Art Publishing Company. Clockwise from top right: David Jaundrell, Joan Somerville, Toni Goffe, Sarah Jane Szikora and Govinder Nazran.

DRAW UP A PLAN

Illustrators often imagine that fine-art galleries are a no-go area as far as their work is concerned but I have discovered that if you plan ahead and treat a gallery as if it just another client with certain requirements you can tailor your work to suit their needs.

When I first became aware of this potential market for my work I made the mistake of painting only when the 'mood' took me but because I am slightly lazy when it comes to setting up for painting (and clearing up afterwards) I soon lost interest.

Eventually it occurred to me that it might be easier if I imagined that I had to do the paintings for a client or as part of an assignment so I set myself the following 'brief'.

Brief:
Create ten finished paintings, a portfolio and a résumé that will help launch you into the fine-art world.
Develop a unique and instantly recognisable style that will fit in with contemporary trends in fine art and appeal to a wide range of tastes.

Tasks:
1. Check out the galleries.
Visit as many 'high street' galleries as possible. Talk with the owners. Find out what kind of work they like and what kind of work their customers like. Imagine your own work on the walls. Could you tailor your usual style to meet the needs of 'gallery art'? Are they finding it easy to sell your style of paintings? Get some idea of the prices they fetch and the commission the gallery takes.

2. Gather research and reference material.
Study current trends in design, architecture, home furnishings, fine-art prints, contemporary art cards etc. Build up scrapbooks of images that really appeal to you. What are the best selling images? Are certain themes more popular than others?

3. Develop a unique yet widely appealing style.
To begin with, experiment with a variety of techniques, colours, textures, mediums, sizes, shapes and subjects. Try to develop a recognisable style that will enable you to render a wide range of subjects while retaining a certain continuity.

4. Research your target audience.
What type of people want to (and can afford to) buy your type of paintings? What age group? Where do they shop? What magazines do they read? What type of images are in vogue? Is colour, size, shape, texture or subject matter an important consideration?

5. Do at least TEN finished paintings.

6. Photograph or scan the paintings for your portfolio (see page 70)

7. Get several or all of the paintings framed (see page 72)

8. Present your portfolio to the galleries

DO SOME MARKET RESEARCH

Although this may seem a rather cold and calculated way to approach such an emotive subject as fine art, artists with a background in cartooning or illustration are often more easily inspired when working to a brief in a planned and disciplined way.

Because I am not a practised painter it took me about six months working on this 'project' before I felt confident enough to even attempt ten finished paintings.

Based on my own experience, here are a few things I learned along the way.

Illustration Fine Art
It is important to know how the majority of people differentiate between illustration and fine art.

- **Cartoons and Illustrations**
 Pen and ink line drawings on paper, with maybe a colour wash. Either funny, satirical or illustrative of some accompanying text. Created specifically to be printed in a magazine or book. Created by clean cut graphic artists wearing pyjamas at a nice drawing board in a cosy studio.

- **Fine art**
 Any medium but mostly oils on canvas, acrylic or watercolours (not gouache). Created specifically to be framed and hung on a wall. Can be purely representational or abstract, serious or lighthearted, fun but not 'funny'. Created by starving, angst-ridden, bearded and emotionally disturbed artists in a ramshackle garret.

'Fine art' (for our purposes) is any painting that people won't immediately think of as either a cartoon or an illustration. It's just a sad fact that most people don't take cartoons or illustrations as seriously as 'fine art'. Nor will they pay much for a cartoon or illustration whereas the sky is the limit for a 'fine art' painting.

Experimentation is vital
Don't try for finished paintings to begin with, have fun, make mistakes, be outrageous. Treat them as if they were roughs for an illustration project.

To begin with I tried working in conventional ways with oils or acrylic on canvas and board but my lack of experience with these mediums was very apparent. I then tried more experimental techniques that I felt might give my paintings a more 'painterly' feeling whilst making use of my more obvious 'graphic' ability.

Take regular breaks from the work
Seriously, if you have a break from the work, when you return to it you will see it in a totally different light. If you need to continue experimenting it is better to do it at this point. You don't want to be changing your style *after* you've spent weeks doing finished paintings. Keep at it until you are *sure* you've found a style you're happy with. Be patient.

Get plenty of feedback
Show your efforts to a variety of people. Don't bother with anyone under the age of about 25 – they buy CDs, clothes and cars, not paintings. And don't dismiss what your grandmother has to say. If your work is *too* modern you may alienate a lot of potential customers. It *is* possible to be contemporary yet acceptable to more traditional tastes.

If you need to do dozens of paintings in order to find ten that are good – then do so. Remember, these are for your portfolio – they have to be *brilliant*!

Contacting the Galleries
Call in to galleries – in person (it's too easy for them to put you off over the phone) – and take your portfolio. Ask would they be interested in seeing a few 'originals'. Set up an appointment. Try to strike up a friendly relationship. Praise their gallery. Never say you dislike any of their paintings – remember – *they* picked them.

Your 'calling card'
It is essential to have something you can leave with the galleries such as a portfolio of photographs or slides. You could have some made into postcards which can double as a business card.

Try to build a special relationship with ONE gallery

If one particular gallery seems more interested in your work (and you, in return, are impressed with the gallery) then build on this as best you can.

The quickest way to become established is through 'catalogue' exhibitions. Catalogues can prove useful long after an exhibition is over. They add greatly to your portfolio and give you a lot more credibility. Just make sure the work in your first catalogue is the best you can do. You don't want to send out a few thousand examples of work that you aren't happy with.

Most galleries split the cost of the catalogues with the artist so be prepared for this. You may only just break even to begin with but it will pay off eventually.

Try to have a clear idea of what your goals are.

You will need to develop a style that will allow you to paint *thousands* of paintings. To make a basic income to start with you will need to sell about 50 paintings a year. You will be lucky if you sell half of what you paint, so realistically you will need to paint 100 or more pictures a year.

Market Research

Remember that you not only have to gather research and reference for images that *you* like, you also have to find out what people who buy paintings like.

- **If you want to earn a living as an artist** you *have* to think commercially – If you really really love to paint pictures of squashed hedgehogs – fine – but don't expect to sell too many paintings. Stick to themes that the majority of people can relate to. In my own experience my best selling paintings have figures in them. Traditional themes done in a modern way can also be popular. People don't want to stray too far from the 'safe' traditional images yet they want something that seems contemporary.

- **Colour** Paintings nowadays have to fit in with modern decor – in fact they *are* sometimes a part of the decor. I have heard people say things like 'oh, that would go nice with my lilac curtains.

- **Texture** This can make a big difference. People imagine they are getting something more 'substantial' if they can actually see the texture of the paint or the brush strokes. This is one reason why oils have always been more popular.

- **Hidden meanings** Paintings with hidden meanings (e.g. Salvador Dali's work) are often perceived as being more 'arty'.

- **A recognisable style** It is important to develop a style that will be instantly recognisable. Think of paintings that *you* like, what is it that sticks in your mind. Your style should be your 'signature'. Unique and unforgettable.

- **Consistency** Art buyers like consistency. One of the best selling artists in Ireland paints practically the same picture over and over again using various compositions of the same elements. Nearly all his paintings consist of Irish cottages, fishing boats, women in shawls and stone walls. The colouring, texture and the application of the paint – whilst expertly done – is always exactly the same. He has made a fortune out of *one* idea. There is a three year waiting list for his paintings.

Try to look at your work from the buyers' point of view. The more popular your work – the more people will want it. But they will want the work that was popular, not totally new ideas. If they see something in a catalogue and think 'Oh, I like these, I must have one' – they want something very similar.

Remember that people have their eye on only *one* painting. *You* may get fed up doing the same theme again and again but the buyer doesn't worry about your work collectively as you may do.

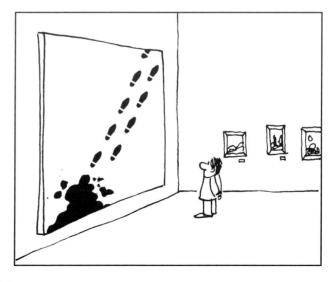

SKETCH, SKETCH, SKETCH ...

Before you even start painting it is imperative that you spend several weeks – even months – sketching. Don't do anything else *but* this. Use reference to spark off ideas and keep your drawings fast and loose. The more you sketch, the more you loosen up and this helps ideas flow more easily. Later on you can sift through these sketches and pick out the best ones.

Not only will this practice improve your artistic ability but it will also give you a clearer idea of whether or not you are *capable* of coming up with the large amount of paintings you will need. Sketching is probably the most creative part of the whole process.

A FINE SINGIN' VOICE

62

faces
from
magazi
photocopi
study
painted

VENICE

REFINE AND COLOUR YOUR SKETCHES

Tidying up the roughs

Once I have decided which roughs I want to use, the next step is to tidy them up by tracing them on a lightbox. If I am working from a tiny sketch I enlarge it up to A5 to make it easier to trace. These 'finished' roughs will be projected on to specially-textured boards so that outlines can be drawn for the paintings so they have to be as perfect as possible. Particularly faces and hands, if *they* look wrong, the painting can be ruined.

Rough sketch

Add colour using Photoshop

Because I am not a practiced painter I have always found it difficult to pick good colour combinations 'from' my head. I know what I like *when* I see it but arriving at that point is the problem. It would take me *hours* of experimentation if I had to use conventional paints but the computer allows me to try different colour combinations at the press of a button (and without the mess).

I scan the finished rough into Photoshop and colour it as best I can using the paintbucket tool or the gradient tool. When I have the whole image coloured I then use some of Photoshop's special effects to create different colour and tonal variations.

The most useful ones are:
IMAGE – ADJUST – HUE/SATURATION. This allows you to gradually change the colour of the entire image.

IMAGE – ADJUST – REPLACE COLOUR. This allows you to gradually change each colour separately.

IMAGE – ADJUST – CURVES. If you experiment with this effect you can come up with some fantastic colour combinations. (Use the 'eye dropper'.)

Try *all* the effects under 'IMAGE ADJUST'. Every time you hit on one that you like – save it (and don't forget to give each one a different name) and then try more variations.

Steer clear of Photoshop's FILTERS – they are a novelty at the start but not of much use when it comes to flat colour images.

Finished Rough

Coloured Rough

TRANSFER THE SKETCHES WITH A PROJECTOR

First prepare your boards

Cutting To keep costs at a minimum I have my boards cut from 8 x 4ft sheets of MDF or plywood. Ask for an accurate cut because it is a *lot* easier (and cheaper) when you come to have the pictures framed if they are all the same size or at least batches of them are the same size. I mostly work around 24 x 20 inches which is the preferred average size of most galleries.

Prime After the boards are cut, dust them down thoroughly before priming with an undercoat of white emulsion. If you want to work on a flat surface, all you need to do next is to add a few coats of Acrylic Primer. I recommend Daler Rowney System 3 Acrylic Primer which is reasonably priced compared to ordinary white acrylic.

Add texture If you want a textured surface you could try the following method.

Mix two parts 'Readymixed Textured Finish' (this is very thick in consistency – it weighs a *ton* – and is *not* the same as textured paint) to one part PVA glue which helps bind it together to stop it from cracking. This is spread on the boards (like honey on bread) using a 2 inch household paintbrush. Don't worry at this stage about how it looks.

The next step is to create an interesting texture by dragging and swirling the surface with the flat side of a small piece of card (bend an edge of it to hold on to). You need to experiment with this technique until you get what you want. You may want it like an old rugged plastered wall or you may want swirls and patterns.

When this is dry (give it a full day) you then need to paint it with a couple of coats of acrylic primer. I use a gloss roller to apply the primer. When this has dried, if you find the surface is too rough, rub over it with an old *clean* towel until it reaches the smoothness you require. This is a process of trial and error. You need to try painting on various boards with various textures.

Transferring the finished roughs on to the boards

The quickest and most accurate way to do this is to use a projector. It may not seem very 'artistic' but keep in mind that throughout history all the great artists used various 'mechanical' methods to transfer their drawings – When Michaelangelo was painting the Sistine Chapel he didn't just start in one corner and 'hope for the best'. In an illustrative approach to painting, the artistry is as much in the technical rendering and the inspiration behind the design.

The projector I use is called an 'Artograph Tracer Projector' (no. 555-360). It allows you to enlarge a 5 inch (12.5 cm) square image up to 30 times the size. I have also used it to paint murals. It is a terrific device to have – and not that expensive either! The only drawback with it is your friends constantly want to borrow it.

I have a tiny shelf attached to one wall of my studio where I can prop up the boards at a reasonable height. I also have a tripod that I have modified to enable me to set the image and the projector on it. This way I can move the projector up or down to position the image rather than having to move the board.

I use a special ballpoint pen that will write when upside down (from a specialist pen shop), to transfer the image. The reason I don't use pencil is that my technique involves wiping the paint back with tissue paper and pencil runs when I do this. When I have transferred the sketch to the board I then add another thin layer of acrylic primer which takes the harshness out of the pen line. It's a *long* process.

AIM FOR A HIGH QUALITY FINISH

Once the drawing has been transferred onto the textured board it's time to start painting. I use Griffin Alkyd fast-drying oil paints. You can work with them for several hours before they dry. I apply the paint evenly to one section at a time and then dab and wipe it back with 'kitchen' tissue paper to create a shaded effect. I then wait for this section to dry before moving on to the next. To save time I work on several paintings at one time. This mixture of a strongly-textured surface with a soft, almost air-brushed paint effect gives the paintings their unique quality.

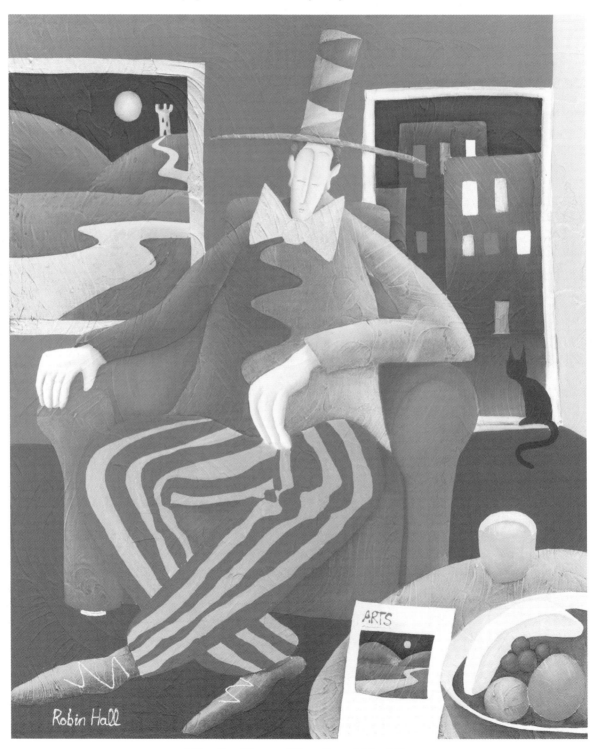

After the Show *Oil on Board 24 x 20ins*

BUILD A PORTFOLIO

End of a Perfect Day

The Lovers

The Three Tenors

Always There

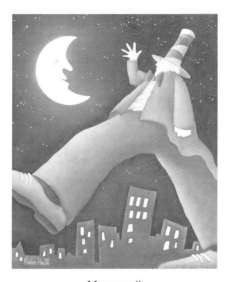

Moonwalk

Serenity

Pink Lady

The Ferryman

The Estate Agents

SCAN YOUR PAINTINGS ON YOUR HOME A4 SCANNER

Although it takes time and some figuring-out it can be worth your while scanning your paintings on an A4 scanner. Photographs can be hit and miss (quality-wise), expensive and don't always enlarge well.

You will need to do as many scans as it takes to cover the entire painting. I work mostly around 24 x 20 inches and in order to scan the whole painting on an A4 scanner, I need to take six scans.

Make sure that there is a reasonable 'overlap' between the scans. You will need this overlap later on when you blend the scans in Photoshop to make up the whole picture. (I am assuming that you have a working knowledge of both Photoshop and your scanner software).

- Select the entire scanner screen in your scanner settings window.
- Set the mode to CMYK and the resolution to 150 dpi (go higher or lower depending on your needs).
- Place the bottom left hand corner of the painting on the scanner.
- Scan and save as 'bottom left' (or BL). Save as a TIFF file in an appropriate folder.

- Carefully position the painting on the scanner for the next scan – keeping at least a one inch over-lap on the previous scan. Try to keep the painting parallel to the edge of the scanner.
- Scan (at the same setting), save again and continue until you have worked your way around the painting.
- Now open a new page in Photoshop. Make the dimensions slightly bigger than the full size of the painting and use the same resolution as you did for each scan. For instance, my painting was 24 x 20 inches. I did each scan at 150 dpi. So I need to open a new page that measures 24.5 x 20.5 inches by 150 dpi. This will then accommodate ALL six scans.
- Now open the 'bottom left' scan and drag it over and on to your new page. Place the image near the bottom left hand corner. This will appear as a separate 'layer' in your layers window.
- Then open the 'bottom middle' scan and drag it over the other scan until they look as if they 'match up'.
- Temporarily change the opacity of the top layer (the scan called 'bottom middle') to 50% so that you can see the layer below to help match the two images. 'Zoom' in for accuracy.
- When they match up, the 'join' may be noticeable because of the straight edge between them. Use the 'rubber' tool to rub and blend the two pictures together. Use it on a low opacity for very subtle blending.
- Now merge these two layers ('Merge down') and open the next part of the 'puzzle'. Continue until the entire image has been built up. Then flatten the image, crop and save.

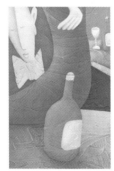

Bottom left *Bottom middle* *Bottom right*

Top left *Top middle* *Top right*

The finished result (which unfortunately I can only show in black and white).
I could never have captured the same detail in the texture if I had taken a photograph of this painting.

The quality of this scan was equal to that of a professional scan (which can be very expensive).

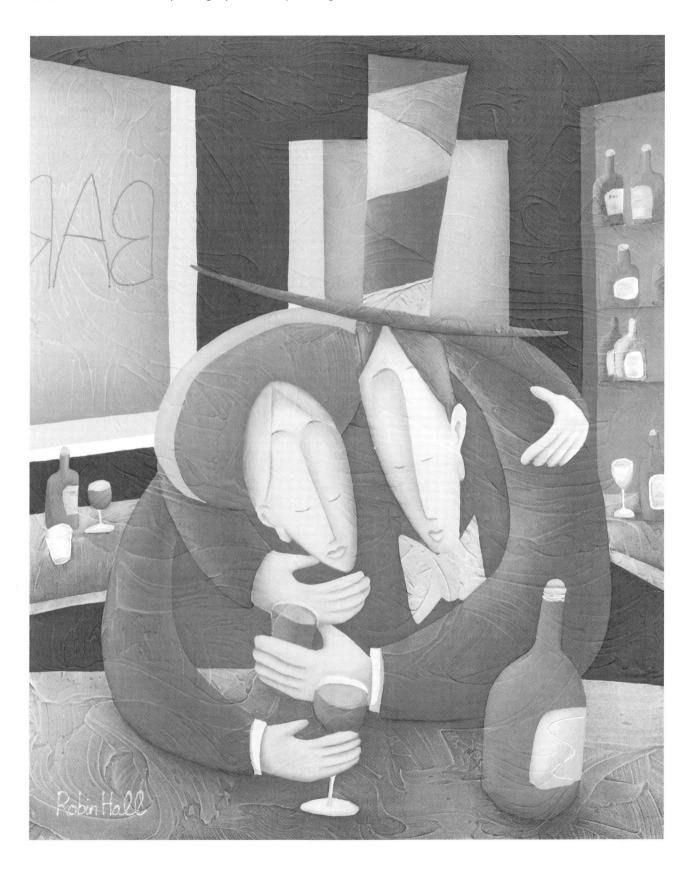

FRAMING TIPS

The way a picture is framed is of utmost importance

I have seen many a good painting ruined by a bad frame and many a poor painting enhanced by a good frame. As soon as you put a frame around a painting it *becomes* part of that painting.

If you have never framed a picture don't just walk into a framing studio and choose a moulding from the selection on display. It is *very* difficult to judge from a 3 inch sample hanging on a wall. The best way is to look at how other artists' work is framed. Take a note of the frames you like best, especially on work that is similar to your own. Try to avoid *my* mistake of framing a dozen pictures without making sure that the frames were suitable. (I *still* have them in the roofspace).

If you work on paper (watercolour, pen and ink, pastel, etc.) you will need to put a cardboard mount around the image and a thin-ish moulding around the mount. Double mounts can look impressive but again, check out the galleries to see what looks best before you start guessing.

If you work on canvas or board you can frame right up to the edge of the painting but I personally prefer to let the painting breathe by putting a small 'slip' frame between the image and the outer frame. If you use a slip frame, paint it with lime coloured emulsion (or any off-white colour) rather than bright white. Try not to make the outer frame and the slip frame the same width. Either have a wide slip and a narrow outer or a narrow slip and a wide outer.

To begin with, avoid colour-wash mouldings, go for either 'natural colour' stained wood, limed wood, or gold. Avoid anything overly ornate or anything plastic. The object is to make the painting look as if it *must* be worth a lot because it has a quality frame – without the frame overpowering the picture. You want it to look 'substantial'. I discovered that my oil paintings had more of a 'quality' feel to them when I put them under glass even though oils aren't really meant to be under glass. This may not work for *all* oil paintings however.

You need at least two or three of your 'portfolio' paintings framed so that you can show some original work to the galleries. When you receive some interest you won't mind investing in frames for the rest of your work. Some galleries will have work framed and add the price to their commission.

Buy your own framing equipment

I would recommend this to *any* serious artist.
- Professional-standard equipment is relatively inexpensive – the sale of ten pictures would pay for it.
- If you make your own frame it will cost you a *third* of what it would cost in a framers.
- It took me just a few weeks to learn how to use the equipment and the results are incredible.
- You don't have to transport your paintings around.
- Framers are always busy. You can frame your picture as soon as you need it.
- You can guarantee how the frame will look – you can think about it for hours on end – something you can't do in a framing studio.
- You can experiment with a variety of frames without losing a fortune in the process.
- You can set up a framing business.
- It is extremely satisfying when you see the finished results.

The main equipment
- Foot-operated Mitre Guillotine – for cutting the 45% angles in the mouldings.
- Underpinner – for joining the corners of the frames together.

Mitre　　　　　*Underpinner*

Mount cutter

- Mount cutter (if you need one).
- Sheets of picture glass, long metal ruler for cutting glass and quality oil-filled glass cutter (picture glass is so thin it is extremely easy to cut).
- Mouldings (you can buy this as and when you need it).
- Staple gun, pin-gun, wedges for the underpinner, tape, glass cleaner, etc.

Framing tips that you won't find in the manuals

When setting up a workshop to make frames don't forget that you will have to have an area to set the frames as you make them; somewhere long enough to accommodate ten foot lengths of moulding; an area to store off-cuts of glass (and off-cuts of mouldings) and a large table covered with carpet on which to cut 4 x 2ft sheets of glass. An average-sized garage – cleared of junk – is ample space.

Don't even contemplate buying the cheaper 'DIY' framing gear – unless you are the type of person who likes to cut the lawn with a pair of scissors.

A framing supplies store will give you a demonstration of how to use all the equipment if you express an interest in buying from them. They may also know where you can get second hand gear. They won't mind because you will still have to buy mouldings from them.

Here's a trick I learned when using the underpinner – 'snap' the wedges in place (with the spring at the back of their plastic holder) before you put each one in. If *one* wedge goes askew it can ruin the entire frame.

- Accept that you will make a *lot* of mistakes to begin with.
- Mark the measurements on the mitre ruler with a felt tip pen that can be rubbed off.
- Check every measurement three times. Check every measurement three times. Check every measurement *three* times.
- How to avoid dust when putting the frame together: join your slip frame or mount to the painting. (When you attach a picture to a mount, tape it at the back but at the *top only* – nowhere else or it will buckle). Blow away any dust.
- Set the painting face up on the table.
- Clean one side of your glass – spray it with glass cleaner, rub it with 'kitchen-roll' until it looks clean and dry, then give it a final wipe (don't 'rub') with a non-static shamy cloth to get rid of the dust from the kitchen roll.
- Now flip the glass over and set this clean side on top of the painting. This is now sealed from dust.
- Then slip your outer frame over the glass, flip the whole thing over and put in the pins or staples.
- Now you can clean the front of the glass.

Make sure you seal all gaps at the back of your pictures with gummed tape. If you don't, within a few months, tiny insects will make their way in to even the smallest of openings. Wet the tape by running a damp sponge along the lengths you cut.

Position the 'D' rings (the hooks that the cord is attached to) one third down from the top of the frame.

Always wrap your frames in 'bubblewrap', especially if you have to transport several of them at one time.

It is less expensive to buy a mitre machine that is operated by a foot pedal, but keep in mind that it can be tough going on your legs. Sometimes each 45% angle needs 5 or 6 cuts which adds up to 24 cuts per frame.

If you are going to frame a lot of pictures, buy a hydraulic connection for the mitre machine so that you can operate it by the push of a button. It will save you time and money in the long run.

Get hold of a book by Pete Bingham called *Picture Framing – a practical guide to all aspects of the art and craft*. It has everything you'll need to know.

PART 5

The Greeting Card Market

GREETING CARDS

If you compare the minuscule amount of available space in the cartoon section of any newspaper with the ever-increasing amount of greeting cards and gift products, you will understand why the card and gift industry is such a lucrative area for freelance cartoonists and illustrators.

There are thousands of greeting card publishers worldwide from giants like Hallmark to small-time sole traders working from home. There are two main types of publisher, 'wholesale' and 'direct-to-retail'.

Wholesale

Wholesale publishers produce the sort of cards you would find in a small gift shop, post office or newsagents. The designs are usually based around occasions and are geared towards a mass market. Very often they will carry a message or verse and will generally have a traditional feel; flowers, scenes, cute teddy bears, ponies, horses, etc., nothing too risque or obscure.

To save space, wholesale cards are displayed in such a way that only the top third of the card is visible so this is the most important part of the card from a design perspective.

Direct-to-retail

Direct-to-retail publishers produce the more 'contemporary', 'off-beat' card ranges that you might find in specialist card shops. Each range – usually around eight cards – has a separate design theme. You will often see successful ranges mimicked by rival companies. Most of the ranges are blank inside with the caption or joke – sometimes relating to an occasion – on the front.

The most successful direct-to-retail cards are uncomplicated, 'to the point', 'hip', trendy, and able to fit a wide variety of sending situations.

Submitting your work

There is no standard way to present your work. My advice is simple – make sure your submission is finished to a high standard and is clear and concise. I always try to imagine myself as an ultra-busy editor reviewing *my* submission at the end of a hectic day. Would the designs inspire a closer look? Would the presentation be easy-going for a muddled, tired mind?

In saying that – I submitted about *fifty* designs to begin with and it actually paid off, but I had each design finished to very high quality on a computer and then I printed about ten designs per A4 page so it was easy to see everything quickly and only on five pages, (look at how well 16 cards reproduced on page 82). I didn't even use a folder, I just paper-clipped the pages together to save on postage. Remember – if your designs are poor, a neat, expensive folder will *not* save them and if your designs are good you won't *need* a fancy folder. Same goes for your cover letter. You aren't applying for a job, a card company won't care if you are the King of Siam, only whether your designs are good or not.

If you are new to the greeting card world and you have lots of designs and a variety of styles, by all means send everything and ask for feedback. Ask if they might be interested in seeing more samples of a particular style or if they would be interested in seeing designs for wrapping paper, mugs, calendars, plates, etc. This is another *huge* area for designers to consider. But make *sure*, if you send a lot of designs, that it only takes a minute or two to view them. If certain companies respond favourably you can then send them half a dozen designs every week or every few weeks. And always put your name and a contact number on every piece of paper in case they get separated from your cover letter.

As far as captions are concerned – I like to submit designs that are as close as possible to what I imagine the printed cards would look like. This is why a computer is so important. Even if you create your cards using traditional mediums you can scan them in to a computer, add captions or verses and print them out in glorious technicolour. This means you don't have to send original artwork or get expensive colour copies. You can literally make the card up and get a real feel for how the finished product will look.

I recently spoke with someone who has been a freelance card designer for 30 years and he told me he is finding it harder than ever to sell his work. He puts it down to too many amateur artists willing to sell their work for next to nothing but he wasn't computerised and in my mind that is a *big* drawback in this day and age.

THE MARKETS

Targeting

The usual advice is only to target companies that produce cards that are similar to your own style but, since there aren't that many 'major' card companies, it's not going to cost you much to check out companies you aren't sure about.

My policy is – send to *everyone* simultaneously. It saves time, you get a lot of feedback, more of an idea of what various companies are looking for, which ones are more 'approachable' and whether any of them liked your work or not. Why pussy-foot around sending to one or two publisher's a week when you can get it all over and done with in one go. The companies don't mind that designers do this. One publisher might like actual designs you submitted, another may like your style and offer to commission work at some later stage (if they do this remind them every few months that you are still around). You may even be lucky enough to find that everyone is fighting over the same designs. If that happens, be very open with each company, tell them that others have expressed interest and you want to see what each has to offer. Don't try to make them bid against each other – you are likely to lose *all* of them if you do that. Be nice, express that you are new to the game. Forget all about 'wheeling and dealing'. Take what you can get. You have bills to pay.

Card, gift and product companies

The first thing you have to do if you are serious about designing cards is to get hold of as many 'Artists Markets' books as you can. I'm sure every country has one. At least get the UK *Writers' and Artists Yearbook* and the US *Artists and Graphic Designers' Market*. These books contain a wealth of information about card design, lists of card and gift companies looking for freelance work, useful resources, and information about trade fairs where you can meet publishers face to face. The great thing nowadays is that most companies have an email address, so you can direct *any* company in the world to visit your online portfolio – instantly – at the click of a mouse.

It *is* a good idea to physically check out the cards in the shops, not only to find addresses of companies but to get a better feel for which cards are in vogue. I actually asked several card shops would they mind if I photographed some of the ranges of cards on display with a digital camera and they were all very obliging. I took note of the various card companies and then printed out the results to use as reference. You can also find lists of addresses by typing 'Greeting Card Companies' into a search engine on the Internet. The Greeting Card Association has a list of members willing to receive freelance work (for address see page 139).

But remember, again, if your work is poor, it won't matter if there are a *million* card companies out there. Concentrate most of your effort on improving the quality of your work, not on compiling groovy submission packages. I talk from experience – trust me – I have the rejection letters to prove it!

Payment & Copyright

Most publishers pay a flat fee for the rights to use your design for a specific period of, say, three years. But it can vary, sometimes they will offer to pay a small fee *plus* a small royalty. They might even offer just to pay a royalty. If you are new to the industry you really have to take what you are offered. Make sure you sign a contract, retain the copyright of the design and hold on to the actual artwork. Read the contract carefully but don't get on like Perry Mason if you can avoid it – you'll just put editors off you.

E-cards

I keep reading that the e-card market is huge, the turnover is incredible and the demand for new designs is increasing every day but I'll be damned if I can find an e-card company that wants to look at some samples. Maybe I'm just not that good at finding the relevant information. If the market *is* there I suppose the first thing to do is to build an online portfolio. Then email your site's address to every e-card site you can find and also to the websites of 'traditional' card companies. Its easy enough to find the sites, getting them to respond is another matter.

In *Artists and Graphic Designers Market* – Terri See states that 'due to the explosion of animated e-card content … designers with quality conceptual skills combined with proficiency in Flash animation will have a tremendous advantage'. Better make room on your bookshelf for that six-thousand-page manual on 'Flash'!

SENDING SITUATIONS

First check the market thoroughly. Look at every card in print, the humour, the colours, the styling, the size, the shape, 2D cards 3D cards, occasional, off-beat, traditional, cute, juvenile...

Don't stray too far from your own preferred style, but don't be afraid to try all types of sending situations from adult humour to children's birthday cards. You'll never know unless you try. I know I wasted a lot of time trying to mimic *only* specific card ranges that I liked in the shops. I am now more willing to have a go at any corner of the market (huge credit card bills being partly to blame).

The quickest way to learn the trade is to do hundreds of roughs and pick the best 20 or 30. Finish them off to a high standard, send them off and get some feedback. Then do another hundred roughs and pick the best 20 or 30 of *them*. Don't even worry about making sales to begin with. Invest in yourself by spending time learning your craft.

Writing gags for cards

Read up (in my first book – *The Cartoonist's Workbook*) on how to write gags and then make a list of every sending situation imaginable. The list below should help you get started.

Then start expanding on each situation. Write down everything you can think of to do with each situation. Just make lists to begin with. If a joke comes to mind, fine, but don't worry at this stage. Once you have your first list you then start to expand on *that*, as well as keeping in mind that you want to think more and more 'humorously'.

Sending Situations

Christmas	Mum/Dad/Son/Daughter	Anniversary	(USA)
Easter	Brother/Sister	Engagement	Thanksgiving
Valentine's Day	Auntie	Wedding Day	Jewish New Year
Mother's Day	Uncle	Silver Wedding	Hanukkah
Father's Day	Brother/Sister-in-law	Ruby Wedding	Sweetest Day
Graduation	Daughter/Son-in-law	Golden Wedding	Passover
Halloween	Mother/Father-in-law	Diamond Wedding	Secretary's Day
St Patrick's Day	Grandson	Christening	National Boss's Day
Birthday	Granddaughter	Retirement	Nurses' Day
Eighteenth	Grandma	Driving Test	
Twenty First	Grandad	Good Luck	
Thirtieth	Grandparents Day	Get Well	
40/50/60/70 etc.	Wife	The one I love	
1 today ('You are 1')	Husband	Retirement	
2 Today/3 Today etc.	Nephew	Leaving	
Thank You	Niece	New House	
Sorry	Friend	New Job	
Sympathy	Boyfriend	Missing you	
Congratulations	Girlfriend	Passing Exams	

FINDING GAGS

Expanding on your list of sending situations

For example – CHRISTMAS CARDS

LIST 1	Expand	Expand again	Expand AGAIN
Santa	Santa in chimney	Santa gets stuck	Do lots of doodles, sketches – scribble down anything that comes to mind
Presents	Santa on sleigh	Santa Claustrophobia	
Turkey	Santa's little helpers	Santa gets drunk	
Sleigh Bells	The north pole	Santa forgets	
Crackers	Etc., Etc., Etc …	Etc., Etc., Etc …	Just keep doing this and you can't *fail* to come up with ideas eventually.
Snow			
Rudolph	Presents round a tree	Awful presents	
Mistletoe	Santa leaving presents	HUGE presents, tiny presents	
Scrooge	Kids opening presents	Poor people's presents	
Stockings	Etc., Etc., Etc …	Rich people's presents	
Yule Tide		Etc., Etc., Etc …	
Carols	Carving the Turkey		
Xmas TV	Burning the Turkey	Stupid Turkey can't wait for Christmas	
Xmas pudding	Stuffing the Turkey	What Turkeys eat for Christmas	
Xmas trees	Etc., Etc., Etc …	Etc., Etc., Etc …	
Etc., Etc., Etc …			

One idea may even spark off a 'Range' of cards

A GREETING CARD DISASTER

My first foray into the greeting card market was several years ago when I submitted about 50 ideas to over 20 card companies simultaneously.

The response was very encouraging. Several companies expressed interest in my style and told me that they would like to work with me in the future. (None of them got back to me by the way – which goes to show that you *do* have to remind people of your existence from time to time).

One major company not only liked my style but offered to take 28 of the designs I submitted. They wanted to buy the copyright for three years at a flat fee for each card. Obviously I was over the moon. While I was preparing the designs for publication the company contacted me again and said they wanted to take another 14 designs which made 42 in total. I had to pinch myself.

It was at this stage that I had my first taste of the wheeling and dealing that goes on. They told me that they wanted to change the terms of the deal. They wanted to pay me half the fee up front and the other half *if* the cards passed their marketing test (they place the cards in 100 selected shops and see how well they do). If sales were poor then the range would be dropped and the copyright of the cards would belong to me again but I would lose the other half of the fee. To be honest I was just glad to be getting *half* the fee – I had bills to pay.

It was nerve-wracking drawing up the 42 designs. They wanted a full range but split into different categories – computers, sci-fi, famous quotes, films, malaprops. and 'general' humour. The reason I got nervous was that I myself felt that the range was too big and too abstract. I had submitted a lot of designs hoping that someone would see one or two ranges in amongst them, not six ranges in one go.

Finally the big test came and the range failed miserably. Strangely the editor who commissioned the designs left the company just before the bad news came in. I got paid my half fee but was gutted that my cards were not going to be in all the high street shops, as I had desperately hoped.

So WHY didn't they work??

They sent me two boxes of the cards and the laughable thing is whenever I need a card for some occasion I can *never* find a suitable one. They are just too one directional, too off-beat, I think I had only one card that said 'happy birthday' on it. The chances of 8 out of 10 people finding a card that would suit their Auntie Jean, their Mum, or their sister, was too remote.

This is why I warn people to stick to 'occasion' cards to begin with. It's a safer bet. I know that the off-beat ranges look great but I reckon you stand a greater chance of making a sale if you submit designs that will suit some occasion or other.

I have reprinted 32 of the cards on pages 82 and 83. Unfortunately I can't show them in glorious techni-colour so you'll have to use your imagination. See if you can figure out yourself why they failed. I still believe that individually most of the designs are clever enough but collectively they fell apart. Another strange thing is that, because they chose *so* many themes, they didn't have enough of several of the themes for people to make a decent selection. For instance, I would have preferred a big range of 'film' cards rather than 5 or 6 in amongst 42 widely diverse cards. The same goes for the quotes and the malaprops.

I had to design logos for each 'theme' – to go on the back of the cards. Keep in mind that you may have to do this at some stage if you develop a full range of cards. All the designs were linked by the overall title 'Foggy Notions'.

ILLUSTRATED BY ROBIN HALL

ILLUSTRATED BY ROBIN HALL

ILLUSTRATED BY ROBIN HALL

ILLUSTRATED BY ROBIN HALL

ILLUSTRATED BY ROBIN HALL

ILLUSTRATED BY ROBIN HALL

ILLUSTRATED BY ROBIN HALL

THE CARDS THAT FAILED THE TEST

 RESERVOIR HOGS

 SILENCE OF THE CLAMS

 STAR WARTS

 PUP FICTION

 "The best way to a man's heart is through his chest" — Roseanne Barr

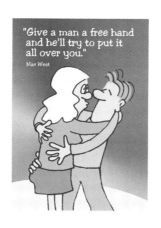 "Give a man a free hand and he'll try to put it all over you." — Mae West

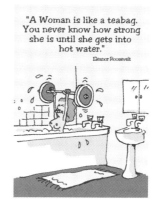 "A Woman is like a teabag. You never know how strong she is until she gets into hot water." — Eleanor Roosevelt

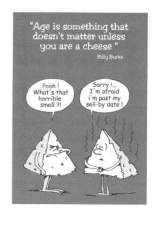 "Age is something that doesn't matter unless you are a cheese" — Billy Burks

 Nine Stone Cowboy

 Knights in Black Satin

 No Woman No Fry

 Strangers in my Tights

 SLAPHEAD

 MOVIE BUFF

 POT HEAD

 BEACH BUMS

WORKING PRACTICE

One of the Companies that *did* express an interest in my first ever submission was Card Connection. They didn't like any specific designs but liked my 'style', particularly my cat and dog characters. They asked would I send them some new Birthday Card ideas using these characters. They said that about eight roughs would do at this stage. First of all I scribbled and sketched down everything that came into my mind to do with birthdays, these are only a few of the pages.

I then did 12 ideas as 'half finished' roughs and sent them off to Card Connection.

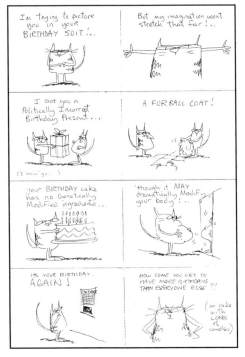

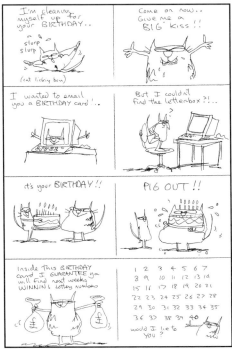

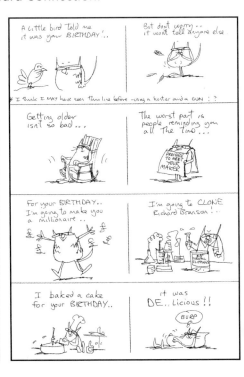

They picked two of the ideas and it was then just a matter of doing the finished artwork in Photoshop.

1. First of all I tidied up the drawings by using a lightbox. I then scanned them into the computer, gave them appropriate names and saved them as TIFF files. I made sure that the resolution was *very* high (see page 46).
2. I asked the designer at the card company what exact size and resolution they required. In this case the card size was 14 x 19 cm by 300 dpi. I had to allow 3 mm all around for 'bleed-off'.
3. I opened a new page in Photoshop and made it 14.6 x 19.6 cm in CMYK mode.
4. Then I opened the first drawing, made a selection around it and dragged it over onto the new page. This put it on a separate layer. Then I resized the image by going to EDIT – FREE TRANSFORM (don't forget to hold down the shift key as you

resize to maintain the proportions of the image). I then flattened the image.

5. To colour it I used the paint bucket tool on the cat. Then I made a selection around the cat which I angled by going to SELECT – TRANSFORM SELECTION. I filled the area between the cat and selection with Yellow using the paint bucket and finally I filled the surrounding area with blue.
6. I then added yellow type – using the font 'Comic Sans'.

I used a similar process for the two cards, both inside and out, and sent the digital artwork off to the card company on a CD ROM. A few weeks later they sent me samples of the finished cards.

 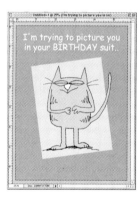

| *4. Resize* | *5. Transform selection* | *Colour selection* | *Colour surround* | *6. Add Lettering* |

| *Front* | *Inside* | *Front* | *Inside* |

GREETING CARD WRITING

The Essentials of Greeting Card Writing or 'W.I.S.H.' (write it short honey)

Greeting card writing is one of the most exciting, lucrative and just plain fun writing genres around today, however, just as in anything else, there are some definite things to keep in mind.

First, don't quit your day job. Card writing, at least initially, is a supplemental income with the writer having a work-for-hire relationship with companies. As in anything freelance, you get paid per verse sold – no extra cash for hours spent trying.

Second, just because you write 'poetry', don't think you can write greeting cards. Yes, there are some companies that take rhymed, metered verse from freelance people, but the focus of today's cards is on the conversational, down-to-earth 'voice', whether humorous or heartfelt, soft prose. Notice I use the word 'voice' rather than the more conventional 'style'. That's because today's greeting cards are all about one person communicating with another; the most successfully written cards today are those that sound as if a person is talking. Also, poetry's essence tends to be introspective; in other words, 'about me'. This is exactly the opposite of the greeting card's essential 'me-to-you' message.

Now that I've told you a couple of the 'don'ts', let me tell you about the many 'do's'. The competition here is much less than in other writing genres. That's because most people don't have a clue who to submit to or how to submit their work. One of the most pleasant surprises people discover is that there are a multitude of mid-size and small greeting card companies – some of which are 100% freelance written and most of which are not known to the general public. In some cases, a writer is competing against five or six other writers – instead of the thousands of writers who submit to the big greeting card kids on the block.

And how do you go about finding these lesser-known companies? First, use the method I use myself – the old 'pound the pavement'. You'll be surprised at the variety of stores that carry greeting cards – florists, pet stores, gift boutiques, drug stores, book stores, stationery shops, convenience (one-stop) shops, to name a few. Always turn the card over, noting the company name. Some even have their postal address on the back; today, most have a website address as well. Write to these companies asking if they accept freelance work and if so, to send you a copy of their writer's guidelines. (If writing via snail mail, always include a long, self-addressed, stamped envelope for a reply.)

Another great method of discovering unknown card companies is something that wasn't available to me back in 1986. Plug in 'greeting card companies' in your search engine and you'll be overwhelmed at what comes up. Keep your request for freelance guidelines short and to-the-point (All websites have a 'Contact Us' icon. Use it!) and send them out *en masse*. Believe me, you'll hit pay dirt sooner than you think!

Besides submitting to lesser-known companies, a successful greeting-card writer must 'think – and write – short'! Obscure, esoteric or long-winded narratives simply don't cut it. A writer must always keep in mind 'rack impact' – that second-and-a-half that each card has to catch the reader's attention. Why does a writer have to know such things? Because every editor knows such things – and judges each writer's work by standards such as 'rack impact'.

The focus of greeting cards has changed over the years in specific ways; not only in the text, but the visuals too. With the advent of e-greetings and 3-D cards, whole new markets are available as never before. Greeting card sales statistics show a steady rise – through good times and bad – since 1943, when records were first kept.

I can't say enough good things about greeting card writing. I still love it after more than a decade and a half. I've met creative, exciting people because of it – not only writers, but artists, photographers, publishers. Writing greeting cards has developed my writing skills and these have spilled over into other genres as well.

Sandra Miller-Louden *has been writing greeting cards professionally since 1986. Her work won a Louie – the industry's highest honour – in 1991 and was nominated again in 1992. Sandra's definitive book,* Write Well & Sell: Greeting Cards, *has been praised as 'high quality, no fluff guide … not just a quick read [but] a workbook with plenty of exercises to open up your thinking' by Suite101.com.* Visit Sandra's new website www.greetingcardwriting.com (www.sandralouden.com) for more information about her books and writing classes or contact Sandra directly at sandra@greetingcardwriting.com

PRO TIPS – ANNE CAIN
A HOME GREETING CARD BUSINESS

Anne Cain – 'Grass Roots' Greeting Card Designer and Seller
Anne Cain lives in Sussex in England. She wrote to me and explained how she designs and sells her own greeting cards. What amazed me most was the train of events that followed her first putting her cards out into the market place. Talk about 'casting your bread on the waters'. I know its all the rage to 'think big' but sometimes it pays more to stay closer to home.

This is what she had to say...

'When the time arrived when I thought my cards were perhaps good enough to sell I had to find people who were perhaps good enough to buy them. Luckily, in our village, we have a thriving W.I. (Women's Institute) weekly market. I very tentatively took my cards in to show them - and I haven't looked back - and that was 10 years ago - it's only open for one and a quarter hours every week and I usually sell about 10 to 25 each week.

I then offered to personalise special orders and I got asked to do "something special with ribbons on" for "DEAR AUNTIE FLO - WITH OUR LOVE ON YOUR 90th BIRTHDAY". I have had 415 orders in the last 14 months. I sell at the huge South of England Show every June and do very well. Amusing cards sell like hot cakes. I cut out all my designs and raise them up into a 3-D effect and SO many people have said "Oh ... these are so different ... I'll have a few!"

I also use Rubber Stamp impressions. My favourites are of the "Peanuts" characters (Snoopy and the gang). They are copyright of course, but I obtained written permission to use them and sell the resulting cards. There is a lot of money to be made designing for the big stamp companies. Some of them in the catalogues are AWFUL. I have been asked to submit a few of my drawings to a local company but I don't think they are good enough yet - although when I look at some of the horrors in the catalogues I'm not sure.

I always trawl through *Crafts Beautiful* Magazine, and there I found a couple in my area, advertising for Handmade Crafts and Cards for their new little shop - they charge a small weekly fee, but the shop is in a holiday spot, so sales should be good. They and their daughter also take their crafts round lots of school fetes and Open Days, Horse Shows, Farmers Markets, etc. Fortunately my cards sold very well and since then the couple arrive at my house periodically and take 100 at a time. They pay me what I ask and then put on as much as they think people will pay, as their cut. Their daughter works in a big hotel, in charge of the fitness centre - she took 60 of my Christmas cards in, sold the lot and has just ordered 50 Easter cards.

So really, it just grows. Show people what you do, read the craft mags and try to make your product just that bit different to anyone else's. Above all, enjoy what you're doing and always ... ALWAYS ... make sure that your work is immaculate and really well packaged and priced. Customers will pay that bit extra for an appealing, eyecatching and well presented product. I recently took my cards to a craft fair and next to me was somebody doing the same. She told me that she always buys the cheapest blank cards and envelopes and doesn't bother with see through bags, thereby cutting her costs (her's were a good bit cheaper than mine). At the end of the day I had sold 140 cards and she had sold 15. It just shows that customers do NOT always go for the cheaper option ... '

PART 6

Syndication

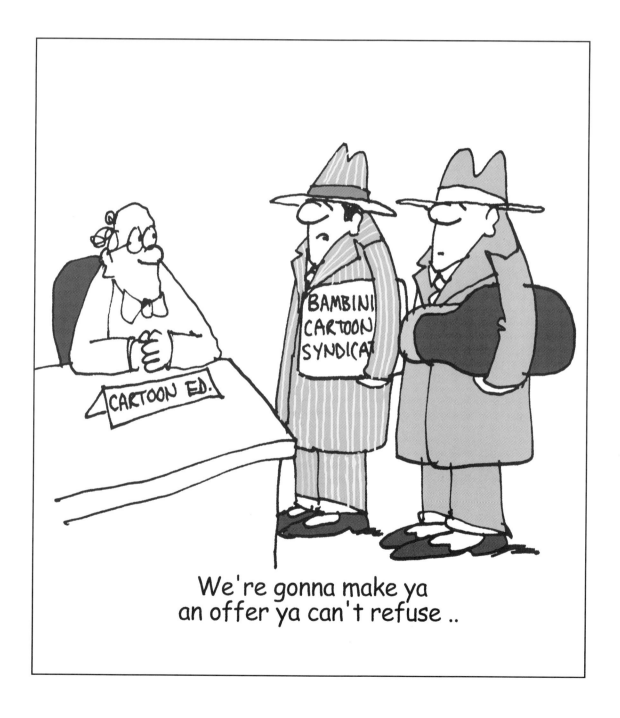

SYNDICATION

Be Realistic

Most cartoon strip artists dream that one day they'll be snapped up by one of the major syndicates who will turn them into the next Charles Schulz, Bill Waterson or Gary Larson.

But what are the odds of that *actually* happening. King Features receives over six *thousand* submissions a year of which they'll pick two or three, so only 0.05% of aspiring cartoonists become syndicated. You have just as much chance of winning the lottery!

I don't want to put you off trying, but be realistic about the likelihood of success. I could be positive and say – 'If your work is good enough you'll make it…' but to be honest there are a *lot* of great strips being submitted – the sad fact is, most of you *won't* be accepted.

Try the major syndicates – you have nothing to lose – but don't pin all your hopes on them. Get your work out anywhere you can – get *any* experience you can. I once submitted a strip to a UK national magazine thinking it was a 'weekly'. They told me they would like to run the strip but pointed out that they were actually a *monthly* magazine which appeared once a month inside a weekly newspaper. I didn't want to spread my weekly cartoons so thinly so I told them I would get back to them. Luckily my UK agent Peter Knight (who was handling another of my strips) told me not to be an idiot – that I should *never* turn down work and should accept their offer. So that's what I did. From that one strip the magazine ran an article about me. I then got another strip into the weekly paper which ran for four years at very good money. (They eventually dropped the strip because The Guide Dogs For The Blind offered them a *free* cartoon strip. Who says charity is a good thing!) So trust me, even if the local church bulletin offers you a spot – *take it* – you never know where it might lead.

Where to begin

First off – get hold of a book called *Successful Syndication* by Michael Sedge which covers everything in a lot more detail. It contains a comprehensive listing of American syndication agencies as well as the major syndicates submission guidelines and sample contracts. You can also check out submission guidelines at the following website –www.reuben.org/syndicate.asp

Always begin with the major syndicates and work your way down. Jim Toomey, creator of 'Sherman's Lagoon' (King Features) warns 'go with a major syndicate like King, UPS, or UM. Don't mess with the others – they are not capable of taking a strip big. A lot rides on how well your syndicate launches it.'

I know what he means! I had a strip with a UK syndicate for two years and *nothing* came of it –

Submitting your work

Most of the syndicate submission guidelines will tell you exactly how to submit your work. Keep in mind that a brilliant cover letter or nifty folder will *not* make up for a bad cartoon strip so don't spend more time on this than on your jokes. Get your priorities right. Even if your drawing is brilliant, if your jokes suck, you've no chance. Jokes first, drawings second, submission package third.

Also, send your work to all the major syndicates simultaneously. I made the mistake of sending to one at a time and had to wait weeks (sometimes *months*) for news (rejection slips) each time. Let's face it if *any* of the majors are interested you'll be overjoyed. The syndicates do not mind *at all* if you send out simultaneous, multiple submissions but if you do this, mention it briefly in your cover letters.

Work out who your target audience is

Try to come up with ideas that will appeal to a mass audience. Don't create for editors, create for newspaper readers – *they* are your market. Even if your jokes don't appeal to the editor's tastes, if you can convince him/her that your strip will appeal to a *huge* market and won't clash with other strips then they may be more interested.

Check your market place

Check out what strips a syndicate runs and if any of them resembles your strip the chances are they won't consider it. It wouldn't make sense for them to sell two strips that compete with one another.

I submitted a strip to King Features which they were interested in, but they asked me could I 'get rid of' the dog character because they already *had* a strip with a cat and dog like mine.

Problem is, if you try to be *too* original, you may just come up with ideas that have *no* mass appeal. Try to contain your originality *within* the safe

boundaries of a popular theme. More importantly, make sure you actually *enjoy* the topic or theme of your strip. You may have to live with it for a very long time.

Michael Sedge writes' … cartoon editors are advising artists to avoid cavemen (*à la* 'B.C.'), animals ('Garfield', 'Mother Goose and Grimm', 'Sherman's Lagoon', 'Shoe'), children ('Adam', 'Calvin & Hobbes', 'Peanuts', 'The Family Circus'), historical topics ('Hagar the Horrible', 'Prince Valiant', 'The wizard of Id') and military topics ('Beetle Bailey'). So, you might ask, what's left?…'

Become a plumber, that's what's left. But seriously, think long and hard before you waste two years working up a strip that editors will feel is too similar to ones already in print.

If you know in your heart that your strip or panel is basically a variation on 'Dilbert' or 'Garfield' then get back to the drawing board. It takes a lot of courage to shelve your pride and joy and start over but sometimes it has to be done.

Can you handle one strip a day for the next twenty years?

The fantasy is that cartoonists wake up around 10am, have their breakfast, read the funny section in the morning paper, play with the dog, do their cartoon and then go and play a round of golf before lunch time.

The reality is, some days you just don't feel like being funny or everyday life gets in the way, so work builds up, deadlines loom, eventually you have 30 strips to do and two weeks to do them, you get panicky, this blocks the creative flow, more work builds up, you stop going out, forget about golf, forget about sleeping, forget about your sanity, AAAARRGGH!

I am *not* kidding. This is exactly what happens to me *every* time I put together an exhibition of paintings. The plan is – 2 exhibitions a year – 50 paintings in each = 2 paintings a week – no problem, right? Wrong! Two weeks before an exhibition I usually have 20 paintings to finish off and quality often goes out of the window. Right

now I'm wondering if I can handle even *one* exhibition a year and retain my sanity.

Try and place your work into a local daily or weekly publication first of all to see if you can handle the pressure – if not – no harm done.

It's a funny old business

My own experience with syndicates is as follows. At one time I had three major syndicates interested in my work. King Features asked me for more samples then suggested I get rid of the dog in the strip and change the main character from an old man to a young woman. At the time it was like asking me to wipe out my family.

The Washington Post Writer's Group kept me dangling in mid air for months – I really and truly thought they were going to sign me up. Stupidly, I overworked the strip when they asked for more samples and this put them off (I had my house in Beverley Hills all picked out in my mind – what a let down).

Then Tribune Media Services told me that one of my strips was in a shortlist of 15 picked for review out of a few thousand – but in the end they went for a strip to do with food – so that cooked *my* goose! Later on, King Features expressed interest in another strip so I sent more samples only to get them back a few weeks later with the usual rejection letter – no mention of anything else!

So, did I learn anything from all these near misses? Well, foremost, I learned that the sun still shines, but I also learned that there was more to it than a few dozen slick jokes and a fancy submission package.

These guys are seriously 'picky' – that's their *job*. Do yourself a big favour, take a long hard look at your work and if you know in your heart that it isn't as good as the strips in the papers, don't waste time sending it out. Work at it until it can compete with the big guns. Otherwise, you'll waste years living in hope only to wake up one day to the fact that you have bills to pay and King Features or United Media aren't going to send you a cheque.

SELF SYNDICATION

Is self syndication a viable option?

Jeff Danziger an editorial cartoonist with Tribune Media Services, had this to say about syndication. 'I don't know that I have any reliable tips on getting syndicated because the business is changing so much. Syndicates do three things. They distribute the work, they collect the money, and they sell to new customers. Anyone who can afford a computer can do the first two things without cost to themselves through the internet. That leaves sales. And syndicates have very few salesmen left. No one wants to do the job. Thus you are left doing the selling yourself …

… Now, how you go about planning your life in this new environment is a mystery. It might be better to self-syndicate and just work at it than to rely on a syndicate. If you think that there is some cachet to being a syndicate, just write Worldwide Amalgamated Syndicate under your name, and there you go. The selling is a little hard because it involves rejection, and this is particularly hard if it's your own work. But if you can get used to the process, you make some progress. In any case, the time you spend self-selling gives you a much better idea of why things, including your work, are or are not selling. Otherwise you have to rely on some salesman giving you his interpretation of what they want … '

Where to begin?

The Package

First of all put together a professional-looking package. Remember that you are competing with the likes of King Features. With home desktop publishing technology there is no reason why you can't put together a package that looks as if it comes from a reliable, professional source. Put yourself in the editor's shoes. What type of package would impress *you*? What would make *you* want to buy 'your' feature? Ask a local newspaper would they mind if you used their address to receive a sample package from one of the big syndicates.

The Pricing

Pricing is based on newspaper circulation. Pretend you are a potential customer and phone up other syndicates and ask for quotes. Tell them you are the cartoon editor of 'The Daily Whatever'. Pick a variety of papers that have different circulation figures – from regionals under 100,000 up to nationals over 500,000. Or just ask a variety of newspapers what they pay for their features. Tell them you are a student working on your dissertation. You could also check out prices at the syndicate websites. Try to keep your pricing in line with everyone else but make sure you have it *well* worked out. You don't want to sound like you're making it up as you go along.

The market

Then work out which market you are going to target. For instance there are a *lot* more regional papers than there are national so even though they don't pay as much if you get your work into a good number of them then collectively you could make a reasonable income.

If you *do* try the regionals, assure the editors that no other papers within their distribution area will be offered the same feature. The *only* reason newspapers want your feature is to attract more readers. If every competing paper had the same strip then it wouldn't work as a sales device.

What about self syndication via the internet?

'Of those editors interviewed, 98 percent said that the initial approach should be a package mailed directly to their office.' (Michael Sedge, *Successful Syndication*)

If the downloading of large email files ever becomes instantaneous, then – and *only* then – might it be a good idea to send lots of samples of your work to editors via email. But as things are, I would doubt that any editor would be too pleased if they received a huge email that took 20 minutes to download. It would go straight in the electronic *bin*. If you are considering self syndication via the internet perhaps the most subtle and acceptable way would be to send one *very* low resolution strip or panel as a 'taster' along with a link to your beautifully-crafted and professional looking website. Make sure the link takes them *straight* to the relevant samples and not to the photos of your pet tarantula. More importantly – make sure your images download in the fastest possible time. Editors are always 'busy, busy, busy'. Or, if you were sending your work to hundreds of papers you could cut down on postage by sending a 'mailing shot', for example a postcard with your best gag on it, with a website address for more samples. The more original and eye-catching your mail-shot the better.

Start your own online cartoon service

A lot of cartoonists are selling their work from their own websites to other websites. There are a lot of text-ridden websites out in cyberspace that need cartoons to brighten them up so this is a *very* good market to explore. Check out the following sites to see how the pros are doing it.

www.glasbergen.com
Randy Glasbergen's cartoon service. 'Cartoons for newsletters, business communications, websites and more. Featuring business cartoons, computer cartoons, medical cartoons, and more.'

www.tedgoff.com/
Business and safety cartoons by Ted Goff. 'Hundreds of business cartoons searchable by keyword or topic. A great tool for editors, graphic designers and presentation givers.'

www.bobstaake.com/
Humorous illustrations, cartoons and digital art for purchase.

You can either contact online newspaper editors by email and direct them to your website or get your site listed in the search engines so that *any* website that wants cartoons can find your service.

Obviously, it is important that your website is well-designed, fast to download and easy to navigate but *more* important is letting potential customers know it exists. You need to study up on bringing traffic to your site. If your site isn't coming up in the top ten in the search engines you'll lose a lot of customers.

If you get someone to design your site make sure they know about this side of things or get a good book on how to increase web traffic. There isn't much point having a good site if no one ever visits it.

Web agencies

If you don't have the 'know-how' to sell your own gags to websites you can always submit your work to one of the various cartoon web agencies that are springing up like www.cartoonstock.co.uk

But be warned, these agencies have *thousands* of cartoons to sell. So while the agency makes money from each sale, individual cartoonists have to wait for *their* cartoon to sell. If you give Cartoonstock 30 gags, these get added to the thousands of good gags from other cartoonists and the odds go way down that *yours* will be sold.

I'm not saying that it's a bad idea to submit to such agencies – every little bit helps – just don't put a deposit down on a new Ferrari on the strength of it.

Start your *own* agency – that way you have a better chance of making real money. But don't even think about it unless you intend to do it professionally and are prepared to invest a lot of money to start off. Homemade websites are easy to spot and are unlikely to bring you in a decent wage.

Online Syndicates

There are also online syndicates that work the same way as the conventional syndicates. You submit work to them and if they like what they see they 'sign you up' and like traditional syndicates their commission is 50%. The biggest at the minute is 'iSyndicate' who have a Self Syndication program. (Find out more at their website – www.isyndicate.com)

Also check www.dmoz.org/arts/comics/online/syndicates/ for a list of online syndicates.

Whatever way you decide to submit or sell your work you will need a list of newspapers and editors. There are a variety of sources

Mailing lists online

www.gebbieinc.com
Here you can buy a mailing list with names, addresses (email and postal) and phone numbers of editors.

www.owt.com/dircon/
Email directory for newspapers and other media.

www.mediareport.com/newspaper/newspaper.html
Newspaper listings with phone numbers, fax and email addresses.

www.start4all.com/newsp.htm
Links to thousands of newspapers worldwide.

www.onlinenewspapers.com
Thousands of worldwide online newspapers.

www.etoon.com/newspapers.htm
Huge list of US papers.

Useful publications

Artist's & Graphic Designer's Market 2000
Writer's Digest Books

SYNDICATION RESOURCES

Your Career in Comics
Lee Nording (Andrews McMeel)
Available from the Newspaper Features Council
203-661 – 3386

Editor & Publisher International Yearbook
(appendix E)
Names, addresses (email and postal) and phone numbers. Check out www.editorandpublisher.com for more details. Once you make a few sales you qualify for a free listing in Editor & Publisher's annual syndication directory.

Editor & Publisher Magazine
This is a weekly magazine that carries syndicate advertisements. It has a readership of 80,000 editorial buyers so it could well be worth your while to take out an ad.
www.mediainfo.com/ephome/index/unihtm/home.html

Newspaper Editor E-mail Directory
800+ email addresses of US newspaper editors and some international ones.
Order online at
www.writersmarkets.com/index-orderform.htm

Syndicates E-mail Directory
A list of 100 syndicates worldwide
Order online at
www.writersmarkets.com/index-orderform.htm

Syndicates and agencies
www.dmoz.org/arts/comics/online/syndicates/
List of online syndicates.

www.isyndicate.com
One of the most high-profile syndicates online.

www.cartoonstock.com/links-pages.html
An online agency and database of cartoonists whose work is for sale. Lots of links to other cartoon resources.

www.reuben.org/syndicate.asp
Syndicate submission guidelines.

Syndicate Addresses

Cartoonists and Writers Syndicate
67 Riverside Drive, Suite 1D
New York, NY 10024
Tel: 212-CARTOON
www.cartoonweb.com/aboutcws/

Creator's Syndicate
5777 West Century Blvd. Suite 700
Los Angeles, CA 90045
Tel: 310-337-7003
www.creators.com

King Features Syndicate
888 Seventh Avenue
2nd Floor
New York, NY 10019
Tel: 212-455-4000
www.kingfeatures.com

Los Angeles Times Syndicate
218 South Spring Street
Los Angeles, CA 90012
Tel: 213-237-7987
www.lats.com

Tribune Media Services
435 N. Michigan Ave. Suite 1400
Chicago, IL 60611
Tel: 312-222-4444
www.tms.tribune.com

Universal Press Syndicate
4520 Main Street
Kansas City, MO 64111-7701
Tel: 816- 932-6600
www.uexpress.com

United Media
(United Feature Syndicate/NEA)
200 Madison Avenue, 4th Floor
New York, NY, 10016
Tel: 212-293-8500
www.unitedmedia.com

The Washington Post Writers Group
1150 NW 15th Street
Washington, D.C. 20071-9200
www.washingtonpost.com/wp-dyn/style/comics/

SYNDICATED CARTOONISTS – USA

Tony Cochran –
Agnes (Creators Syndicate)

I had no idea how difficult it was to get syndicated, because it was not that difficult for me. I know that will make me an object of scorn with many. But hear me out. By not knowing how daunting the task was, I entered the fray with a full head of stupidity. I had never submitted a strip before and had never really professionally cartooned before. Looking back now at the quality of my submission, it's a wonder anyone took them seriously. The drawing was poor, the lettering was poorer, and the jokes (or writing) strange. I know now that what I did have was a strong character named Agnes.

As she developed her voice she became even stronger. That would be my best advice. You can get better at writing, improve your drawing, and polish your lettering. But the most important thing is the character of your creation. Make sure you care about your character. After all, you're counting on millions of people to care about him / her / it too. They won't care if you don't care.

Syndication is not the ultimate end all. Many strips die a slow horrible death even after a spirited launch. The sales people may not like it. Newspaper editors may not like it. And even after you convince the sales people and enough editors to create a serviceable income, the newspaper comic readers may not like it. That's when you die. The strip, that is. You could combat this by continually lowering your standards on humour until you have something that darn near everyone will 'get'. Homogenise it. Tame it down. Don't offend anyone. Remove all controversy. Eliminate any diversity. But, personally, I would rather not do a strip than pander to the lowest common denominator. There will always be that temptation to try to appeal to a broader readership when sales are slow and fan mail gets sporadic. I think I can hold out.

Avoid coarseness, vulgarity, and profanity. This is not the television medium. There are just some things people do not want to read in the comics. They are barraged by these things on radio, television, CDs, the Internet, and in conversation all day long. They deserve at least one place where humour and insight are not derived from shock words that don't really shock anyone anymore. Offer them an odd turn of phrase or a twisted thought instead. That will draw them in instead of repelling them.

A relationship with a syndicate is like a marriage in a way. The syndicate is the partner who can pick and choose and is in no hurry to commit. The cartoonist is a desperate, eager to please hopeful who wants a full church wedding and 12 kids no matter what. When a pair like this gets married, real life settles in real fast. The cartoonist assumes that his / her strip will catch on like runny noses in a day care centre, and it will be six months, tops, before they are on Oprah discussing their compilation book. The syndicate knows that this is as rare as hen molars and tends to go toward the slow build. The cartoonist blames slow sales on bad sales people. And sales people blame slow sales on bad product or obstinate editors. The truth is somewhere in the middle. Try to keep an open mind. Concentrate on your product. Make it irresistible. Sales people can sometimes sell inferior product, but they can't make people keep it. One final thought. It's your dream; it can happen. But it's a huge commitment even after you wake up.

Pretend you have the job. Do it for a year as if you're being paid. Do it for two years, three. Picasso asked Braque once 'If you knew you would never be famous, would you still paint?' Braque said that he would. To have that kind of passion is the greatest reward.

Agnes by Tony Cochran

DILBERT *by Scott Adams*

Scott Adams –

'Dilbert' (United Media)

The big mistake virtually all unsuccessful cartoonists make, including me in the beginning, is to assume that the general public shares their love of witty gags. People hate witty gags. Successful cartoons are about the things that people are thinking and feeling in their own lives. No one is impressed by a cartoonist who can make a clever pun about a lamp or a doorknob. Nor does anyone care about the cartoonist's life and travails unless they coincidentally match their own.

Bill Holbrook –

'On the Fasttrack' (King Features) 'Kevin and Kell' (Self-Syndicated)

When I was 23, Charles Schulz gave me the following advice: sit down and draw fifty strips. Of those, maybe five will be funny. Build on those and throw out the rest. Do fifty more. Now perhaps ten will be usable. Repeat this process again and again.

Leigh Rubin –

'Rubes' (Creators Syndicate)

Boy do I wish I had some juicy secrets to share on how to get syndicated. The truth is, at least as far as I'm concerned, you have to be consistently good and be very, very persistent. In other words, don't take no for an answer. Believe me, I had 'no' said to me way more than 'yes'. Eventually the one BIG 'yes' came from Creators Syndicate. I was rejected by all the other major syndicates in the country. Even Creators turned me down the first time I submitted stuff to them. Aspiring cartoonists should try to get published in their local paper first. That's what I did. Then they can use that as a starting point to show the syndicates that they're serious about their work and that they can make deadlines.

As far as what syndicates are looking for? I don't think they have a clue. Really. They just know what they like when they see it!

KEVIN AND KELL *by Bill Holbrook*

RUBES by Leigh Rubin

"Apparently, there's been a misunderstanding. I'm not lost spiritually ...I just can't find my way home."

Jeff Danziger –

Editorial Cartoonist (Tribune Media Services)

In this country (US), I think you can never go wrong by concentrating on quality. In the long run, better quality always sells over the junk. Thus I would advise to concentrate on improving in artistry, studying anatomy, caricature, perspective, media, the work of the old masters, cartoonists and painters alike, and understanding politics and culture. Most cartoonists don't think that it should be hard work because it's a lighter-than-air form of humour. But it is also an art form and a type of communication. Thus to study the mannerisms of, for instance, the human hand or the facial features might take some time, but it is worth it in the same way that a writer's study of vocabulary is. There's no Thesaurus for this; it must be in your memory.

The only other piece of advice I can think of is to get a regular job that will keep you alive during the long time it takes to get established. I taught school for 12 years until I felt I had enough business to quit and depend on my art work alone.

White House Has to Defend Its Policies Against... the Right

Susan Kelso –
Horrorscope (King Features)

What do you have to do to get published?
We hadn't realised, going into it, that the chances of getting published are about 1 in 6,000. If we had, we may not have bothered. But we didn't know what the odds were, so we just barged ahead. We knew nothing about the cartooning biz, so first we researched. We went to the library and looked up names of publishers, read books on cartooning techniques, what to prepare for submissions and how to put a package together. Then, we worked on the toon itself – developing the writing and illustration styles. Once we had our package ready, we sent it off to half a dozen of the biggest US syndicates. We got thanks but no thanks letters across the board. Then, we submitted it to the Toronto Star Syndicate in Toronto. They loved it and made us an offer right away. They later sold the idea to King Features in New York.

What kind of style should I use?
Your own – don't try to copy someone else's. Editors look for ideas and styles that are unique – there's lots of dog and cat strips out there, so if you submit one in that vein, your chances of acceptance are least likely. If you have one on a subject matter that hasn't been done before, or a really original approach to an existing concept, your chances are much better.

Are you rich?
Filthy rich. Actually, that's a lie. I've just always wanted to answer that question with that answer!! But seriously folks, most cartoonists have day jobs. Honest! The really big guys don't need a day job – they have huge followings that keep them going in hundreds, even thousands, of newspapers. The standard syndicate cut is 50%. If you get a book or merchandising deal, you would make about 3% of retail. The publisher and retailer get the rest.

Do you ever have days when you can't think of anything funny?
I have days when I can't think, period. I like to blame it on the fact that I'm in my middle years – a nice way of saying I'm a middle-aged, menopausal dipstick some days. Yeah, there are days when I panic. I research, read, listen to conversations, watch people walking or driving down the street or in the park or whatever and absolutely nothing happens. In cartoon language, I think 'YIKES!' But my brain is just in rest mode for a while. Like Sherlock Holmes used to say, 'Come, Watson, we're going to the opera.' He knew that phase of the creative process. Leave it alone. Think of other things. It comes back. Always. Some ideas develop within minutes when I write the copy for Jeanette. Sometimes, they take months. For some reason, maybe 10 months after I have the germ of an idea, it finally takes shape. Usually when I'm in the shower, driving the car, grocery shopping – whatever – something just makes it click all of a sudden.

HORRORSCOPE

A regular routine proves to be helpful.

Since speaking with Susan, she and her collaborator – Jeanette Jerome – decided to retire the strip on August 4th 2001 after thirteen years because Jeanette felt that there was too little remuneration for the huge amount of work involved. Susan said it will be tough to say goodbye to something that has been such a big part of her life for so long.

Take heed, even if you are riding with King Features the going can be tough.

Nicole Hollander –
Sylvia (Tribune Media Services)

Have you any 'common sense' advice for cartoonists either about work or life in general?
I think that there are two ways to be a cartoonist. One is to truly want to say something new or personal in your work, the other is to study the cartoons already out there and do something just like them but with a slight twist. One will win you an audience of people, quite small, who you can relate to, and know that they will get the obscure bits and the other will get you syndicated more widely.

Do you think that apart from 'talent' – a lot of it is down to luck?
I don't believe in luck, because if I did how could I tell myself it was perseverance? I believe that while you're waiting for the big break, you have to get your work out there, in whatever venue. I do believe in timing. There was a moment for me and the work of others like me. It was the 1970s. There was an awareness of feminism. An excitement about change. A belief that attitudes and public policy could change for the better. That was the moment for me to get my cartoons in newspapers – I ran quickly into that space and then it closed up. Whew! Made it.

I think it would be helpful to advise cartoonists to be aware of the style of humour around them, though there's a good chance they are absorbing it – like Beavis and Butthead and saying cutting nasty things, but … South Park is funny, and a lot of cartoons that I used to get from beginners were not funny, as if they thought it was only necessary to be unpleasant, gross or insulting to be a successful cartoonist. Ah, if that were only the case, how relaxing.

Randy Glasbergen
Internationally Acclaimed Cartoonist

In today's market, syndication is no longer one of the best ways to succeed in cartooning. The most successful cartoonists I know are doing web cartoons, humorous illustration, greeting card art and ideas, books, calendars, magazine cartoons, corporate work, etc. Syndication is only one of many options.

**"I need $200,000 to go to college?
If I had $200,000 I wouldn't *need* to go to college!"**

Mell Lazarus –
'Miss Peach' and 'Momma' (Creators Syndicate)

Have you any 'common sense' advice for cartoonists?
In your subject matter, stick to those areas of life with which you are familiar. Venture too far afield and it will show.

Are there certain things you used to do that you now realise were a complete waste of time?
I used to worry.

SYLVIA by Nicole Hollander

Jim Toomey –
Sherman's Lagoon (King Features)
www.slagoon.com

Have you any 'common sense' advice for cartoonists either about work or life in general?
Control your expectations. There's very little money in it save for a half dozen billionaires. These days, there are many more syndicated cartoonists, but the market is no bigger than it was 30 years ago. Do the maths. I'd say that the top 50 or so are making a decent living. The top 15 are making a great living. The rest still have their day job.

Can you recommend other ways than syndication to get work published?
None that seem to work. This is an old boy's network, so the Internet doesn't seem to work. You could try self-publishing comic books, but in the end, you'll need a large marketing force behind you to rise above the noise.

Are there any definite Do's and Don'ts?
Stay away from religion and sex.

Are there certain things you used to do that you now realise were a complete waste of time?
Stew for hours over writing a gag.

Have you any advice on submitting work?
Say it with the work, not an elaborate cover letter. I think it's a mistake to go into this process thinking that the difference between syndication and anonymity is a trick or two. It's really all about persistence, and going into the process with very realistic expectations and a love for doing it. There isn't much gratification in it if one is at all motivated by fame or money.

Woody Wilson –
(King Features)
Rex Morgan MD, Judge Parker

Is there anything that YOU yourself worked out over the years that you never read in a book but you just KNOW it would help other cartoonists?
Yes, the gags are everything. You can be the best cartoonist on the block, but if you can't write a gag, you're wasting your time. And if you find you can't write gags, have the good sense to find a collaborator who can.

What is the biggest discovery or 'trade secret' you ever made about cartooning or syndication?
That syndicates weren't creative people.

Can you recommend other ways than syndication to get work published?
As I said, self-syndication is the way to go these days. A cartoonist, or writer must find the largest possible audience for their work. Very few cartoonists can make a living selling to magazines. Selling multiples of a single panel, or strip, is the only way (generally speaking) to be successful. Also, I know fairly successful cartoonists who sell their cartoons on their websites. They also sell greeting cards, coffee mugs, calendars, etc.

Are there any definite Do's and Don'ts?
Yes … DON'T ever give up your copyright to a syndicate. No matter how much they try to scare you, never give them the licensing rights. Repeat … NEVER. Also, when you submit a strip or panel to a syndicate, DON'T call them to check if they've read it yet. Never bug the editors … it's the sign of a rookie. Be patient … be calm … be tough.

***SHERMAN'S LAGOON** by Jim Toomey*

REX MORGAN MD by Woody Wilson & Graham Nolan

Jim Keefe –
Flash Gordon (King Features)
http://www.keefestudios.com

Is there anything you know now that – if you had known before – might have helped you become syndicated sooner – or at least kept you more sane?
Don't sit on your ass. Constantly be working up new material and checking out new markets. Ironically, I wasn't in pursuit of being syndicated. I wanted to be a comic-book artist. My first job in the field was a staff position at King Features Syndicate as colourist, looking to do different things I was (infrequently) submitting samples when I heard they were looking for anything. This lead to fashion illustration … spot art for the promotion department … a short stint ghosting 'Secret Agent Corrigan' … and eventually 'Flash Gordon'.

Is there anything that YOU yourself worked out over the years that you never read in a book but you just KNOW it would help other cartoonists?
Don't limit yourself to one small corner of the cartooning world. If I had pigeonholed myself to just being the next comic-book artist on Spider-Man, I'd be flipping burgers right now instead of writing and drawing the syndicated Flash Gordon strip.

Do you think that apart from 'talent' – a lot of it is down to luck?
Forget luck. Opportunities present themselves if you get yourself out there. Learn your craft and constantly be submitting samples.

What is the biggest discovery or 'trade secret' you ever made about cartooning or syndication?
It's not always the quality of a strip that counts. You may have the most-beautifully drawn, funniest strip about a cat … but chances are it will be a hard sell to the syndicates with strips like Garfield and Mutts already in the market.

Are there certain things you used to do that you now realise were a complete waste of time?
Watching TV.

Is there ANYTHING that I've overlooked that you feel is very important?
As mentioned before, TV is a waste of time.

©2001 JIM KEEFE
WWW.KEEFESTUDIOS.COM

PART 7

More Tips From The Pros

KEEP YOUR DAY JOB

Davy Francis – www.geocities.com/davy_francis
A Northern Ireland based cartoonist who draws cartoons for the love of it. He still has a 'day job' in the Housing Executive which he says allows him to enjoy cartooning without the pressure of HAVING to find work to pay the bills.

The first thing any aspiring cartoonist should do is try to build up a stock of printed work. Do whatever it takes to get some work in print, even if it means approaching a charity or a local newspaper and offering them free cartoons. See it as an investment in your future, think of the potential audience – the potential customers you could be reaching. It's also good for your development as a cartoonist – You learn an awful lot when you see your work in print – you get to see your work as others see it – mistakes and all – but don't worry, everyone makes mistakes, so learn from them and carry on.

Never refuse work. For one thing, you might enjoy it, the other thing is, it may lead on to other work. I've drawn nearly everything and anything – caricatures, illustrations for TV, comic strips, kids comics, adult comics, postcards, greetings cards, advertisements, animation, children's books, website illos, murals – I even painted a crocodile box for a circus once. If the customer wants you to draw green flamingos with red hair, that's what you draw. The customer is always right, even when they're wrong. They're the people paying you, so don't argue. If you don't like what *they* have in mind, suggest a few alternatives and then try to meet them half way. Though don't be pressurised into doing something you feel uncomfortable with – say, something political or near the knuckle – you have a reputation to consider, so be careful.

When I first started, long ago – BC (**B**efore **C**omputers), I didn't have the advantage of the Internet. Invest in a good website, pick out your best work and you can reach millions of people at the click of a mouse. Of course, the old tried and tested business card is still one of the best ways to advertise. Don't be afraid to hand them out to everyone you meet. Put your www address on the cards too. Make it easy for potential customers to contact you.

Make sure you keep deadlines – if the job has to be done by tomorrow, then stay up all night if necessary and get it done. You could be the greatest cartoonist in the world, but if you can't produce the work in time, you're going to lose work to the not-so-good guys who can. If you have a good reputation for producing work in good time, the customer will come back to you again and again. I've been drawing for over 25 years and never once missed a deadline – it's paramount.

Don't despair when you hit inevitable lean periods where you don't have any work coming in. Clients are like buses – sometimes you don't see any for ages and then all of a sudden they all come along at once. Take advantage of the lean times to build up your stock of cartoons, hone your drawing skills and make contacts.

Don't be afraid to change your style. It's something that grows and develops in you, so let it. My own style has changed dramatically over the years, it's become looser, I've become faster at drawing and I've stopped doing crosshatching and things like that which take up a lot of time. It still changes day by day, and every job I do, I still think – oh, I made a mistake there, that bit doesn't look too good, that could have been drawn better. A friend of mine who draws for the American comics says his best work is his next job – he hates everything he does as soon as he's drawn it.

Try out your cartoons on friends or family – see if they laugh at your jokes. If they don't, then go back and try again. Sometimes when you're drawing a strip or gags, you can become too close to it and miss out on the funny stuff, so it's good to get a reaction – even if it's a bad one. Also try to meet with other cartoonists or creative people to show your work to for criticism, or to bounce ideas off. It's great for recharging your creative batteries, too.

Most of all – make sure that you have fun cartooning – if you're not enjoying it, what's the point in doing it? You can't be miserable and think up funny cartoons at the same time.

PRO TIPS – ROYSTON ROBERTSON
NEVER GIVE UP

Royston Robertson – *a London-based freelance cartoonist, published in* Private Eye, Punch, New Statesman *and* Reader's Digest, *among others.*

Have you any 'common sense' advice for cartoonists either about work or life in general?
Get used to rejection but don't let it get you down. There can be a million reasons why a cartoon editor felt that your gag was not right for his or her magazine. It doesn't mean its no good. Send it to someone else. Then if it still comes back send it to someone else. It's great seeing a cartoon published after it has been rejected several times. You find yourself saying: 'See. I "knew" that was a funny gag!'

What is the biggest discovery you ever made about the business?
When budgets get tight at magazines, or if space becomes limited because they're selling lots of adverts, cartoons will be dropped. This is one of the many reasons why cartooning is a very precarious business – the market can just shrink overnight.

Do you feel there are certain 'untapped' areas that people could explore?
There always are. Try suggesting cartoons to a publication that has never had them or even thought of having them, such as a trade magazine or a local paper. It's always worth a try and could lead to regular work. But if they've never had cartoons they may place little value on them and try to get you to work for peanuts, so make sure you negotiate a good fee.

Are there certain things you used to do that you now realise were a complete waste of time?
I used to draw up a batch of cartoons then send them all off to a lot of magazines at the same time. This is not a good idea as you'll be in a spot of trouble if two magazines want the same gag (especially if they're the magazines that use the cartoons in without telling you first!) Instead, send in rotation, probably starting with the highest-payer, or most prestigious first.

Are there any ways to maximise the success of submitted work?
There's nothing to stop you selling a cartoon to two different magazines, if you have retained the copyright (i.e. haven't signed it over). But it's best to allow a suitable period of time first and to avoid selling to two magazines that are competing in the same market.

Have you any personal tips about submitting work?
My one key tip would be: submit all the gags you come up with, even the corny ones. I have lost count of the amount of times that cartoon editors have rejected what I regarded as my clever, satirical stuff but took the corny joke that I only threw into the batch to make up the numbers! There's no accounting for taste, and humour is very subjective.

So if you come up with a joke but think it's too corny or obvious, submit it. If you're serious about making a living from cartoons, and don't want to fall into the trap of treating it as high art, then it's far better to sell one corny joke than to submit a batch which you think is perfect then see them all rejected.

PRO TIPS – PETER A. KING
I CAN'T BELIEVE I GET PAID FOR THIS ...

Peter A. King – *Gag cartoonist and caricaturist whose clients include – Punch, Spectator, New Statesman, Private Eye, Liverpool Daily Echo.*

Artwork and style

Do you draw a lot of roughs, sketches, for ideas?
I only occasionally get an idea from doodles. I fiddle around with roughs for the final drawing, making sure the perspective is right, etc. When I'm happy with the rough I transfer it with the aid of a lightbox. My finished inked drawing is on 120gsm cartridge which is thick enough to take watercolour.

How did you develop your style?
I think it just 'arrives', certainly in my case. I was never really 100% happy with my early B/W stuff. I always knew something wasn't quite right. It's only when you find your style you realise what it is. In my early stuff, everyone had a massive nose as I thought this was a prerequisite for a humorous drawing. A 'unique' style is not as important as finding one you feel at ease with, one in which you are comfortable rendering ANY situation. This helps your confidence.

"Well I think it's bleedin' freezing!"

Do you use any reference for drawings?
Yes. I use anything I think might be useful. Kids books are a fantastic source. 'First thousand words' and 'Jobs people do' by Usborne are great, as everything is drawn in a 'cartoonish' manner which aids simplistic rendering. I also have books on 'Famous Lives' (also Usborne) and World History and British History, again from a child's perspective. If you are going to draw a cartoon with a German soldier in it you should at least make it authentic. (German soldiers have a great capacity for making people laugh.)

Submitting work

How do you choose which periodicals to submit to?
The list rarely changes. *Punch, Private Eye, Spectator, New Statesman*, maybe *Prospect*. They are really the only regular mags on my mailing list. I'll occasionally send to a new title or pick out a possible from the *Writers' and Artists' Yearbook* but despite how many magazines 'take cartoons', you'd be surprised at the rejection rate (lots of those magazines *do* 'take cartoons' and you never see them again!)

How do you present your submissions?
I submit 6 to 10 gags on separate pieces of A5 paper. I tend to draw my gag in the middle of an A4 sheet then trim it down to A5 (not very 'green' I know!)

Is it always your best gags (in your opinion) that get accepted?
No! ... NO!

Do you ever re-submit work to the same editors?
Only by accident. I *have* had work rejected and then accepted months later by the same editor.

Do you circulate your work around the various editors?
Yes ... but wait until the work is rejected before you send it on to someone else.

What percentage of your gags are accepted?
Maybe 4 out of 30.

Have you received any good advice in rejection letters?
Yes. When I sent my first batch to *Punch* (1997), Steve Way, who was cartoon editor at the time, returned them with a hand-written note saying how much he liked them. He took two from that first batch. More important than the money was the kick I got out of knowing that someone who sees hundreds of gags in a week, and who I've also admired for years, actually saw something in my work. Those were my first gags and I was really struggling at that time with my other caricature work. If Steve's letter hadn't been so positive, I don't think I'd be doing this now. Top bloke!

What about submitting work via email or fax?
I have submitted B/W topical gags via fax but I am yet to get computerised. I know that the editors *do* check all the email submissions they receive so it is worth going in that direction.

Are there any definite do's or don'ts about submitting work?
Don't send a shed load. These guys will have to get through stacks of these gags a day. Yours might be the last batch they see at 4.30. If it's an envelope thicker than the *Chronicles of Narnia* you've got Bob Hope [Liverpool slang for 'No hope' – Ed.]

'You can't just walk out on 15 years! … GODAMMIT.. I MADE YOU !!'

Are there times when rejection gets too much?
It's a pain, but everyone gets 'em. You'll soon forget your 60 rejected cartoons when you sell one!

Can you submit gags you have sold to other magazines either in the UK or abroad?
Yes, I suppose so. I never have, but I have seen cartoons sold two or three times.

Income and pricing

Can you make a good living as a gag cartoonist?
Only if you have a daily spot in a national paper. I couldn't see anyone being rich just by sending gag cartoons on a speculative basis. To begin with – keep your 'day job'.

How do you price your gags?
Every magazine has a set price that they pay per gag. On average this is around £50 but it can go as high as £120 (*Punch*).

How many gags a month do you NEED to sell to pay the bills?
Never look at it that way. Just sell as many as you can. Don't put extra pressure on yourself.

Is it difficult not having a guaranteed fixed income?
It's a constant worry, eating away at your brain until you can't hold a pencil any longer.

If you doubled your output would you double your income?
Not if the extra pressure meant letting your standards slip.

The creative process

Who were/are your influences?
When I was a lot younger I used to collect (and copy) Andy Capp books. In 1992 when I became a full-time cartoonist (drawing illustrations and caricatures for the regionals in Liverpool – not gags) I used to love Tim Watts and David Stoten (Spitting Image). Also Chris Riddell and various american artists – Mort Drucker and Jack Davis of *Mad* magazine. Gag-wise, Martin Honeysett, Ed McLachlan, Steve Way and Kevin Woodcock. Americans Charles Addams, Gahan Wilson and, of course, Gary Larson.

How do you deal with 'writer's block'?
I *always* have writers block – but luckily I also have what I call 'Creative Spurt' – I'll sit comatose for maybe two days then launch into 15 minutes of creativity.

What is your working routine? How many cartoons do you draw per day/week?
Once Matthew is off to school (8.30) I'll plan what I intend to do. If I'm drawing to commission I'll start with roughs. Usually I'll get a call which means shelving that project to do some tight deadline stuff. Otherwise, I'll get my sketchpads out and see what insane gag ideas I've written down in the week. If I'm doing solely gags and I have enough ideas I'll do maybe 6 to 8 in one day (coloured as well) I think this is most certainly terrible and wouldn't be surprised if the other guys are doing 40+.

What keeps you motivated/sane?
Motivated? Four kids! Sane? I'm not qualified to answer!

Do you follow current affairs?

On radio. Occasionally my addled brain cells couple together and come up with a topical. By the time I've faxed it off somewhere it lands on a pile of 20 similar gags all of which are sharper than mine.

Why do you think your work is selling? Do you find it is getting easier the more you do?

I think it works in cycles. Sometimes you'll sell four in a week (again, it depends on submission ratio) and sometimes you'll not sell ANY for weeks. It took me three years to sell a gag to *Private Eye* and I've not sold another one to 'em since! As for getting easier – there are times you think you'll never draw another gag!

What do you know now that you wish you had known starting off?

That it doesn't matter how funny you think your stuff is, if that particular editor doesn't like it it won't go in his magazine. That doesn't mean it's not good, it's just that HE doesn't think it is.

What would you say are the main pros and cons of being a gag cartoonist?

Cons are that you never really know where you stand month to month. A really good month can be followed by a real stinker. Pros are the kick from getting your gag past editors known for their ruthless and savage treatment of your pride and joys.

"Either you learn to stop slamming that door, or this bloody boulder collection has to go!.."

Top Ten Tips

1. Find a routine that works and stick to it. If you find that during long train journeys you think up lots of gags, then go on plenty of train journeys.
2. Don't expect to make it rich.
3. Keep a sketch pad in all your jacket pockets. You will forget a cracker, just try and minimise the times you do.
4. Don't copy other gags. I sold a cartoon to *Private Eye* and after it was published I received a copy of a cartoon they ran in 1984 which was virtually identical (including caption). This can happen, just don't let it affect you too much. I was distraught, but I KNEW I hadn't copied it and that was the most important thing. I've since seen about 10 gags that are nearly identical to ones I've published myself. Just forget it.
5. You will see junk published and think 'mine are better than that!'. I assure you, when your stuff finally gets published there will be other people saying 'That's JUNK!!'
6. Look at people like Steve Way, Paul Wood, Michael Heath. The characters in their gags always look 'trendy'. They make a point of keeping up with fashions which helps give a contemporary look to their work. Mine, on the other hand, always look like they've come from a second hand shop.
7. Try to avoid word puns. Most top cartoonists could do 30 of these a day. They're a cheap fall-back.
8. When you find art materials that work for you – stockpile! It took me nine months to find the paper I use now.
9. Look at other cartoonists' work and ask yourself why it works. Then look at some of the gags you've had published and ones that you haven't. Is there a discernable difference (other than the fact that the unpublished one needs ironing)?
10. Scour second hand bookshops and charity shops for reference books. They really do come in useful.

You can contact Peter at the following address:
Peter A. King, 225 Church Road, Litherland, Merseyside, Liverpool, L21 7LN. Tel: 0151 474 4077. Fax: 0151 286 6595

Peter *very* kindly allowed me to show some of his early work that he isn't overly proud of. As he said, try to avoid word puns, they're a cheap fall-back. If you have a hundred gags that aren't even as *good* as these, then get back to the drawing board.

Peter calls these 'Early Rubbish'.

"According to our records..,
it's been some time since you've worked"

"I'm sorry, you just don't appear Hardy enough"

You can see by the following examples just how much Peter's work has progressed since his early reliance on the good old pun.

"Welcome to the neighbourhood..My wife tells me you're from Germany?.."

"Yeah...Dodgy....,Good 'un though.."

"And finally.., To my brother Eric.."

PRO TIPS – TERRY CHRISTIEN
CORPORATE CARTOONING

Terry Christien *is a South West London based cartoonist and humourous illustrator. Over the years he has brought up a house and family of six children as a freelancer!*

Why did you go into corporate cartooning?
An interesting and rather disturbing aspect of cartooning was starkly revealed to me when I first joined The Cartoonists' Club in the mid eighties – the aspect of rejection which came about from lobbing loads of gag cartoons at editors and hoping some of them would be published, and for not enough money! What? Paper the walls with rejection slips? Wow, I couldn't handle that! I always sought being commissioned for the work I did. And that meant endearing me and my work to the corporate sector in the form of a mixed 'bag' of advertising, marketing, PR, trade publications, web, film and television, where rates of pay are higher. Having said all that, if you've got time, try both sides of the track!

How does one go about FINDING such clients?
The object of the exercise is to put a portfolio of your work in front of as many commissioners/art buyers as you can lay your eyes on!

Your portfolio can take the form of the standard zipped folder personally presented by you or mailed out as printed sheets, leaflets, CDs, cards, whatever. The content of your portfolio may or may not be entirely relevant to everybody – you won't please all the people all the time but experience and talking to other cartoonists and illustrators will help.Therefore, build on each work as it is commissioned trying to show – as an ongoing task – as many potential buyers as you reasonably can. You can always mix your chosen portfolio with some original conceptual material not sold or published.

Let your imagination and humourous outlook be your guide to encourage art buyers to respond.

In most cases large companies are unlikely to source a cartoonist direct but more so through their promotional agencies (advertising, marketing, public relations, design agencies etc.) as a cartoonist's work is usually part of the whole requirement.

To enable you to 'target' these agencies with your portfolio/promotional material, you can obtain contact addresses through directories, trade directories and trade magazines. Telephone them first to personalise your approach as it's always good to address in person which helps to minimise wastage. You can also buy specific mailing lists from mailing houses who often advertise in the creative press.

When you say 'marketing, public relation agencies' – does one just look up the yellow pages under 'Marketing ' or 'PR' agencies and send them work? Is it that simple or is there a source like the Writers and Artists Year Book*?*
The answer in a nutshell is yes! However, a cartoonist will need to phone and speak to an account handler and ask them if they've considered buying in creative services such as cartoons and if so, who would be responsible for doing the buying? It seems strange, but very often these people can suffer from an imagination bypass and apart from alerting them to a particular cartoonist's style, it can also alert them to the opportunity of using cartoons instead of the usual boring predictable stock library photographs. So, you can see that the selling message is a double edge sword but I'm sure I don't need to tell you that that angle takes significant experience of knowing what the client (the agency) and in turn their client wants and could benefit from buying in cartoons. There are going to be a select few cartoonists who will see that 'light' and will have a go at milking it! But realistically, most won't and that's the difference between a businesslike freelancer and not! I should add that this same procedure applies to approaching book publishers, TV, film and IT (Web) producers and any other likely commissioners and therefore takes an element of wisdom to comprehend the communicative use of cartoons to provide 'image bites' in the same way that writers provide sound bites! In other words – cartoons, the art of a thousand words!

And what about 'directories, trade directories and trade magazines' – where do you actually get the directories and by trade magazines do you mean ones in the high street newsagents or is there a way to find trade magazines that are only available 'within' the particular trade circle?
The directories I mention are more likely to be accessed at the lending libraries' reference section which can then be photocopied. Yellow Pages for example, has sections for advertising agencies and

consultants and the same for marketing agencies and consultants, public relations agencies and graphic design practices. *The Creative Handbook* published by Reeds lists all sorts of creatives free of charge and will charge for advertisers only.

And if a cartoonist wants to advertise by displaying his style and abilities, he can do that in the *Contact* directory which also does it on the web as well as the printed page.

If you choose to work in these markets, you will need to conduct yourself and your cartoon business in a businesslike way, and learn to understand how best to assist a client by demonstrating in your promotional material how effective cartoons can be.

Can you expand on HOW to go about this? Amateurs don't yet know what being businesslike entails. They also probably think that the way they promote themselves is fine. Can you add to their limited viewpoint. ?
Cartoonists must realise that they become small businesses when they take the freelance high road and experience will speak volumes in time – talking to buyers is a rapid learning curve – honing the communication skills is a prerequisite of businesslike behaviour!

You will be selling your cartoon service to all sorts of industries from makers of widgets and merchandise to diverse services of all kinds dealing with an infinite number of commodities.

And what can you as a cartoonist offer? You have the ability, of course, to communicate in a light-hearted, interesting and endearing way with humour and impact! After all, you know that the reader is compulsively drawn to the illustrated image – they say it speaks a thousand words!

Cultivate this cartoon culture through your promotional activity; your website; your advertising; your direct mail however you choose to promote your cartoon service. And show what you can produce for the reading and viewing 'audience' – great bite-size and attractive cartoon illustrations encapsulating in a single frame what it takes many words of text to do.

So, if you're thinking of going into these areas of cartooning, you will need to conduct a businesslike attitude to help instill a sense of confidence in clients who have very little idea about what you do

but know they want a piece of it! Try not to get bogged down in tedious logistical detail but take an overview of the message they're trying to get across with the help of the simplest idea from you.

Don't be afraid to enquire about the extent to which the cartoon will be seen; whether it's just the UK; Europe or the rest of the world. And the quantity of the print run if it's to be paper published, or whether for internal viewing or broadcast perhaps nationally or internationally – these all have a bearing on the final fee you charge.

Learn to be as expansive as you can with your capabilities from characters in single frame stand alone cartoons to multi frame strips and caricatures, all of which will be saleable commodities to likely commissioners.

Have fun, but do it professionally!

PRO TIPS – JOHN FREEMAN
BREAKING INTO COMICS

A brief overview
John Freeman – *freelance editor, writer and creative consultant.*

I found the following article at a terrific website – www.jfree.dircon.co.uk – jam packed with everything you ever wanted to know about comics. John kindly agreed to let me reprint it but only if all of you go and visit his site. Check out his résumé, this is someone who's advice you should heed.

His recent work has included work for Dreamwatch, Titan, Telezones and others. Until November 1999 he was Managing Editor at Titan Magazines in London. His managerial duties included the hands-on editing of *Babylon 5* Magazine and *Star Wars* Comic, and overseeing the creation of *Buffy the Vampire Slayer*, *Star Trek* Monthly, *Star Wars Magazine*, *The X-Files*, *Xena*, *The Simpsons* and *Manga Max*. He still works in a freelance capacity for Titan Magazines as their Creative Consultant.

Between 1987 and 1993 he was at Marvel UK and his work there included editor of *Doctor Who* Magazine and, later, several Marvel UK titles, including *Death's Head*, *Warheads*, *Motormouth* (its last few issues), *Digitek* and the weekly *Overkill*. He has also written a few comic strips for Marvel (among them, *Warheads* and *Shadow Riders*) and Fleetway (*Judge Karyn*); self-published a fanzine, *SCAN*, which counted comics luminary Alan Moore amongst its minuscule number of subscribers; and started writing a novel.

Writing comics is not easy. It takes determination, perseverance and lots of practice, whether you're an aspiring writer or artist. If you didn't already know it, there are one heck of a lot of people out there who think they have what it takes as a writer or an artist to make it in the industry. The fact that 95% of these people haven't got a clue is neither here nor there. These 95% are the ones who bombard editors both in the UK and the US with their work, without undertaking the basics that every comics editor wants to see.

If you want to shine in the unsolicited slush pile your work must be polished, take on board the current trends in the market and particularly those of the company you're aiming at. It has to be something the editor wants to see, be they working on Thomas the Tank Engine or 2000AD. And on that subject, be prepared for the inevitable possibility that you're more likely to get work on a junior title than the dizzying heights of the titles you regularly read. Many an artist and writer I worked with on Marvel UK titles such as *Death's Head II*, *Warheads* and *Overkill*, etc., learnt their trade writing or drawing *The Real Ghostbusters* and *Thundercats*. Grant Morrison started his career by writing *Zoids*, among other things. If you're self-employed and still learning, nothing should be beneath you.

Comic storytelling tips that work …
1. Write or draw anything. Practice. Read and watch things that aren't action adventure or comics. You often find more characterisation in one episode of Coronation Street than twenty episodes of X-Blobs from Mingo. As for classic fiction, it's as good a place to start as any. Novelist Orson Scott Card once wrote: 'I don't know how anyone can be a writer of fiction in any genre without being deeply immersed in the lives of real people as recorded by historians and biographers.'

That said, if you find a comic and style you like, don't be afraid to ask yourself 'Why?' What made the characters interesting? What made the artwork stand out above all the other comics you might have bought in the last month? Like books, 90% of comics are rubbish and like those books, just as unmemorable. But the best-drawn, best-written comics are always those that stand the test of time – and keep a writer or artist in work in a very competitive market place.

2. Self publish if you can afford it. Good editors like to see published work, even published work in fanzines. I started my career in comics by publishing my own fanzine. It never made any money and we only ever produced 200 copies every issue, but several people who started with work in it have gone on to work in comics, including myself. Dave Jones now works on *Viz* and Nick Miller has drawn for many comics. (My co-editor, Matt Bingham, now works for FHM, but that's another story.)

Many top-name comic authors have done nothing but publish their own work, to considerable success, Dave Sim's *Cerberus* being the archetypal example, also Eddie Campbell and Alan Moore's *From Hell*, Bryan Talbot's *Luther Arkwright* or Paul

Grist's *Kane*. There are others, such as the delightful *Strangehaven*, but they are sadly still few and far between. Comics are still dominated by the big publishers such as Marvel, DC and Dark Horse, each with their own very different attitudes towards storytelling, creator's rights, royalties and the like. These major companies are where most of the work is and probably your first targets when it comes to trying to get work.

3. **When you get work, be prepared to revise** your astonishingly brilliant storyline or art when the editor asks you to. The nature of mainstream comics is that a comic is created by more than one hand – mainly the writer and artist, but also the editor, editor-in-chief, etc. Be prepared to compromise but learn your own tolerances when it comes to resisting the 'suggestions' of those above you, especially if you feel that the suggested changes are wrong and alter the basic essence of the story you're pitching. If it was good enough to be accepted, it's good enough to sell elsewhere if things are going horribly wrong for you. And when an editor changes the names of all your characters without consulting you, I think you have every right to blow a gasket!

What editors look for in a submission
Writing

1. **Before submitting your work, check for spelling and grammar.** Also, revise and polish your submission. Is it a story you'd want to read featuring your chosen hero? Have you written a story using characters you're familiar with? Could you edit it to improve the storytelling? Re-writing is an important part of any creative process, be it comics, TV, film, radio or novel.

2. **If you are targeting a particular company, submit work featuring the company's published characters you're familiar with.** It's pretty pointless submitting new character ideas in the first instance, unless you've teamed up with an artist to knock 'em dead (another good idea, and one you can realise by publishing a fanzine). Also, check with the company before you send them anything. Neither Marvel nor Dark Horse now accept unsolicited submissions. Find out what a company's submission procedure is before you make your pitch.

3. **If pitching to a British title such as 2000AD, send in storylines/six page 'Future Shock' ideas, not multi-part epics.** These plot lines should be brief – never more than a single side of A4. If you can tell the story or explain a character in a sentence, it

really helps. US editors will also want to see self-contained short stories. Don't use well-known characters, either – you may stand a better chance of getting accepted as a new writer if you submit a story featuring a lesser-known character in need of development or revamping.

4. **Writer Warren Ellis recommends sending script samples to companies.** It's worth a try if you're an unknown. An editor needs to know you can write good dialogue as well as come up with sparkling ideas.

5. **Always include your name, address and telephone number** on each sample and each page that you send in. Include a stamped addressed envelope.

6. **Be prepared to wait for a reply, but in the case of writing (because there are generally fewer submissions,) I would say a phone call won't hurt your chances.** If you do phone leave it until about four weeks after sending your submission. Plus, be polite and be quick. Editors are always busy, even on the toilet. (They're also partially insane and never in the same mood from day to day. In this, they have a lot in common with traffic wardens, but that's another story.)

7. **If you are sending in story ideas with new characters you've created and feel paranoid (not necessarily a bad thing), you might want to post a copy of the material to yourself.** Then leave the envelope unopened in a box file somewhere. The date stamp on the envelope serves as the indicator of when you sent the company your work, so if your character appears in another form you at least have some evidence of your creations being ripped off.

Many American companies adopt the same principles as TV companies, requesting that you send a legal release form with any submission so they can avoid any potential legal wrangle if 'simultaneous creation' occurs. It does happen …

Submitting artwork
Although this guide is aimed at writers rather than artists, these tips may be of use to aspiring artists …

1. **Have you submitted strip work to the title of your choice, as well as illustrations?** In general, when you submit artwork to a company (British or American), they want to see at least 3 to 4 continuous pages – that is, a continuing story. They don't want to see splash pages or covers.

Your whole package should be roughly 8 to 12 pages long, so they can look at it quickly and get a good idea of what you do. The most important thing an editor is looking for is your ability to tell a story. The next thing they're going to look for is your ability to draw a car, a telephone, a tree, a house, a couch, and so on. Basically, they're looking to see if you can draw. People are the last thing they'll look at; an editor assumes that if you want a job in comics, you can already draw people. But if you can draw anything else, put it in your samples – let them see it.

2. Have you read the comic you're trying to get work on? Do you know what makes the character you're writing/drawing tick?

3. Have you submitted work to a company featuring that company's characters? No one at Fleetway wants to see how well you can draw Spider-Man, for example, and no one at Marvel wants to see Judge Dredd. Tailor your submissions according to which company you're selling yourself to.

4. Have you submitted photocopies? Never send original work. It is almost never returned.

5. When you send something to a comics company, include a covering letter telling them who you are, where you're from, and thank the addressee for looking at your samples. Hopefully, they'll have time to respond although the big companies receive hundreds of submissions a day. Nevertheless, it doesn't hurt to include a stamped addressed envelope, or International Reply Coupons if sending material to the United States. Any response is good, although most US companies now return material as a matter of course to avoid potential claims against them for ripping off characters.

6. Always include your name, address and telephone number on each sample and each page that you send in. In a busy editorial office it's very easy for a covering letter to become separated from the art – it happened to me on a couple of occasions and this is frustrating, not just for the aspiring creator!

7. Presenting art at conventions. Artist Dave Gibbons' advice is: 'Leave the sketchbooks and most of the pin-ups at home. Take a few (maybe six) finished pages showing continuity, and a couple of un-inked pages. Don't bother lettering

them unless you can do it to professional standard. Make sure its your latest, best work. And never, ever, apologise for it!'

Can comic artists make money?

(This is in reply to a question I asked John via email)

'Can Comics Artists Make Money?' the answer is – I think – yes. But it isn't easy. As you mention, several comics now use more reprint than they used to, but in the US there is still a busy, though none-too-vibrant comics industry, even though there are few UK comics these days.

Judge Dredd – Art – Robinson/Hart 2000AD © Rebellion

My feeling is that comics are competing with other mediums – particularly computer games and television where potential readers get a better thrill and more perceptible value for their money. A computer game can take many weeks to complete for most people and can be played again and again, justifying the high price point. There's also a feeling of control to playing a character which children like (witness their insatiable desire to replay their favourite videos again and again).

Compared with these mediums comics can seem pretty humdrum. They're also expensive in comparison and for most people have a once-only use. But that doesn't mean that people have stopped reading comics and it certainly won't stop people writing and drawing them.

It's worth taking a look at one of the strongest advocates for comics, Scott McCloud (http://www.scottmccloud.com/), creator of *Zot* and a major proponent of comics going online.

Comics are being revitalised online – witness the success of Steve Conley's *Astounding Space Thrills* for example, which is posted to a huge number of subscribers near-daily worldwide – and with the advent of PDF print formats it's never been easier for amateurs to distribute their work.

The trick, of course, is how can they make money so they can eat? *Astounding Space Thrills* profits from associated advertising packaged with each near-daily strip. But it took eight months to build that audience so advertisers would start to bite. More recently, Steve has also begun to sell merchandising based on the characters he's created and which have proven popular.

How else can comics artists pay the bills? Many also work in advertising (John Higgins for example), or on storyboarding (Sydney Jordan). That pays the bills, which enables them to create and draw the strips they yearn to produce. And of course comics artists have also found work in the very business which has threatened their livelihoods – computer game design.

The advent of the internet has meant there has never been a better way to reach a mass audience with a comic strip or cartoon, but that audience isn't found easily and it takes hard work to build an audience that might then lead to income generation. But I do see that this work could benefit considerably from the growing popularity of 'honour micropayments', currently being rolled out by companies such as Amazon in the US (http://www.amazon.com/honor), where an online viewer, having read a page or strip, is offered the chance to make a payment to an 'Honour' account for reading it. Horror writer Stephen King has experimented with his own system for a recent story, to some success. But not everyone is Stephen King and there's still more development required in this area.

To sum up for now, although there is still a market for comics and comic art it has changed dramatically in recent years and comic artists will certainly have to consider diversifying if they want to eat on a regular basis! But I do think online comics have the potential to bring the medium to an even bigger audience than traditional comics currently do, and their success may even help the print versions in future.

PRO TIPS – BRYAN TALBOT
HEART OF EMPIRE
THE CD-ROM

On this CD-ROM, he actually does it! He gives all the secrets away! He answers the age-old question: Where do you get your ideas from?

In well over 60,000 words of detailed and entertaining commentary, Bryan Talbot points out the inspirations, influences, references, symbolism and in-jokes underlying the whole graphic narrative. There are also annotations on the technical, compositional and storytelling aspects of the artwork, bawdy anecdotes, silly tirades and many mini-essays on related subjects as diverse as William Blake, English mythology, the sexual activities of Charles II, William Hogarth, Free Love, Catastrophe Theory, Magic Mushrooms, Pagan Festivals, The Golden Section, Orgone Energy, Subliminal Imagery, Synchronicity and the Twenty-three Enigma.

There is the whole of the Heart of Empire graphic novel in its pencilled, inked and coloured forms (both screen size and hi-resolution), plus a brand new piece of artwork, preparatory sketches and a wealth of illustrations showing where the inspiration for certain scenes came from (e.g. the original 18th century Hogarth engraving that inspired the Bedlam sequence).

A veritable treasure trove of entertaining and educational information!

All this plus three interviews, illustrated biographies, sample scripts and reference pictures, a gallery of character illustrations, a Bryan Talbot stripography, a very user-friendly interface and a full index to all the artwork and annotations

A unique and valuable resource for anyone interested in the comic strip medium.
Find out more at www.bryan-talbot.com

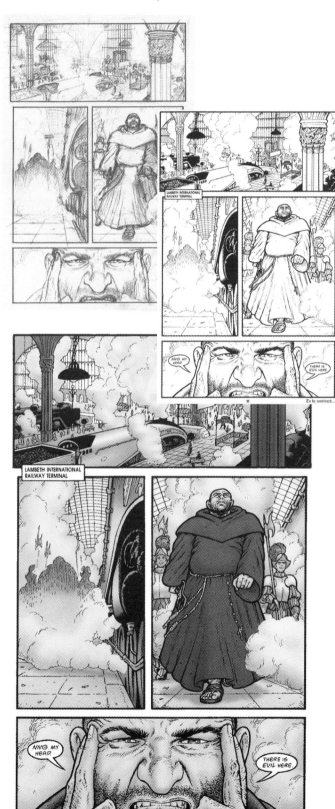

CARTOONS ONLINE

Bob Staake *Humorous Illustrator and Cartoonist*

Where does one begin?

I honestly believe that a cartoonist or humorous illustrator finds himself 'training' for this odd vocation from his childhood – by observing life and soaking up both visual and abstract nuances. I was always a very inquisitive child, and I think I learned early on to 'see' differently – and then manifest those observations in cartoons and drawings. Even today, when I have an assignment, I rarely ever have to refer to visual scrap or photos – and have learned to trust my memory when drawing anything from the White House to a Model T Ford, from a 1932 Underwood typewriter to a crowd scene in front of Buckingham Palace. I guess I was blessed with a 'photographic memory', and once I've seen something, I tend to file it away upstairs. Being able to call upon memories – for *me* that's where it all 'starts'. If a cartoonist lacks curiosity, he'll never mature into being a good, an insightful, cartoonist.

Is it easy to make a living at it?

Once you've established yourself and proven that you have a unique view of things, the rest of it falls into place. I think the key is differentiating your aesthetic and editorial point of view from the rest of the pack. For me, most of the illustration work I do is on assignment – so an art director or editor has to see something unique and special in my stuff – and know that I will bring that perspective to the project he/she is hiring me to take on. I can honestly say that every day I sit down at my drawing table I appreciate how blessed I am. To be *paid* well to draw silly pictures Monday through Friday is simply ridiculous. On top of that, I can sit at my drawing board wearing nothing but my pyjamas. Find any respectable job where you can get away with *that*!

HOW does a website make money – is it through direct selling or commissions?

Every website should have a goal – and be an extension OF that cartoonist or illustrator. For me, BobStaake.com functions as a global, online portfolio for my work, and since the site is very modular in nature, I can allow art directors, editors and potential clients to browse just the work they're interested in (a greeting card company, for example, isn't interested in seeing my advertising work – but

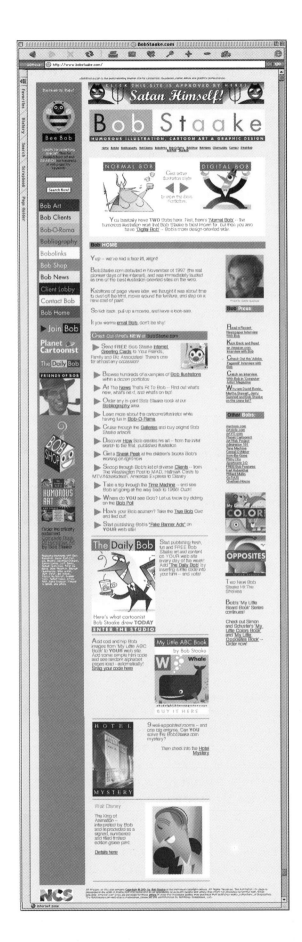

an ad agency doesn't want to see my greeting card work). Ever since my site went up in November of 1997, I have had no need to send my portfolio out to clients. That said, I'm pleased to make a profit on my site by offering my books, original artwork, limited edition prints and specialty products.

Does one need a LOT of work as back-up?
I've always been lucky because my graphic style seems to have a wide appeal, and that's very unusual. I've always enjoyed working in varied venues (from animation design to books, magazines to newspapers, greeting cards to advertising, etc.), but I only appreciated the importance of 'venue diversification' over time. The freelance lifestyle can be a very fickle business, so when advertising work is down, book work may be up, if greeting-card assignments fall, newspaper work may be up. By working in different areas, I'm happily very insulated from the dramatic highs and lows that plague any one parochial and specialised market segment.

I also think it's important to develop a strong 'regular' client base – and then be able to take on new work and clients as they come to you. I have on-going and wonderful relationships with a variety of clients – from the *Washington Post* to *MAD* magazine, Disney Publishing to *The Wall Street Journal* – but my door is always open to clients who stumble in and want me to draw some silly picture for them once, twice, or even developing into an on-going relationship.

What are the pros and con'?
One of the biggest 'pros' of cartooning and illustration for me is the 'mystery' of it all. I never know what the next assignment will bring, and I love that. It is what has always kept my work fresh, and I hope, vital. As far as 'cons', I suppose it's the relative isolation – but I sort of thrive on the isolated existence of being a freelancer. Most of the people I work with, in an on-going relationship, I've never met – and I may have talked to these people once a week for as long as 10 years or so. Why waste a perfectly good business relationship by meeting them face to face?

Are there any definite do's and don'ts?
Cartooning is a *very* individualistic thing. What works for one person won't work for another. Read books like this to find out how different cartoonists approached the art form and the business of cartooning in different ways. The diversity of professional experiences alone should be empowering enough for those who want to learn the big lessons of cartooning.

Are there things you know now that would have helped at the beginning?
Cartooning and illustration are 10% art, 90% business. Young people bristle when I say that, but I honestly believe its true. That said, there are some very artful and creative ways to *conduct* business, and the more I take control of my short- and long-term career, the more satisfied I am. As far as the *art* of cartooning goes, just be natural – and don't force things. It's essential that your inner voice and aesthetic manifest themselves naturally – and without being forced. Nothing is more transparent than a drawing style that is 'consciously coaxed' – and the more work you do, the more effortlessly your style will bloom.

Are there any things that are a waste of time?
Young aspiring cartoonists are always asking me what pen I draw with and on what paper and with what ink – and all that stuff is a waste. It just doesn't matter – because if I ever found myself stranded on a desert island *without* a Fountain Pentel and a ream of white bond paper, I'd find a way to draw in the sand with a coconut. That's because *imparting* an image is more important to me than the actual tools used to do the communicating. The honest truth is that *every* cartoonists learns – in their own time – what tools work best for *them*.

Have you any 'common sense' advice for cartoonists and illustrators about work or life in general?
When it comes to art, be spontaneous. *Nothing* is more irritating than a piece of cartoon art that looks 'laboured' over. When you're being spontaneous, that's where your true 'spirit' as an artist comes, so learn to trust your judgement.

I also think it's important for cartoonists to look beyond the traditional sources of inspiration – which is usually other cartoonists. Architecture, design, literature, even nature – these are the things that will influence your work in very dramatic ways – and enrich your spirit at the same time.

Check out more articles by Bob Staake at
www.Bobstaake.com
www.planetcartoonist.com

PRO TIPS – GRAHAM TOMS
3D COMPUTER ANIMATION

Graham Toms *worked for four and a half years at the Disney Institute as an animation Instructor. He is currently working as an art director on an animation project for a software company, producing the storyboard, character design, character modelling and animation.*

For anyone completely new to 3-D computer animation – what are the principles behind it?
First of all the characters and backgrounds have to be 'modelled' *in* the computer. In a sense you could say this is done with 'virtual clay' but instead of using your hands to shape the model you use a mouse to click and drag points and polygons that build up a 3-D structure on the screen.

One method is to create a 3-D sculpture in *real* clay – and then use a video scanner to import it into the computer. The resulting image is a mesh-like structure, the points of which can be pulled around to alter the shape. This is good for toy modelling, figurines or product designers but it may not always be suitable for character animation.

Character animation is usually best designed entirely *in* the machine. Like any artform you start with nothing and build up basic shapes into more complex designs. I could build a basic model in about five minutes. A total beginner could do a face in a couple of hours.

It really is a good idea to familiarise yourself with the basics of your package. Once you're hooked it's all down to how much time and effort you want to put in. If you are a good artist and you develop a working knowledge of a 3-D package there is no reason why you couldn't submit work to the studios within months. Studios are looking as much at your potential as at your present level of ability.

Remember that any 3-D package is just another tool – it is the means to an end – not the end in itself.

With the advances in computer technology many 'would-be' 3D computer animators imagine that all they have to do to produce the next *Toy Story* or *Shrek* is to become proficient in the latest 3D software package.

The truth is, it takes a lot more than computer skills to make a good 3-D computer animator. If you are a mediocre 2-D animator or cartoonist it doesn't matter how well you know your 3-D software, the lack of 'basic' drawing skills will show.

My advice is to build a solid foundation with two dimensional work first – in both drawing and animation. In my experience working for Disney, the most important attribute an animator possessed was his skill in life drawing. Practising drawing the human body was the best way to hone your skills. Gesture drawing being probably the most valuable form of draughtsmanship for the animator. Ten- and thirty-second poses being a good way to warm up. Progressing your way up to five-minute poses. Animal studies are excellent poses because they don't usually stay still unless they are sleeping. This is an opportunity to develop a 'snap shot' memory, getting a fraction of a second to see the animals pose before it moves again and then trying to produce some sort of coherent sketch.

Where does someone begin with 3-D computer animation after they have studied 2-D drawing?
If you can state on your résumé that you use an industry standard software package you will be taken more seriously by the animation studios. The four top packages are – Lightwave, Maya, Soft Image and 3D-Max.

I personally would recommend Lightwave because I honestly feel it is the best value for money out of all the high end packages available.

- It runs on a standard PC (the other three usually need 'high-end' hardware) Technical support is FREE with Lightwave, unlike the other three packages I have mentioned.
- It is extremely user friendly and allows you to approach animation either as a 'technician' or as an artist.
- It has everything in one package – the others usually need plug-ins for specialised areas of work (for example you can add 'character studio' to 3D Studio Max at considerable extra cost). Lightwave has character animation as part of the basic package.
- Other packages charge a yearly licensing fee.
- It has a good pedigree – It has been used in films such as *Titanic, Blade, Deep Blue Sea, Lost In Space, Pitch Black*. It is used in *loads* of commercials (like the 'm&m' sweets ad). At least 70% of Hollywood studios have a licence for Lightwave. Over 2000 licences have been sold to games companies in Japan.

You can try the free tutorials for Lightwave at www.flay.com and through NewTeks own web site at www.newtek.com. I would also highly recommend a great book *Lightwave 6* by Dan Ablin (Newrider publishers). There is a fantastic tutorial for modelling a head which took Scottish animator Stuart Aitken 1000 hours to create – the book is worth it for that tutorial alone.

What about submitting work and portfolios?
I would say that the top thing that animation studios look for in a portfolio is good life drawings – they don't have to be 'painterly' just proficient. Quick 'gesture' drawings are a must. It really depends on what type of job you're after. You may prefer to work your way up from the bottom in which case all you'll need is a reasonable portfolio, a *lot* of enthusiasm and rich parents to supplement your low income. If the studio just need 'grunts' then all you'll need is 3-D modelling skills but if you are a good artist *and* have 3-D modelling skills as well you have a good chance at Art Direction and big money. Research any studio you submit work to. Look at their requirements. Remember that an animation studio needs a lot of people who are all at very different levels on the food chain.

If you are a cartoonist wondering what skill you have that could be immediately applicable to animation, think seriously about 'storyboarding'. Storyboarding is a career in itself and if you can combine it with good prose, and dialogue for the characters you could then be a precious contributor to the animation process.

Good scriptwriters are rare and extremely valuable because in animation the story is everything. The greatest animation in the world cannot save a bad story, but a good story can make you overlook poor animation. This is why the big studios rely so much on the 'classic' fairytales and stories though even here, if the 'adaptation' is badly done the production can take a nose dive.

Another important cartooning attribute that can be applied to animation is character design. What is worth mentioning, for the cartoonist, is that not all good cartoon characters' designs can be easily transferred to animation. This is because drawing a character for a comic strip relies on setting only one good pose for each caption. In animation the character has to move convincingly for each incremental movement, which usually numbers 12 or 24 separate drawings of the character per second. Charles Schulz who designed the Charlie Brown comic strip didn't animate the series for television himself. This task was left to an animator who had to 'fudge' certain motions of the characters. The reason for this was that Schulz only drew his characters in 'side' or 'three quarter' profiles. Although fine for the strip, this was nowhere near enough for the animation which especially needed 'head-on' poses.

A 'classical' approach to character design helps avoid this problem. In classical design characters

are designed to represent three-dimensional volume, not a two-dimensional outline.

As well as a portfolio of drawings you will need some animation work on a CD-ROM. Make sure any movie files are quick to view and at a low resolution. You can show high res images in your portfolio. The CD is just to show how you approach actual animation. They want to see good 'narrative' (is it telling a story?). They will look at the cinematography – the stylistic quality of the environment. Are you thinking like an Art Director? What does the environment tell you? Does it complement the styling of the character? Ultimately, the environment should be like a 'stage' supporting the character – NOT the other way round. A lot of amateurs get this wrong. This is one area where the storyboarding is important. Too many artists want to get straight down to the animation without working on the storyboard and it shows in the long run.

I think it is important to know as many aspects of the business of animation as possible. Then no one can argue that they can't do something if *you* know that they *can*.

Also keep in mind that more and more studios are using PCs rather than Macs because there is more software available. You will have more options as a 2-D or 3-D animator if you work on a PC.

What's the best way to submit work?
There are three ways to submit your work which I will put in order of personal preference.
1. Not everyone may agree with me on this – (especially tormented Art Directors) but the way I did it was to barge in – unannounced – at lunch time – saying I knew 'such and such' in the art department and that 'he said I should bring in my portfolio' and 'would you like to see it' – and then I flung it on the table before anyone had the chance to throw me out. If you do this – make *sure* your work is at a high standard.
2. Use the Internet – build a website – put your work on it – email the studios with a link to your site and wait for their replies. Simple.
3. Post a portfolio along with a video and a CD-ROM. Make sure that you have all the required 'extensions' on the CD, as well, so that anyone will be able to easily open your mpegs or quicktime movies easily. If they have *any* trouble opening stuff your CD will go back in the envelope.

Who to submit to?
The animation industry can be put into the following categories
A. The feature animation industry, which includes companies like Disney, Warner Brothers, Pixar, PDI, ILM, Dream Works, Bluth Studios and recently to join the fold is Aardman animation (producers of *Chicken Run*)

B. TV animation which is cheaper to produce and therefore much more widespread. With TV companies you can either sell an idea, seek employment or be commissioned to do an animation. I know people who *have* got work through TV but don't hold your breath – it's not the fastest way to make a living as an animator.

C. Animation for the Internet; Flash software seems to be mainly the tool of choice in this category. This is probably the most inexpensive form of animation because most people can gain access to the Internet and submit their own work for next to nothing. In my mind Flash is the most democratic way of producing animation

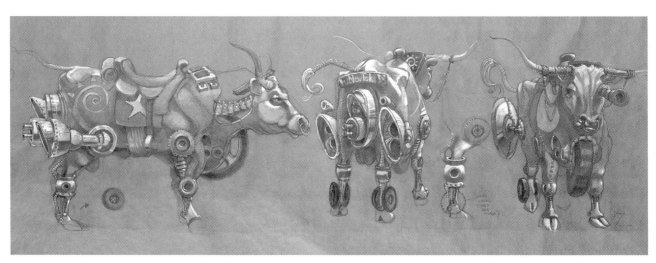

on the planet. It is useful to know Flash even if you want to work for a studio as it is often used to promote a studio's work on the Internet. Disney use it.

D. 'Experimental animation' is a category of animation and animators that covers a vast spectrum of styles and approaches. Arts Council grants are one way to scrape up money in this area.

E. The Computer Game industry is the biggest developing market for animation. The biggest 'Games Houses' are in France because the French government wisely pours money into this huge revenue making area. Other countries take note!

F. Advertising. Some 40% of all TV commercials use computer animation. You could either try to go to work *in* an ad agency or work *for* them as an independent animator. Just let them know you exist and see what happens.

How did YOU get into the business?
At college, I borrowed some software and experimented in my spare time. I remember having this 'state of the art' equipment in my bedroom mostly playing 'doom' on it and now and then I would do an animation. If only they'd known! After several people at college saw my work they sent me out to demonstrate it.

Eventually – through 'word of mouth' I got to do some work for a local company on a small animated film which was shown in the US where the Disney people saw it and they asked me to submit a portfolio. I then had to attend an interview which was not something I would like to go through again. It lasted a full day from 9.00 to 6.00 and each hour a different interviewer would ask me the same questions as the previous interviewer – mostly about my character and personality rather than my views on animation. Disney is very much a 'personality' based company and they *really* check you out – big time!

What about learning animation?
There are well over 200 courses throughout the British Isles in various colleges and universities. Mainly they have a very 'freeform' and 'experimental' approach to animation. This can be very interesting but if you want to make a living from animation this approach has little relevance to

companies employing artists with animation skills. The approach which will give you a greater chance of succeeding commercially, is the 'Classical Animation' approach which deals with the basics of drawing and tries to educate the student in methods adopted globally by the animation industry.

Try to find out as much as you can about the type of animation being taught at the various colleges before you commit yourself to any of them.

There are two colleges I know of that concentrate on a commercially viable approach for training animators.

One college I have been involved with in the past is Ballyfermot College of Further Education and Design, which is located in West Dublin. They concentrated heavily on a classical approach and have produced an excellent standard. Another I am aware of is Bournemouth College of Art and Design, which is building a very good reputation in this field.

When I visited Graham in his home-studio the thing that left the greatest impression was the amount of NON-computer work he showed me. I was expecting to sit for hours watching as he dazzled me with computer wizardry but instead he dazzled me with incredible paintings, sculptures, life-drawings (which he has practised for half an hour *every* day for the past five *years*!), doodles, sketch books, and on-the-spot drawing demonstrations. He even showed me his trademark 'napkin sketches' that he draws to 'amuse' (and impress) prospective clients over dinner.

When he finally got around to dazzling me on the computer it was obvious that good 3-D computer animation can *only* arise from good 2-D drawing skills and it *cannot* be otherwise. A computer cannot design the characters – nor can it bring them to life. If a computer animator can't draw or hasn't worked out a good idea, a good storyboard and good sketches, then no amount of technical computer knowledge will help.

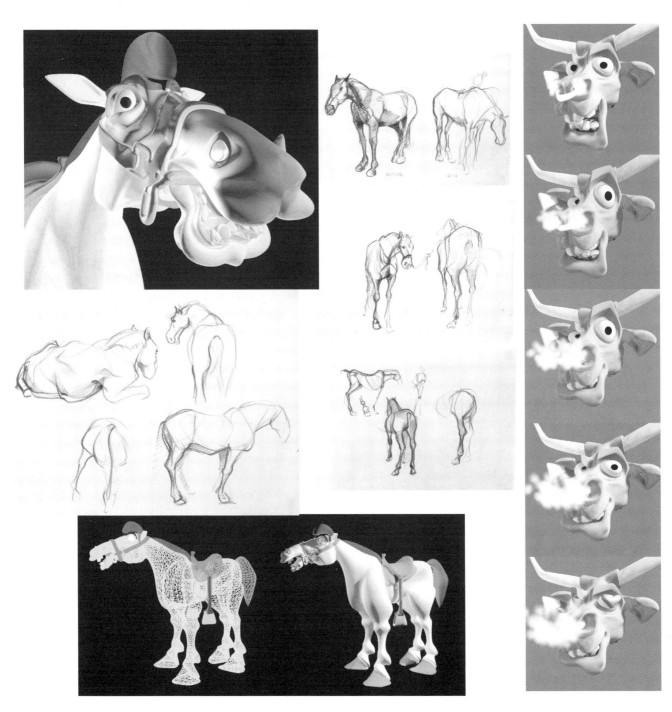

124

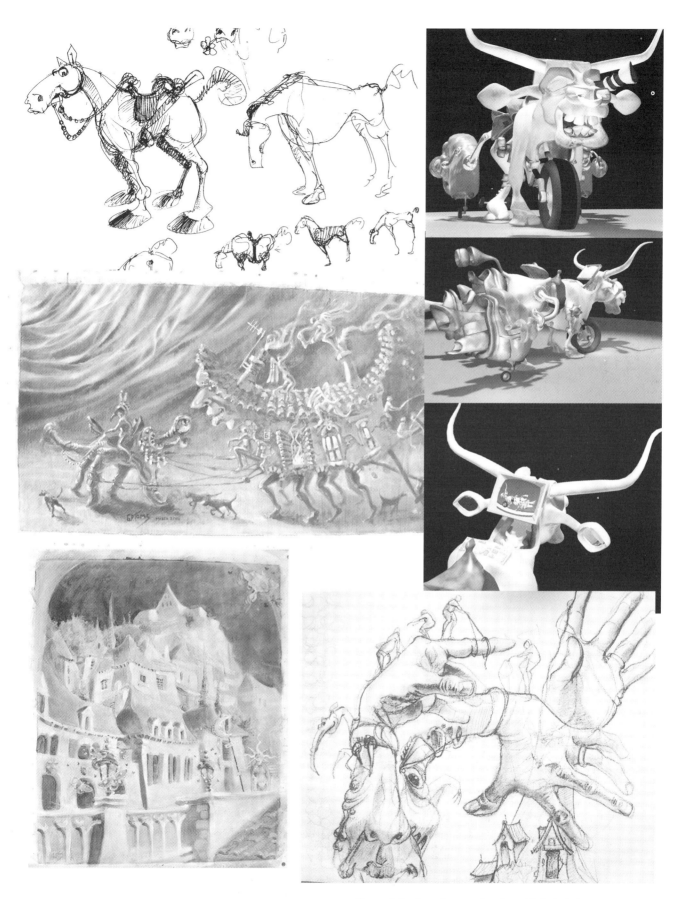

One of Graham's amazing 'napkin' sketches

CHILDREN'S BOOK ILLUSTRATION

John Amoss *has illustrated for books, textbooks, and other publications for over 15 years. His clients have included Simon Schuster, Children's Television Workshop, Scholastic, AT&T, New York Times and others. He also teaches visual art at the University of Georgia.*

Getting the pen rolling
How to be seen – and by whom
One of the illustrator's greatest challenges is to be noticed by the right people. Artistic ability is an important concern, but without the exposure, it is not a viable product. A tool used by advertising and public relations firms is the focus group. You might do the same – you should look for authors, publishers, designers – anyone in the children's book field for advice on what they think of your work. Joining a society like the Society of Children's Book Writers and Illustrators (SCBWI), can provide contacts and the means to ask the opinions of other illustrators and publishers. Several critiques are offered throughout the year. The *Artist's and Graphic Designer's Market* has numerous addresses of publishing houses with a description of what each company is looking for. Also, check out your local library or bookstore for publishing houses that publish 'your kind of book'. Keep in mind that the smaller publishers may be easier to work with, but will probably offer a substantially lower advance against royalties. They also may not be able to afford a large advertising campaign, but a larger publisher may drop your book after a season.

Where do jobs come from?
It surprises some people to learn that most authors do not pick their illustrators. This function is largely relegated to the editor assigned to that particular manuscript. So how can you get those people to call on you? The paths to the editor's desk are: presenting a portfolio of your work; being featured in children-related publications; sending printed samples to publishing houses; and, last but least of all, the Internet.

Portfolio reviews
These reviews are the shoe leather solution to being seen. A portfolio should contain around five pieces of your best work. Printed samples are great, although a great original piece beats a mediocre printed sample any day. I have found it useful to include a brief statement explaining my work along with a profile of myself. Remember, people generally want to be 'taken away' while looking at illustrations. Try to make it easy and pleasurable for them. Allow for ease in turning the pages – and if it is a collection of loose work – have them matted and sealed in shrink wrap.

If you get a chance, ask to see other artists' portfolios (or 'books' as they are known in the trade). While looking, don't compare your work to what you see, just pay attention to what you could learn from people's successes and mistakes.

To schedule the portfolio review, call and make an appointment. Ask the front desk who would be the best person to show 'your book' to. The review may be in person or they may ask you to leave it for them to browse at their convenience. Most artists prefer the dropoff scenario – your work should speak for itself and salesmanship rarely helps.

After the review, don't bug anyone for their opinions of your work. If they want to comment on it, they will. Try including a very brief questionnaire for them to mail back to you anonymously.

Unless the publisher contacts you, I would avoid sending a portfolio in the mail. If you must, use colour copies or slides instead of originals. Mailed portfolios have a habit of sitting around forever, waiting to be taken back to the post office while the artist's life is left on hold.

Printed work – seeing is believing
In order to gain some real experience, to collect some printed pieces, and to release some creative energy, you may be well advised to illustrate an article in a children's publication. Highlights, Cricket, Ladybug, Nickelodeon, etc., could be a great springboard for the enterprising illustrator. They may not pay that great (if at all), but many publications may

also own a book division. It may also be good exposure with other publishing houses as well.

Also, local school and church newsletters and bulletins may be in desperate need of visuals. Small illustration jobs offer experience, don't require a lot of work, and allow for some experimentation. Projects may initially be limited to black & white line drawings, but at least you are dealing with deadlines and are taking steps in the right direction.

Direct mailing and Artists' Directories

This method is basically a printed advertisement taken out by the artist. Direct mailers are sample sheets that are sent to the appropriate publisher or art buyer. Most illustrators nowadays can design their mailer on a home computer and give it to the printer on a disk.

Artists' directories are publications that are basically a collection of artists' images for prospective clients to review. They are paid for by the artist and/or artist representative and are distributed largely free, to art buyers, publishers, designers, etc. – although they are also available at larger bookstores. Be warned – they can be pricey. Most provide 1,000 or 2,000 reprints of your page for you to use as direct mailers. As with the mailers, you are responsible for the design, but with a little more support from the publisher's production staff.

Simply used as a reference tool, artists' directories are highly recommended for anyone as a guide to what and who is out there. They are available at major bookstores.

The Internet

No mess, no hassle, little expense, possibly little response. The good news is that the Internet now allows most everyone to be seen by most everyone. The bad news is that the internet now allows most everyone to be seen by most everyone. In other words, how do you stand out from the already hundred-or-so illustrators out there? Yahoo.com makes no delineation between children's book and other illustrators, search engines come up with 200,000 results and so on. The way to use the Internet for advertising is to be more intrusive – by including your website address on your printed pieces. If they like your work, they can see more samples online – plus you can update the selection at practically no cost.

Possible illustration pitfall No. 1
'MY COUSIN WRITES GOOD'

Children's book illustrating and writing is one of those fields that attracts a lot of people. Children's books are everywhere and are a very obvious avenue for pursuit. For the beginner, it is very tempting to take on whatever offer comes your way. Whenever possible, you should try to ferret out *published* authors. Publishers do not like to take chances on non-experienced authors. If that variety is hard to come by, then look for people with some experience in the field.

The publishing end –
Act 1. Scene 1: A book is born

Before the illustrator gets involved, much work has been done by a lot of people. The manuscript is sent by the author to the publisher. Invitations are reserved for the hot commodities, most entries end up in a stack called 'the slush pile'. Usually publishing houses are swamped with such manuscripts and have created positions whose sole purpose is to review each of them. Unfortunately, most stories are judged quickly and harshly by people who may or may not have the proper skills or appreciation.

After being chosen, the lucky manuscripts then move up the ladder of succession from editors' assistant to editor to acquisitions editor, and so on. *if* the story passes muster, the author is called in for an initial meeting. Sometimes the book needs drastic changes as a result of the editor's or the advertising or marketing department's influence. The author is then presented with a contract agreement at an acquisitions meeting and the book is assigned a tentative publishing date. If it is a picturebook, the hunt for the artist is on.

Scene 2: Enter the illustrator

If the job of illustrating a manuscript has been offered to you – after the initial excitement has died down – ask the following questions to find out if this project is for you:

1. How extensive are the illustrations?

Children's picture books are usually 32-pages (not including front/back cover) and are 4-colour. While some devote the majority of space to imagery, others may only require a few black and white spot illustrations.

2. How much time will I have to work?

Ask for a schedule that includes when thumbnails/approval of thumbnails, tight sketches/approval of tight sketches, and finals/approval of finals are due (remember, most of the time spent is in the sketch stage). The schedule is designed to protect both the illustrator and the publisher. Most books are published in either the spring or fall, but may need time to be laid out, printed, shipped, etc. Sometimes, the cover is the first piece of artwork required because it needs to appear in the publisher's catalogue.

3. Is this over your head?

Everyone likes a challenge, but you need to ask for help when dealing with something new. Projects such as pop-up books require a lot of technical precision. Make sure you are also confident in your use of the medium. Experiments with new materials could lead to nasty surprises.

4. Who gets what?

There are two ways that an illustrator is hired:

- Royalty basis – The illustrator shares a percentage of the retail sales with the author as outlined in the contract. The advance is an amount paid to the artist to keep her/him happy until the sales royalties arrive. Unfortunately, the royalties must recoup the advance amount before the artist receives any royalty money. Unless you are working with an extremely well-known author while you are still an unknown, an illustrator should expect half of the customary 10% royalties.
- Flat fee – This is a more common practice for older-children's books and non-fiction publications. Flat fees guarantee a specified amount (be sure to have a contract drawn up for larger jobs) to be paid in one of two ways:
 A. Half the total amount when the sketches are approved and half upon acceptance of the final artwork.
 B. Paid in full after the acceptance of the finals.

Method A is generally preferred by artists because it allows payment earlier and sets a schedule for all involved.

5. How many books will be printed on the first run?

This is a good indication of how the book is anticipated to do. An initial printing of 5,000 is certainly respectable.

Phrases to look out for:

'Work for hire' (in which the artist forfeits all rights for a flat fee), 'buy-out' (same as work for hire), and 'working on spec' (doing work to qualify for consideration with no compensation). The first two phrases put the artist at a disadvantage. Working on spec (in most artist's opinion) is an open door for abuse and should be avoided. If you have accepted and signed a royalty-based contract, you should receive your first advance cheque to help you buy materials. Please ask the person in charge of payroll at the publishing house when to expect the money and hold that person to that date.

Let's begin!

Fun 'n games – Inspiration before Perspiration

If you decide to do the book with a resolute 'YES!' – then the process of production can begin.

There are two ways to be introduced to the story: The first is for the prospective illustrator to read the story and relate his/her first impressions. This approach allows the artist freedom and the possibility of unexpected visual solutions. Most illustrators appreciate the chance to express themselves and I believe it makes the final product a more mutual undertaking. The author may or may not have considered the visuals while writing the book. Often, the initial sketches can inspire the open-minded author to rewrite portions for the benefit of the whole.

Sometimes, the author or publicist will want to present the book in her/his own way. This can be a good way of letting the story come to life – much as a radio listener imagines what an announcer may look like. Be sure that the author describes as much 'between the lines' stuff as possible in addition to any questions you may have.

Sketches

Sketches are a means to a better end. Most beginners discount the worth of sketches because they are unaware of how many important decisions are made during these stages.

Personally I like to use tracing paper for sketches – and I use reams of it. With tracing paper, you can piece together good elements into a better drawing by tracing, but you can also flip the paper over to get a 'fresh eye' effect that can reveal overlooked weaknesses.

Doodles

To be as effective as possible, try to play as children do to be in a state of possibilities. Act things out if you can. At this point, DOODLE! Sometimes the act of laying some lines conjures up creative ideas. Doodles are playful thoughts that should fly off your pencil. Don't worry about draughtsmanship. Likewise, the author should be encouraged to doodle also to get a point across. Look for rules to break. You can always pull back to a more conservative solution of producing your world.

Thumbnails

Thumbnails lay the foundation of the book. They are small, compact glimpses of what is developing from previous doodles.

I work in only 1' wide frames. The purpose of thumbnails is to lay images down in such a small space that there is no room for unnecessary details. Thumbnails also take less time, so that you can alter the drawings with the minimum of time spent.

Consider a few concepts to get started on the thumbnails:
- *What is the format?* Discuss whether the book is to be a horizontal, square or vertical. Then lay out the frames so that they are contained on one piece of paper. Photocopy some copies for templates. Leave some room to write notes in the margins next to each frame. Remember – type should be well away from the pages edge and be sure that no words or important images

run into the gutter of the book.
- *How much image?* If there are a lot of words to fit in, give them room to spare so that the images and type have breathing room.
- *Beginning/end:* How can you introduce the objects/characters visually? First impressions are important for the characters in a book, too.
- *Composition:* Where is the focal point in the design? What direction are the movements? From what perspective should the viewer be positioned? Once again, don't worry about details at this point-simple lines and shapes will do.
- *Transitions/movement:* Do the images hint at what is to come? Have you implied motion when necessary? Such devices can develop a sense of anticipation and energy.

You may want to schedule a weekly review with the editor to check progress. Get through the first draft early – you may have to go through many new sets of thumbnails until you get a go-ahead to the next stage – roughs.

© John Amoss 2001

Possible illustration pitfall No. 2
When the muse is over -
If disagreements arise, the editor should get involved. In order to expect others to have an open mind, you should expect the same of yourself. When discussing ideas, be sure to use your drawing skills. Authors and editors are generally much better at verbally expressing their points than illustrators are. Remember that you should be an equal in the process and that all parties should be interested in the same thing – the quality of the book.

Roughs
Now that you know, more or less, what the basic elements are, you need to work larger to be able to flesh the drawings out and to get across more

subtle elements. I would start out with frames about 4" wide (probably about half the size of the final.) Lines and shapes are still the building blocks here. You will need a lot of reference. You can sift through magazines, books or my favourite source – the Internet. I would encourage you to take your own photos – especially if there are a lot of human figures involved – or get in the same poses in front of a mirror.

Consider a few concepts to get started on the roughs:
- *Setting:* What style is appropriate? simple/complex, futuristic/old fashioned, bright/dark, exotic/familiar, fantasy/reality?. Try to think about what medium would be most appropriate. For example, if the book is to have a complex old– fashioned feel, you would probably not use collage or big shapes of bright colour.
- *Character development:* What is the character like? What would she/he/it feel like or react to? What are the physical properties of the character?
- *Minor elements:* Do you want some images that are partially hidden or as a way of showing incidental elements (such as a kitten playing with yarn in the corner or a spider web)?
- *Helpful hint:* It may be a good idea to print out the text and xerox it onto a piece of acetate for an overlay so that you are sure the layout can accommodate the text.

© John Amoss 2001

Tight sketches/Colour comps
Tight sketches and colour comps are ways of resolving the most complex and subtle qualities of the artwork. You shouldn't want to go to the final until everyone involved is *completely* happy about the tight sketches. You may possibly omit the colour sketches stage if you are confident with the use of colour.

Consider a few concepts to get started on the tight sketches/colour comps:
- *Lighting:* Is lighting a factor that would enhance the story? Is the day progressing from light to dark? Shadows can be an effective emotional device.
- *Colour:* Is this book for very small kids (usually primary colours along with strong contrasts are favoured) or for older kids that may enjoy more subtle, moody palettes?
- *Texture:* Texture is a very effective way of adding visual interest to things if used in moderation. Too little and things can be lifeless, too much and things can get neurotic. Look for appropriate uses such as a scraggly coat.
- *Detail:* You should also learn as much as you can about the subjects. Studying how things are constructed allows you to understand how to 'ad lib' the forms beyond the reference in front of you.

Finals
Well, it is time to reveal what the book will finally look like for production. Even with all of the preliminary work, don't be surprised if you have to redo any one of the finals.

Anticipate the flow of work from the blank boards to the finished pieces. Try to work under the correct lighting if possible. Indirect sunlight is the best but you can use corrective light bulbs that will allow you to work well past sundown.

You need to decide whether your finals will be at the actual size of the book or proportionally a bit larger. The reason for the latter approach is that when artwork is reduced it helps to 'pull everything together' so that the possible flaws are less apparent. After deciding on the size, make a template of the page making sure that elements such as page numbers are taken into account. It is mandatory that you allow a 'bleed' around the artwork. A bleed assures that all of the image appears on the page regardless of printing and binding errors.

Before you start, try to gather all of the materials you need ahead of schedule (your favourite watercolour paper could end up on backorder). I suggest working on many pieces at the same time to foster consistency, so go ahead and transfer the final tight sketches (only the contour lines) onto several of the boards. There are two ways of transferring your sketches to the final paper or board. The easiest is to use a light table from which to trace through the paper and sketches. This technique doesn't work

with heavy boards however, so you would need to use tracing paper. After the sketches have been transferred, it may be a good idea to tape a protective piece of paper on top to keep the drawing from being smeared and the paper clean of flying paint and coffee cups!

Use a scrap piece of whatever board or paper you are using as a test strip before applying a new colour to the final. Step back and view the work from a distance, upside down or in a mirror to gain a fresh perspective on your progress. Once again, it is a good idea to keep a couple of pieces going at one time. If you get tired of one or need to let it dry, you can go on to another one. Hairdriers are a good idea. There will always be things you would like to redo in your finals. Unless they are major problems, few people will notice. Endpapers, posters, ads may all need your attention. Therefore, I would recommend finishing the book and then if there is time, you can rework what time permits. While doing the pieces you will probably have several check-in meetings so that you can show the progress of the book to whoever is interested. Because of the previous steps taken in the sketch stage there will be no surprises in store. Colour and technique are the only unknowns at this point.

The cover

The front cover is the most important image of the book. It will appear on ads, commercials, catalogues – it is the symbol that stands for the book. You may find that the cover illustration takes much more time than the other pages. The marketing and advertising departments have a lot of say at this point because the cover becomes an ad in itself. When a customer comes into the bookstore, her/his eye should be drawn to the cover image and be compelled to pick it up.

Layout and post production

After the finals are accepted, I suggest that you become involved with the layout of the book. You may learn a lot about the production and printing procedures at this point. Most layouts are done on a computer and then sent to a production facility – usually, at the printing plant. From there, the layout is assembled and printed out as a keyline (similar to a blue print). The keyline is a good indication of the placement of images, another chance to be type edited, and allows everyone to see the book as a flow. After the corrections are made, production then prints out film negatives from which (barring any additional changes) the final book will be made.

A 4-colour proof (Cyan, Magenta, Yellow and Black) is generated on acetate. Colour corrections are made, glitches on the negative are removed and the book is given a go-ahead for printing.

If the book is printed locally, you may get to see a press proof. The press proof is basically a review of the first acceptable book printed on the spot. I would encourage you to meet the printers and see the equipment to get a sense of what goes on behind the stage.

© John Amoss 2001

Selling the book – public relations

While the book was in production, many people at the publishing house were busy at work drumming up support for your creation. Orders from buyers are taken, signing dates are scheduled and you may get a launching party! All of this should be your time to enjoy the possibilities of the book and to look around for contacts to help you. If you know of any influential people in any business that may benefit from the book – pass them on to the marketing department.

You should be scheduled for signing after the book is on the shelves. Signings are a great way to meet children and folks that deeply care about books. As a way to entertain the kids, you may want to illustrate a story with the author. During the signing, try to find a way to add an image to your signature. People love to possess original artwork and it will be going to the people who deserve it the most – the book-loving public. There is a good deal of work to be had going into schools and presenting your work and abilities, for a fee. Scheduling services can arrange events for you.

Check out Amazon.com for a comprehensive list of books on Children's Book Illustration.

And get hold of *The Artists and Graphic Designer's Markets* for a list of publishers and Artists' Directories.

PRO TIPS – ROBIN HALL
HOW THIS BOOK WAS CREATED

Cartoonists and illustrators can very often extend their creative abilities into other areas of publishing. They may write and illustrate fictional or instructional books (like this one) or they may be commissioned by an author to not only illustrate but also design and set up an entire book on a computer ready for printing.

As I neared the end of writing this book it occurred to me that I have acquired quite a few new trade secrets about book design that I can pass on to you.

How 'Trade Secrets' evolved

I was commissioned to write this book as a follow-up to *The Cartoonist's Workbook* but I first had to prove to the publishers that I had enough original material *for* a second book. I obviously couldn't cover the same ground. The first thing I had to do was write a proposal. This is a 'break down' of the various chapters and the ideas within each chapter. The following is exactly what I submitted to the publisher's.

As you can see, a lot of changes have been made since this first draft.

INTRO – UPDATES ON BOOK ONE

PART 1
THE EVOLUTION OF A CARTOONIST
* Using my own work as examples – from feeble first efforts to today's work
* How to REFINE your work
* the importance of self criticism
* The 2 keys for success – PRACTICE and REPETITION …
 PRACTICE and REPETITION..
* The importance of reference – learning from the Pro's
* Broadening your horizons – branching out
* Keeping up to date with current trends and affairs
* Originality
* Zen and the art of Cartooning – ideas come from 'within'.
 How to develop your most important tool – your awareness
* The pros and cons of 'writers block'
* learning to write for different age groups

PART 2
CARTOONING IN THE DIGITAL AGE
* Why use a computer
* HOW to use a computer
* Software / Hardware / Drawing tablets
* The ESSENTIALS
* Do's and don'ts
* Printing – emailing – faxing – submitting work
* The Internet – for reference – useful sites – making a website
 Etc etc

PART 3 (haven't worded this title yet)
A CLOSE LOOK AT A VARIETY OF 'ACTUAL' CARTOON JOBS AND PROJECTS
* Taking the reader step by step through a series of 'actual' commissioned jobs from the initial briefing to the finished artwork.
* a book cover
* Gag cartoons for a nightclub advertisement
* A cartoon for a poster (semi-caricature)
* A regular comic strip for the Sunday Post
* A range of Greeting Cards

PART 4
THE PROFESSIONALS TELL ALL
Interviews with various cartoonists who all work in different areas
* Gary Hamilton – regular cartoonist for the DANDY
* Peter A. King – regular Gag cartoonist for PUNCH , PRIVATE EYE, SPECTATOR, Etc
* Ronnie baird – cartoon illustrator and Art College lecturer
* Allistair Mc Ilwain – renowned Animator (the Smarties ad)
* Will Simpson – artist for top comics like 2000AD

PART 5
ADVICE FROM THE TOP TEN AMERICAN SYNDICATES
* I will be sending them all an in-depth questionnaire to fill in several have already agreed
* Cartoonists would kill their Grannies for this information

PART 6
A HUGE MARKET FOR CARTOONISTS – GREETING CARDS
* results of a questionaire I sent out
* submitting work
* advice from a company called M. G. Media – Designers consultants
* current trends – colours – humour
* Art cards
* Setting up a card company
* My own replies from various companies – and rejection slips
* my own published cards

PART 7
CARTOONS AS ART AND ILLUSTRATION
* What's the difference ?
* developing an 'Artistic' cartoon style
* Paintings or limited edition prints ?
* Getting work into Galleries – Framing – Presentation
* Art Greeting Cards
* Art agents – pros and cons
* Book illustration

PART 8
THE MANY FACES OF CARICATURE
* Semi-realistic
* Cartoony (like the Simpsons doing mel Gibson)
* Using photocopies
* Using an amazing piece of computer software – 'Super Goo'
* using other artists 'techniques'
* Sketching for 'flukes'
* Using 'collage'
* Examples of many styles

PART 9
MISCELLANEOUS
* 4 more pages of Gag situations (as in book 1)
* 4 more pages of POSES (as in book 1)
* How to find 'names' and 'titles'
* maybe expand on some other areas like Ad Agencies etc
 Etc Etc

USEFUL ADDRESSES – WEB SITES – BOOKS – CARTOONING COURSES – SCHOOLS- ETC
ACKNOWLEDGEMENTS

Once the proposal got the 'all clear', my editor set me a deadline for completion of the first draft.

According to my computer, it has been almost two years since I submitted the proposal. I was given a year to hand in the first draft but I kept begging for extensions.

It didn't actually take me two years to write the book. I wrote it in about six months but it took me a year and a half to find the motivation (and the inspiration) to begin.

I enjoy writing about as much as I enjoy washing dishes. Putting a book 'together' is fun, writing one – for me – is an absolute torture. I remember being almost close to despair when I sat down with the first chapter.

Luckily, due to my vast experience with 'writer's block', I knew what had to be done.

When in trouble – make a list

If you are writing anything 'factual' or 'instructional' (and writing doesn't come naturally to you) the best plan is to keep writing 'lists' of ideas about each topic you wish to discuss. You can then put each idea in some kind of order and form sentences around them that you can then hopefully join together to form paragraphs, pages and chapters. When you *do* come to do this, try to 'write' the way you would 'speak'. Print the text and cut out each paragraph so that you can move things around.

I also made separate folders for each chapter and started gathering notes and reference material. By doing this I immersed myself into the book gently and slowly began to feel that I was getting some-where. If I had sat staring at a blank page (or screen) I might still be sitting there – cobwebs and all!

It is also helpful to design a few finished pages to get a feel for how the book will look. This inspires you to want to do more.

The Design Process

I'm starting to realise that experience is everything when it comes to doing anything in this world. I imagined, because I had a certain amount of artistic ability, that designing a book would be quite a simple matter. After a few weeks I realised that my book was looking more like a hastily-compiled college report. I had set the text in only one column which was the full width of the page. The letterstyle was plain old 'Helvetica' and was *way* too large. The illustrations didn't seem to have any structuring and the whole thing was just very amateurish to look at. It was time for some research. I started looking at how other similar 'instructional' books (around the same size) had been produced and designed.

- *Every* large book – without exception – was set in two or three columns. Text is simply easier to read in shorter lines.
- Most books use a letterstyle (font) that gives plenty of space around it.
 This book is set in the font 'Univers 55'
 This sentence is set in 'Helvetica'
 This sentence is set in 'Times New Roman'
 You can see what a big difference the font makes to the legibility of the text.
- It is also important not to run the text too close to the edge of the book. The more white space your pages have, the easier it will be on the reader's eyes. If the whole page was covered in text it might seem like a lot to take in.
- Most books have various places where you can rest your weary eyes. Paragraph spacing, chapter breaks and sub-headings all help to split the text into smaller segments.
- Illustrations can be positioned in a variety of ways. Portrait-shaped images fit nicely anywhere into the columns. Landscape-shaped images can either sit right across the top or bottom of the page or be reduced in size to fit into one of the columns.
 Alternatively, illustrations can be arranged on a 'facing' page that has no text. A small description can be written beside each image or in one corner of the page.
- There is a growing trend nowadays for 'dynamic' book design where each page looks like a page from a trendy magazine for teenagers. You have to decide if you want to go in that direction or stick with the more subtle, traditional layouts.
 It depends on who your target audience is and whether you want the book to be fast paced or slightly serious.

SETTING UP A DOCUMENT ON THE COMPUTER

I set this book up in Quark Express. If you use another page layout package hopefully you can still get the gist of how to produce a document from these instructions.

Again, I will assume that you have a basic knowledge of your page layout software.

Work out your measurements

First of all you need to work out your page measurements. Ask the publisher for the exact width and height of the book. Then *you* decide on the width of your columns of text? How much space is there top, bottom, left and right, *around* the text?

Open a new page and set the measurements. Check the 'automatic text box' which means your page will automatically have a text box already inserted.

Create a Master Page

Then open your 'document layout' window and double click on the 'master page' symbol (A-Master-A).

On a master page you can create certain guidelines, borders and text boxes that are repeated throughout the book. You can then duplicate as many pages as you wish *from* this master page. (these duplicated pages can be altered if needs be)

The master page for this book contained the text box in the two columns, the text box for the headings and the text box for the page numbers.

You create new pages by dragging the master page into the Document Layout part of the window. (You can also drag down 'blank' pages as well)

You can rearrange the pages in your document layout window any way you wish by dragging them around. You can also set two pages side by side which will give you a better idea of how they look together.

That's your document set up - easy!

Add your text and images.

When you start typing, the text, by default, will be a certain font and a certain size. You need to try a few pages and then decide on a letterstyle and what point-size it will be. Again, check out other books. Experiment, print a few pages and see how it looks.

Selected text can be altered by going to STYLE in your main menu but it is easier to use the 'Measurement' toolbox (VIEW-SHOW MEASUREMENTS) to make adjustments or learn the keyboard shortcuts.

The font I used for this book is Univers 55.
The main text is 10 point
The space between each line of text (Leading) is 13
The space between each single letter (Tracking) is 0
Page headings are in the letterstyle **STENCIL.**
Paragraph headings are in **Univers 65 Bold.**
Images are in 'Grayscale' and at least 300DPI (at the size they appear in the book)

****Take note!** - Do NOT use the 'easy' shortcuts on the computer to make letterstyles bold or italic. It may *look* bold on screen and it may print out bold on your home printer but a professional printer needs you to place in the *actual* letterstyle.

For example, When I wanted bold lettering, rather than just making the Univers 55 lettering 'bold' by clicking on the 'bold' icon, I had to select the type and change it to an *actual* bold letterstyle - in this case **Univers 65 Bold.**

Justified Text
All of the text in this book is 'Justified' (STYLE-ALIGNMENT-JUSTIFIED) which means it spreads out to both sides of the text box which gives it a tidier appearance.

Avoid 'broken' words
On a computer, when the text reaches the right hand side of the text box, some words are split into two with a 'hyphen' in between. For instance the word 'letterstyle' has been 'split up' as you can see, but it doesn't look very professional that way. You need to go through your text and get rid of 'broken' words by placing the relevant number of 'spaces' before the word until it moves on to the next line. This can cause more 'broken' words which in turn have to be fixed. It is a process of trial and error.

Sometimes you may need to alter the space between each individual letter in a paragraph of text (The 'Tracking') in order to make it fit on the page or to fix a 'broken' word. For instance, if you select a block of text and make the tracking 'minus one' (-1) you will see it all shrink in length.

Document L...

A-Master A

A
133

A
134

A
135

A
136

A
137

A
138

A
139

A
140

A
141

142

A
143

143 P...

111% Page: 140

X: 22.5 mm W: 174 mm ⟋ 0° 13 pt Univers 55 10 pt
Y: 23.5 mm H: 235 mm Cols: 2 0

Linked Text

If you have filled a page with text, when you come to the bottom if you keep on typing the text will automatically run on to a new page. Pages of text created in this way will all be connected which means that the text will move as a whole unit if any part of it is altered. So, if you have created 50 pages of 'linked' text, every single page will change if you add in a paragraph on one of the pages. This is useful if you are writing a novel.

Unlinked text

If you want to create pages of text that *aren't* linked in this way you need to *stop* typing when you reach the end of the page and then create a new page by dragging another one from your 'master page'. Drag it down below the previous page in the document layout window. Then double click on it to open it. When you add text to this new page it will not be linked to the previous page. This is useful if you are writing a book such as this one where the pages are separate entities.

Removing unwanted pages.

Often, when you are working on a page and you are adding images the text can 'spill over' on to a new page (that IT creates) if you have made the image too large. When you make the necessary adjustments and you have got the text back on to the one page you will still have the (now blank) 'spill-over' page in your document. If you double click on this page the trash icon will become available and if you click on the bin the unwanted page will be removed.

Placing Images

Make sure images are at a high enough resolution (see page 46) and save them as TIFF files.

To place an image on a page you must first create a picture box using the 'picture box tool'. Should you wish to remove the picture box you need to select it with the 'item tool' (the top one in the tool box) and then go to EDIT-CLEAR and it will vanish.

However, if you create the picture box within the boundaries of your text box it will become linked *to* the text box and you will not be able to move it outside the text box boundary *or* remove it unless you click on the 'unlinking tool' (the bottom tool in your tool box) You can avoid this problem by creating your picture box by starting the box at a point *outside* the main text box. Then it will not be linked *to* the text box and can be moved anywhere or easily removed.

Making Modifications

*Changing the text box colour.

If you wanted white lettering on a black background. First create a text box with the textbox tool. Then go to ITEM-MODIFY-BOX-BOX COLOUR-BLACK. The text box will then be black. To change your lettering to white go to STYLE-COLOUR-WHITE and start typing.

*Making the text box transparent.
You may want to place text over an image as if it has been written on clear acetate. Go to ITEM-MODIFY-BOX-BOX COLOUR-NONE. The text box will then be transparent.

*Making a border (frame) around text or an image.
To put a border around a picture box select the box and go to ITEM-FRAME and choose a width and a colour. The edge of the box will then have a border.

Because text is tight against the box it is created in it doesn't look right to place a border around text in the same way. You need to create another *larger* box and place it *behind* the text box (by going to ITEM-SEND TO BACK) and then put a border on the *bottom* box.

LIKE THIS

Save every five minutes

In your 'Preferences' set your layout package to automatically save your work every 5 or 10 minutes. Don't trust your computer not to freeze.

Collect for output

When the document (book) is finished go to FILE-COLLECT FOR OUTPUT and a folder will be created on your computer with everything necessary for the printing of the document in it. If you have used uncommon typefaces, you may have to place a copy of the fonts IN the folder as well.

Put it all on CD ROM

All that's left is to send the document and images off to your publisher (along with a printed version) where it can be edited and eventually passed on to the printer who will set the pages up in the correct sequence for printing.

Then you can celebrate.

AND FINALLY ...

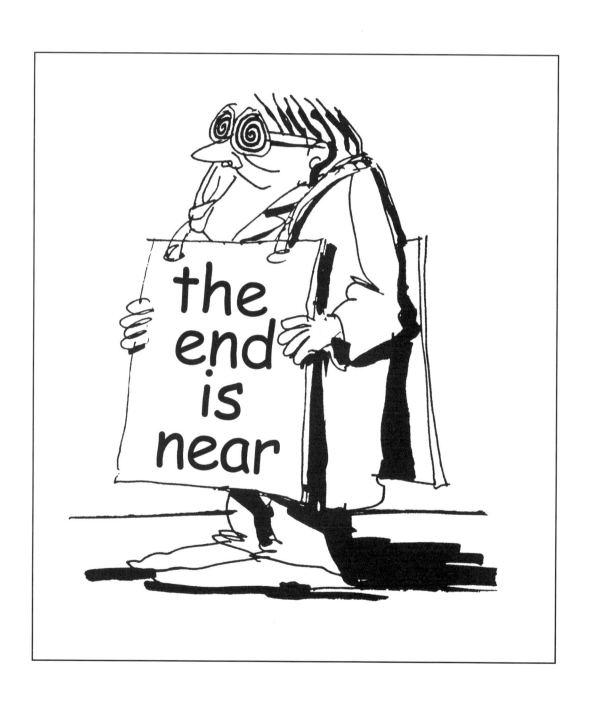

WEB SITES

http://www.planetcartoonist.com/top100.shtml

CARTOON RESOURCES

www.planetcartoonist.com
HUGE resource for everything to do with cartooning

www.suite101.com
Articles on various cartoon topics plus links to
1000+ comic strip resources on the net.

www.astronerdboy.com
Various stuff about comic strips.

www.wewebu.com/amazon/html/cartooning.htm
List of the 50 most popular cartooning books at
Amazon.com

www.cartoons.com/

www.starvingartistslaw.com
A launch pad for artists and writers looking for
self help legal information.

www.cartoonsforum.com
Internet Cartoon Forum

COMICS

www.jfree.dircon.co.uk
See 'Breaking into comics' Page 112.

www.hometown.aol.com/comicbknet/index.html
Comic book network

www.ripoffpress.com (Underground comics)

www.icomics.com

www.comicon.com

CARTOONISTS ONLINE

www.cartoon.co.uk
5 professional UK cartoonists

www.etoon.com Cartoonist Vlad Kolarov.

www.snoopy.com (my hero)

www.royston.dircon.co.uk
UK Cartoonist Royston Robertson

www.waylay.com
Great cartoon artist called Carole Way

www.pierotonin.com (Cartoon service)

www.jeffcline.com Humourous illustrator

www.marsdencartoons.com/directory.htm
Huge directory of top cartoonists with web site
addresses and emails.

www.cagle.com/
Daryl Cagle's Professional Cartoonists Index

www.oliverjeffers.com
Cartoonist/Illustrator - Nice online portfolio

www.cartoonology.com
Terry Christien, Cartoonist/Illustrator and
secretary of the Cartoonists Club of Great Britain

SYNDICATES and AGENCIES

Toler Media Services
email cannaday@global2000.net
Former rep for United Media and TMS, Jim Toler
offers consultation to artists through his syndication
and syndication assistance company

138

GREETING CARDS

www.writerswrite.com/greetingcards/publish.htm
Links to Greeting Card publishers and resources

www.writerswrite.com/journal/feb98/gak4.htm
Article - 'Using the internet to crack the
Greeting Cards Market'

Greetings Today (785) 843-1235
www.greetingtoday.com
members.tripod.com/Marie_Bahr/

Greeting Card Association
1200 G Street, NW, Suite 760, Washington, DC
20005 Tel: (202) 393-1778 Fax: (202) 393-0336
www.greetingcard.org/

www.greetingcardwriter.com

www.partypaper.com (Party & Paper magazine)

ORGANIZATIONS

www.cartoon.co.uk/college.htm
The College of Cartoon Art
The Moat House, 133 Newport Road
Stafford ST16 2EZ

www.reuben.org
The National Cartoonists Society

www.pipemedia.net/cartoons/index.htm
The Cartoonists Guild contact directory (UK)

www.apcatoon.com
The Amateur and Professional Cartoonists
Association

http://www.kubertsworld.com
The Joe Kubert School

www.ccgb.org.uk
The Cartoonists Club of Great Britain.
46 Strawberry Vale, Twickenham TW1 4SE
Tel: 020-8892 3621 email terry@cartoonology.com

POSTERS & PRINTS

www.irishartgroup.com
Some of my own paintings and prints

www.artframing.com

www.iframeart.com

www.art-posters-prints.com

www.bentleyhouse.com
A large publishing house that uses my own paint-
ings for merchandising and as fine art prints

ANIMATION

www.cartooning.about.com/arts/animation/
links to animation sites and resources

www.web.top100.by.net/raymation/private/anim.htm
Animation links - post production, news, events,
resources, sites and multimedia

www.celluloidstudios.com

www.awn.com
Animation World Network

www.bergen.org/AAST/ComputerAnimation/

www.asifa.org/animate/main.htm
International Animation Association

www.theclayman.com/links2.htm
Loads and LOADS of terrific links

ANIMATION STUDIOS that produce intro movies and sequences for games.

www.axisanimation.com/
AXIS ANIMATION
2nd Floor, 150 St Vincent Street
GLASGOW G2 5NE , UNITED KINGDOM
Tel: [44] 141 572 2802

www.digital-animations.com/
DIGIMANIA / DIGITAL ANIMATION GROUP PLC
Hamilton House - Phoenix Crescent
Strathclyde Business Park
Lanarkshire, Bellshill ML4 3NJ
UNITED KINGDOM
Tel: [44] (0) 1698 503300
They are producing famous consoles games like
'Collin McRae', 'Toca', 'World Championship
Soccers' etc …

www.codemasters.com/index2.htm
CODEMASTERS SOFTWARE LTD.
Lower Farm House,Stoneythorpe, Warwickshire
Southam CV47 2DL, UNITED KINGDOM
Tel: [44] 192 681 4132

There is also Criterion Software/Studios Ltd.,
this is also a big company owned by Sony.
www.csl.co
CRITERION SOFTWARE LTD.
Westbury Court
Buryfields, Surrey
Guildford GU2 4YZ, UNITED KINGDOM
Tel: [44] 01483406230

WEBSITES

CHILDREN'S BOOK ILLUSTRATION

www.scbwi.org
Society of Children's Book Writer's & Illustrators

www.ipicturebooks.com
Childrens ebook publishers who will look at submissions

www.underdown.org
Advice for children's writers and artists from a childrens book editor

www.write4kids.com
'The children's writing supersite'
Articles, tips, message boards etc

www.shefelmanbooks.com
A husband and wife team

www.joanholub.com
Author and/or illustrator of over 50 children's books. Advice on writing and illustrating

www.lights.com/publisher/index.html
Publisher's Catalogues Home Page

www.faxon.com/title/pl_am.htm
Publishers on the Internet

ONLINE PORTFOLIOS AND SOURCEBOOKS

www.artnetweb.com

www.art.net/ (Art on the net Index)

www.esinet.net/ac.html (Artisan's corner)

www.illo.com

ww4.choice.net/~ktbarney/thenose
The Nose. online caricature artist index

www.onlinegallery.com

www.portfoliocentral.com

www.theispot.com

www.uscreative.com (U.S. Creative Directory)

SHOWCASES

www.webcomics.com
Showcase for online cartoonists

www.ecards.com/info/artists
Ecards artist community programme.
Showcase for artists (free)

www.lrishartgroup.com
Some of my own paintings and prints

ILLUSTRATION/GALLERIES

http://www.booklocker.com/books/109.html
Excerpt from a book - 'Illustration 101 - Streetwise Tactics for Surviving as a Freelance Illustrator'

www.members.aol.com/thedrawing/links.htm
The DRAWING BOARD for Illustrators.
Internet Resources for childrens bok illustrators and writers. Loads of links

www.zuzu.com/artlink.htm

www.artdealers.org

www.dart.fine-art.com/artlinks

www.genart.org

www.artmarketing.com

www.artcalender.com

WEB DESIGN

www.sitesell.com

CREATIVITY AND WELLBEING

www.ozemail.com.au/~caveman/Creative/

www.eckharttolle.com/

www.theopensecret.com

www.thedailyguru.com

www.deeshan.com

www.osho.com

www.ramana-maharshi.org/

www.mokshapress.org

www.chopra.com/

www.elsajoy/spiritus.com

www.dmoz.org/Society/Religion_and_Spirituality/Enlightenment/

www.enlightenmentintensive.net/

www.oneness.com

www.spiritsite.com

www.ibiblio.org/zen/ (zen links)

BIBLIOGRAPHY

You can find most of these titles at
www.Amazon.com

Writers' and Artists' Yearbook
Published by A & C Black
UK 'bible' for artists' and writers' market

The Artists and Graphic Designer's Market
Writer's Digest Books (USA)

Understanding comics
by Scott McCloud

Successful Syndication
A Guide for Writers and Cartoonists
By Michael Sedge

Write Well and Sell Greeting Cards
By Sandra M. Louden

Illustration 101 – Streetwise Tactics for Surviving as a freelance Illustrator
By Max Scratchman
ebook
(www.booklocker.com/books/109.html

Writer's Market
Writers Digest Books
Has a Greeting Card section with listings for companies looking for text for refrigerator magnets, notepads, keyrings, plaques, coffee mugs, slogan buttons, bumper stickers, etc.

Cartoonist PROfiles
P.O.Box 325, Fairfield,CT 06430, USA
A quarterly magazine with all sorts of advice for aspiring cartoonists

Drawing from Within: Unleashing Your Creative Potential
by Nick Meglin, Diane Meglin

Humorous Illustration: Top Artists of Our Time Talk About Their Work
by Nick Meglin, Federico Fellini

Picture Framing: A practical guide to all aspects of the art and craft
Pete Bingham

Increase your Web Traffic in a Weekend
William R. Stanek

The Complete Book of Humorous Art
By Bob Staake
Excellent illustrations and text

Drawing Cartoons That Sell
By John Byrne
Good practical advice

From the Heart
Mackenzie Thorpe
Incredible contemporary painter/illustrator
Gorgeous book

Constructive Anatomy – George B. Bridgman
Bridgman's Life Drawing – George B. Bridgman
(Two recommendations from Graham Toms on the subject of 'gesture drawing')

The encyclopaedia of cartooning techniques
Headline

USEFUL RESOURCES

M.G. Media
Bolton Enterprise Centre, Washington Street,
Bolton, Lancs, BL3 5EY
Tel: 01204 524262 Fax 01204 535995
email mgmedia@aol.com
Proprietor Marcia J. Galley (a very nice lady)
Produces a bi-monthly newsletter aimed at writers and artists who wish to place their work with greeting card publishers. Publishes the artwork and editorial needs of top publishers in England and overseas.
Not an agency.

Robin Hall
That's HALL folks c/o Peter Hall
70 Downshire Park East,
Belfast BT6 9JQ, Northern Ireland
Tel: +44 (0) 28 9080 3776
Email: Robin@cartoon.sol.co.uk
or Robin@thecartoonfactory.com
www.thecartoonfactory.com

READERS GALLERY

As I mentioned at the start of this book, I have received some wonderful letters from around the world in response to my first book. These letters made all the effort worthwhile and I would just like to say a big thank you to everyone who wrote to me by putting some of your terrific drawings where they deserve to be – in print! Copyright belongs to each artist – of course …

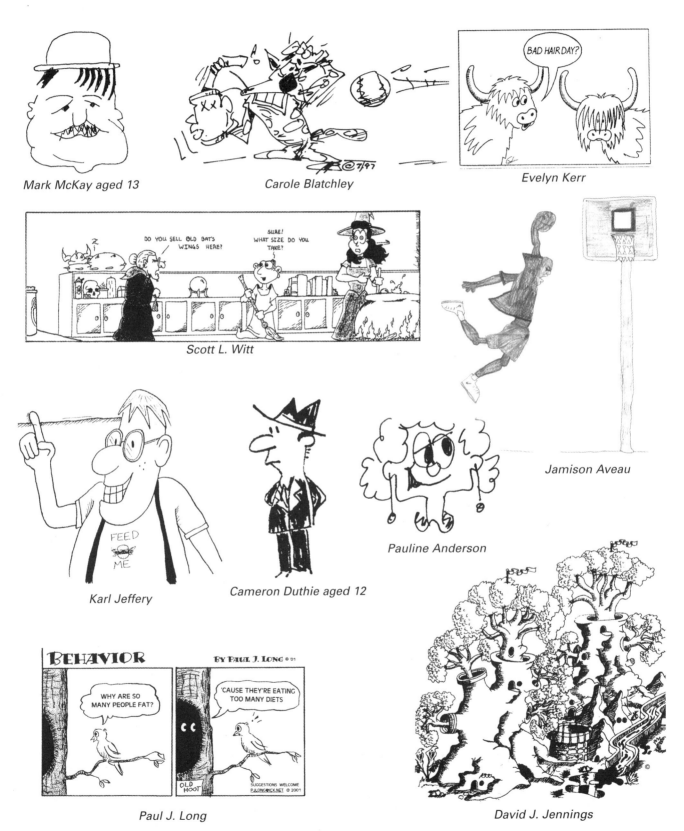

Mark McKay aged 13

Carole Blatchley

Evelyn Kerr

Scott L. Witt

Jamison Aveau

Pauline Anderson

Karl Jeffery

Cameron Duthie aged 12

Paul J. Long

David J. Jennings

ALSO BY ROBIN HALL

A book of practical information and reference for all cartoonists. Robin Hall provides his unique 'keyhole' drawing method for the beginner, which shows step by step how to build faces, bodies, expressions, movement, costume, etc. He then describes techniques for freehand drawing, composition, perspective and caricature – with hundreds of useful drawings. The hardest and most overlooked aspect of cartooning is writing 'gags' for single cartoons and comic strips. It is here examined in detail with lots of suggestions for exploration and development. Finally, there is helpful advice on presenting finished work and, what is most important, on getting it published.

"The approach of this book is one of the best I have ever seen" – Charles M. Schulz

Unique drawing method for beginners

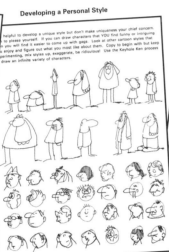

Advanced drawing techniques

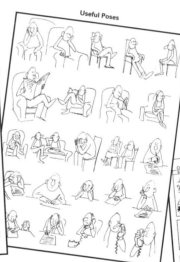

Hundreds of useful reference drawings

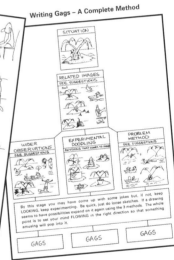

A complete method for writing gags

What readers have to say

'… it is the first book of it's kind to delve into the most difficult side of cartoons, that is the ideas themselves, and the various reference sections are an absolute godsend … I had no qualms about purchasing your book as it was so informative.'

P.A.King – Merseyside (1996)

'… I think it is a really great book, very practical, easy to follow and an inspiration to someone like me who has very little ability to draw.'

Colin Middleton – Yorkshire

'… your book is a great encouragement to keep going and a great source of inspiration. I hope it's earning you millions.'

William Freeman – Middlesex

'… I've bought £70 worth of cartooning books and this is the first that helped a lot.'

Andrew Crisp (aged 9) – Somerset

'… enjoyed and indeed continue to enjoy your book … I sincerely thank you for making the truth (about the business) known, at the same time showing the way.'

Mike Robinson – Manchester

INDEX